The Handcraft Revival

in Southern Appalachia

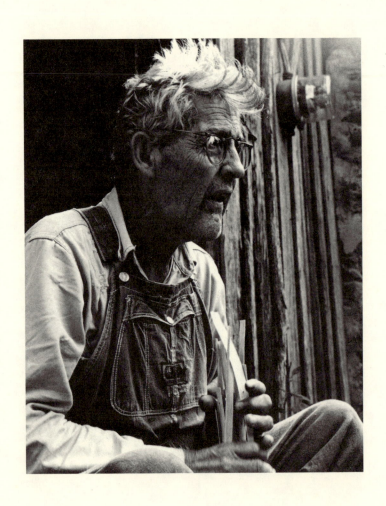

The Handcraft Revival in Southern Appalachia, 1930–1990

Garry Barker

The University of Tennessee Press

KNOXVILLE

Frontispiece: B. S. Gilliland at his home a few weeks before his death.
Gilliland made birdhouses and baskets from oak splits cut from his
mountainside farm near Asheville, N.C., to support a family of
fourteen children. Photo by Alan Ashe, used with permission
of the Southern Highland Handicraft Guild.

The paper in this book meets the minimum requirements
of the American National Standard for Permanence
of Paper for Printed Library Materials.
∞
The binding materials have been chosen
for strength and durability.

Library of Congress Cataloging in Publication Data

Barker, Garry, 1943–
 The handcraft revival in southern Appalachia, 1930–1990
Garry Barker. — 1st ed.
 p. cm.
 Includes bibliographical references and index.
 ISBN 0-87049-703-0 (cloth: alk. paper)
 1. Handicraft industries—Appalachian Region.
Southern-History—20th century. I. Title.
HD2346.U52A1273 1991
338.6'425'097691—dc20 90-26214 CIP

To Bob and Verdelle Gray,
and all the others
who made it possible

He who does creative work, whether he dwell in a palace or a hut, has in his house a window through which he may look out on some of life's finest scenes. If his work be a handicraft he will be especially happy, for it will help him not only to perceive much of the beauty of the world around him but, what is man's greatest privilege, to identify himself with it. If it enables him to earn his daily bread then he should rejoice, for blessed is the man who has found his work; but if, as will be the case of many in our day, his handicraft is not a way of making a living, but through self-expression a help toward a fuller life, he too will rejoice, for he has all the privileges of his fellow-craftsmen without the need of fitting his product to the market.

—Allen H. Eaton,
Handicrafts of the Southern Highlands, 1937

Contents

Illustrations

TABLES

Foreword

Allen Eaton's 1937 book, *Handicrafts of the Southern Highlands*, has been and still is used as *the* reference in the study of Appalachian crafts prior to 1935. Through continued leadership, this region's crafts continued to flourish after Eaton's study was published. Because of this continuity within the mountain craft world, there has been a demand for an update of the information on Southern Appalachian crafts and craftspeople. Garry Barker has responded to that challenge by writing the present book. The author, through his involvement in and observation of the craft programs of this region, has compiled the information needed, and this book is written from firsthand knowledge of the period.

In the first few chapters, Barker makes the transition from the period covered by Allen Eaton's study into the present by introducing the craft leaders mentioned in *Handicrafts of the Southern Highlands*. Barker knew many of these people; some have continued their leadership to the present.

Because of the author's involvement in Kentucky craft programs, a large part of this book is focused on what was happening in Kentucky during this period. The activity in Kentucky paralleled the craft movement in other parts of the region, as is reflected in some chapters. Barker has continued to work with craft leaders both within and outside of Appalachia, and his personal involvement in craft administration gives him an insight into crafts that other writers do not have.

Barker's style of writing, which he developed through writing short stories about Appalachian people, is straightforward with a

touch of mountain humor. His book is more than a collection of statistics; it is a record of the craft movement in Southern Appalachia as seen through his eyes. This is a valuable document of the crafts movement from 1930 to 1990 in the Southern Appalachian Mountains.

Coupling his love for writing and his knowledge of the craft movement, Garry Barker is able to make this book both interesting and informative. No other author could write with such authority and integrity about the Southern Appalachian crafts of this period.

—Robert W. Gray, Director Emeritus,
Southern Highland Handicraft Guild

Preface

I write before daybreak, in my kitchen, surrounded by crafts. The chairs are walnut "mule ear" ladderbacks. Originally they came with cornshuck bottoms, detailed craftwork which finally succumbed to ten years of claw sharpening by an uncivilized Siamese cat. Our coffee mugs are stoneware. The chopping block, cutting boards, rolling pin, plates, throw rugs, iron hooks, teapot, saltshaker, butter dish, and even the chipped ashtray are handmade.

We are not collectors, in the conventional sense. We *use* our crafts in everyday living—furniture, clothing, quilts, the wrought-iron fireplace set, even my walking stick—and that *function* is a large part of how the modern craft marketplace was built. It's a different kind of function. I can purchase commercially manufactured chairs, mugs, and rugs that work as well, sometimes better, than the handmade products I use. But every handcrafted piece tells a story, evokes a memory of a very real person, adds a special warmth and character to daily life.

For me, the stories and the memories begin with June 1965 when I drove a heavily loaded old Ford down U.S. 25E to Asheville, North Carolina, for the first time. That trip took twelve hours if you count the two hours I was lost somewhere near Tazewell, Tennessee, and time off the highway to inspect the bear cubs on Clinch Mountain and peer through the dime-a-look telescope at the TVA lakes down below.

Now, whenever I zip down I-75 and cut across on I-40, Berea to Asheville is an effortless five-hour cruise. But always I remember that first trip, the first days, my first association with the

Southern Highland Handicraft Guild and the new world that was to become my life.

Bob Gray, director of the guild, came to Berea College in 1965 to find a "leg man," a nontitled assistant, somebody to write press releases and newsletters. Bob assumed English majors could write, that Berea graduates would work, that a Kentuckian could fit in. Would even *I* dare, today, to risk those same assumptions? Mr. Gray offered me hard work, irregular hours, extensive travel on the steepest, twistiest roads in America, and assurance that I didn't have to wear a tie all the time. I accepted the job during the interview, found Asheville on a road map, and headed south two days after my graduation.

My first work assignment was, to a fresh college graduate weary of homework, apparent drudgery. Bob told me to read Allen Eaton's *Handicrafts of the Southern Highlands*. I did, reluctantly at first, then sat up all night to finish my initial reading of the classic study. Over the years I've reread Eaton countless times, worn out or given away a half-dozen copies of the paperback reprint, and learned something new from each reading.

And, by the end of that first summer, I personally knew many of the people from the Eaton book. O. J. Mattil, Miss Lucy Morgan, Shadrack Mace, Helen Dingman, George and Marguerite Bidstrup, Louise Pitman, Clementine Douglas, and many other leaders of the 1930s Appalachian craft revival were still active in 1965. They were, to a person, gracious and willing to teasingly accept and educate a gawky young Kentuckian whose previous concept of "craft" was rubber tomahawks and plaster-cast roosters. Like many poor mountain youngsters of the time, I grew up ashamed of "handmade" and would have preferred the store-bought stuff my wealthier friends had, and as a student at Berea College I had made no effort to learn about the craftwork being done there.

O. J. Mattil and Rude Osolnik worked my feet to blisters during the 1965 guild fair, the first of a dozen we were to share. A few weeks later, gentle Clem Douglas read into my tape recorder for the soundtrack of a movie being made about the guild. Clem's voice lives in "Hands: The Story of the Southern Highland Handicraft Guild." And, if you look quickly at one scene, there's a brief sequence which includes a gangly twenty-one-year-old newcomer dressed in a plaid nine-dollar jacket from the Navy Surplus Store.

I worked for the guild from June 1965 through August 1970, busy years coinciding with the marketplace explosion for mountain crafts. I *did* drive thousands of miles on mountain roads, first in a sluggish Corvair Greenbriar bus and later in a rugged Chevy van. I hauled pottery from Bybee, glass from Blenko, brooms from Gatlinburg, skittles games from Berea, and portable houses from New Jersey. (The "houses" were plastic domes used in a futile attempt to add booth space to the Gatlinburg fair, already overcrowded even in 1965. The open courtyard in the rear of the Gatlinburg Auditorium seemed to be a perfect expansion space, but we had not allowed for the runoff from several acres of roof, got flooded during a downpour, and had to move all the booths inside the first night.) For three years I made the trip from Asheville to Louisville almost every month, a hard dash loaded heavy with dulcimers, carved birds, bark birdhouses, turned bowls, split oak baskets, pots, and whatever else had been brought to me for delivery. When we moved the guild's gallery from Louisville to Bristol, Virginia, I hauled the fixtures, displays, and merchandise over Clinch Mountain in a twenty-four-foot rented truck.

Always, I was learning. From Bob and Verdelle Gray, Eric Picker, Mr. Mattil, Marian Heard, Persis Grayson, Charles Counts, Rude Osolnik, Earl Huskey, Ellen Jones, Margaret Howell, Carol

Smith, Hugh Bailey, Fannie Mennen, Alan Ashe, Sam Stahl, and the others, I soaked up knowledge that doesn't exist in books. Lots of the lessons were learned the hard way. There was too much work to allow time for specific instructions, so Bob Gray turned me loose. Afterwards, he'd help patch up my wounds, tell me what I'd done wrong, and assume I wouldn't make the same set of mistakes again. I plunged into marketing—retail through four shops, and wholesale through the craft wholesale warehouse opened in 1968—and learned enough about budgets, accounting, promotion, display, education, and public relations to fill a half-dozen books the size of this one.

I still have, and treasure, the craftworks from those first years: Edsel Martin's carved wild boar, his gift to me before I ever got there; Shadrack Mace's ladderback chair which was used in my office the whole time; the last basket B. S. Gilliland ever made (he got up out of bed, dying from cancer, to weave one more basket so we could photograph his process); an inscribed copper enamel tray from Joe and Pearle Godfrey; and much, much more.

I loved every minute. But, like so many of my fellow Eastern Kentuckians, I wanted to come home. I did so in 1970—first to manage Berea College's Log House Sales Room, then to become director of the Kentucky Guild of Artists and Craftsmen for most of that hectic decade. I left the Kentucky guild in 1980, worked for MATCH, Inc., and in 1982 was one of the four organizers of the Berea Craft Festival.

By 1980 I was seriously writing fiction for the first time since college, with enough success to keep me at it. Then, to combine my interests in writing and Appalachia, I took a position as com-munications coordinator for Morehead State University's Appa-lachian Development Center in Morehead, Kentucky.

When Berea College asked me to work in their newly reorga-nized Student Crafts Program, it was not an easy decision. I was

enjoying *not* being an administrator, while concentrating on communications, with much free energy for my own writing. But the chance to help rejuvenate a ninety-year-old program was a challenge I couldn't resist and I've been here, coordinating the marketing effort, since June 1985.

My job with Berea College has taken me back to the Kentucky and Southern Highland Handicraft guild fairs, this time as an exhibitor. Ironically, at the Asheville fairs I'm now an old-timer, sort of a living link to the past; of those craftspeople who were at my first fair in 1965 only a handful—Fred Smith, Bill Lett, Dorothy Brockman, G. B. Chiltosky, the Presnells—were still there in 1985. For the fortieth anniversary, in 1987, some more old friends showed up when Bea Hensley and Edsel Martin came back to demonstrate their skills. But the face of Appalachia's senior craft event has totally changed in twenty years, and that's part of what I will be discussing later.

The other advantage of moving back to Berea was the opportunity to write this book. Since I first read Eaton in 1965, I've wanted to update the regional handcraft history. Students from Loyal Jones's Appalachian studies classes at Berea College have come to me since 1970 for information about the craft movement in the region, and inevitably they have asked if there was a book anywhere with a more current history than the Eaton study. A 1982 grant from Berea College's Appalachian Center, encouragement and support from Loyal Jones (director of the Appalachian Center, former director of the Council of the Southern Mountains), together with my own interest in publishing and the enthusiastic cooperation from the region's craftspeople, got me off to a quick start, but work pressures interfered. The unintentional long delay has actually helped in some ways, including my shifting the focus from straight history to more of an interpretative recording of fifty years of development in the craft world.

This is a somewhat unorthodox history, a mix of people, organizations, marketing, fact and opinion, evaluation and prediction. It is perhaps as uneven and sporadic as the Appalachian handcraft revival itself. This movement has not been a measured, controlled process, but has happened in bursts and flurries, surges and side excursions, a seemingly disjointed effort which has somehow succeeded in bringing about tremendous growth.

Many of the books I quote in this study are not readily available. Some are out of print, and others were essentially vanity publications never widely distributed. My own bookshelf has been a primary source, but most of the volumes can likely be found in the Berea College Library Special Collections Department or the library of the Southern Highland Handicraft Guild. I am indebted to Robert Stanley Russell's doctoral dissertation, "The Southern Highland Handicraft Guild: 1928–1975." Dr. Russell's study confirmed many dates and facts for me, and I quote him at length.

The facts in this book are historical; the opinions are personal. I'm certainly no longer the innocent, fascinated twenty-one-year-old who went to Asheville so eagerly and worked so hard; much of the romance faded years ago. The crafts are now a solid element of this region's culture and economy, a factor in teaching, production, and tourism—and big business in places like Berea, Asheville, and Gatlinburg.

The gravy days of federal crafts funding are over. Poverty won in LBJ's war against it, but some solid results are thriving (such as the Southern Highland Handicraft Guild's Folk Art Center in Asheville, largely financed by the Appalachian Regional Commission). Two very distinct and different elements dominate the craft world—craft as art, and craft as economics—and this distinction reflects the national scene.

The native Appalachian craftspeople—like Shadrack Mace,

Chester Cornett, Pearl Bowling, Edd Presnell, and other self-taught or family-trained artisans—are now the distinct minority, displaced in influence by the college-trained, aggressive, contemporary craft professionals. The state and regional handcraft guilds are still here, still strong in some cases, but are no longer crucial to a craftsperson's survival.

The Appalachian craft movement, from its very beginnings, has been torn between economics and art, a somehow healthy tension which has led to significant success in both directions. Surprisingly, after the passionate arguments, the divergent elements have always been able to join forces for the overall good. A near-century of this unlikely partnership is now weakening. The cooperative success has fostered much more specialized directions, and now the craft organizations must deal with the reality that not every program will directly benefit every constituent. Some tough decisions must now be made, choices that will determine whether the organizations retain a vital role in overall development or continue to exist only as marketing and promotional devices. The almost missionary leadership of the likes of O. J. Mattil, Marian Heard, and Clementine Douglas has given way to a new generation, as it must, and the contemporary craft fair is a slick, organized marketplace.

As you'll see, I have very mixed feelings about much of the progress, and I have a realistic, pragmatic outlook on current and future developments. This book is mostly about the period from 1965 to 1985, though the early chapters go back to the turn of the century, and—since that's where I've worked—there's particular emphasis on the Southern Highland Handicraft Guild, Kentucky Guild, and Berea College.

This is a limited history, a starting place for other studies. Though heavily influenced by Allen Eaton, I have not attempted to duplicate his gentle, comprehensive approach. Mr. Eaton set

the stage and helped the craft revival happen, and I'm writing about the results. I do not claim to be a historian, but I was there when the 1960s–1970s Appalachian craft movement leapt into a new and exciting era, and this is the way I saw it.

This study has been supported by a Mellon Foundation grant through the Berea College Appalachian Center. Some material was previously published in *Appalachian Heritage* and *Hearthstone*.

1.

The Beginnings

They were the necessary crafts, the everyday skills essential to the survival of the Appalachian settlers.

Every mountaineer had to be carpenter and cobbler, adept at "making do" with the materials at hand. Thick hardwood forests provided the logs for cabin shelters, clear walnut and cherry boards for rugged furniture, tough oak and hickory splits for egg baskets and chair bottoms. Tanned, softened hides were sewn into clothing and shoes. Honeysuckle vines, river cane, and hickory splits were woven into durable baskets.

Cornshucks, the winter food for livestock as well as a noisy mattress stuffer, also were woven into rugs, chair seats, and exquisite dolls. Wool from carefully guarded sheep was carded; spun; dyed with walnut hulls, berries, and roots; then woven into cloth for shirts, dresses, and coverlets. Animal fat, tallow, made thick candles which gave off a flickering yellow light. Raw clay was shaped and wood-fired to make crockery. Wood shavings or broomcorn, wrapped on a sassafras handle, made a sturdy hearthbroom. Nimble fingers and a sharp jackknife created the mountain playthings, dolls and animal figurines, whistles and whimmydiddles, slingshots and puzzle games.

Later, as the settlements grew, skilled craftspeople opened shops to sell and barter their wares and services. Blacksmiths, cobblers, potters, chairmakers, wheelwrights, gunsmiths, and

A shorter version of this chapter appeared in *The Hearthstone Collection* (Ironton, Ohio: Infinity Press and Publications, 1989).

furniture builders served communal needs. Talented potters were drawn to the plentiful clay deposits in Kentucky, North Carolina, and Georgia to turn out crocks, platters, and churns from ground–hog kilns.

These same resourceful, independent people could sometimes be seen differently from the outside. Historian Arnold Toynbee earned a permanent niche in Appalachian hearts when he concluded that "the Appalachian mountain people are no better than barbarians. They have relapsed into illiteracy and witchcraft. They are the American counterparts of the latter-day white barbarians of the Old World—Rifis, Albanians, Kurds, Pathans, and Hairy Anus."[1] That we preserve Toynbee's comments is a sample of mountain humor; we've been called worse things by worse people, but Toynbee's reputation makes his remarks more comical.

Though the Industrial Revolution bypassed most of remote Appalachia, store-bought goods began to filter in and replace the handcrafted essentials. Factory-made shirts, rifles, dinnerware, shoes, and blankets were readily available, and most of the looms, drawhorses, spinning wheels, and boom-and-treadle lathes were soon stored away in attics and barns. Only in isolated pockets did the crafts continue to be a way of life, and the overall craft culture was dangerously close to becoming extinct.

In this rugged land where each family was largely self-sufficient, cash needs were meager until well into the twentieth century. Food was grown, gathered, or shot; the miller would grind corn for a percentage of the crop; and enough money for necessary items could be earned from trapping, logging, selling ginseng, or from temporary labor in the mines. The progress which eventually came to Appalachia and lightened the burdens of life also brought a new need to the mountains, a need for a cash income to pay for ready-made clothes and other factory ware, and progress also brought a new wave of missionary effort.

"At the same time that mountaineers were trading virgin timbers for fruit tree slips, rolling logs for mill whistles, and one-horse farms for a miner's dinner pail," wrote David Whisnant in his 1983 study *All That Is Native and Fine*, "the culture industry was also booming in the mountains. Vassar graduate Susan Chester opened her Log Cabin Settlement in Asheville, North Carolina before 1895; about the same time, Berea College started its 'fireside industries' craft program. The years immediately after 1900 witnessed the founding of countless schools, academies, and institutes in the mountains, many of which had a pronounced cultural and preservation focus: Hazel Green and Oneida in Kentucky, Pleasant Hill in Tennessee, the Berry Schools in Georgia, Dorland-Bell in North Carolina, and many others."[2]

David Whisnant, professor of American studies at the University of Maryland–Baltimore County and author of several controversial studies of cultural politics in Appalachia, gives his assessment of *why* the early twentieth-century mountain missionaries concentrated on culture:

> Culture was so central to missionary work in the mountains for two reasons. The first is that, in the interaction of such disparate groups as northeastern missionaries and southern blacks or mountain whites, culture—that is, the entire range of belief, attitude, value, characteristic behavior, posture, and so on, which makes up the collective and individual identity of an ethnic, regional, or socioeconomic group— generally proves to be the most available touchstone, the handiest standard to which everything may be referred, by which everything may be measured. [3]

That so many of the mountain missionaries were women or clergymen, claimed Whisnant, was because both groups had been systematically excluded from conventional activities such as business and politics. "Women and their ministerial counterparts had claimed what was essentially a narrowly perceived *culture* as their special concern only a few decades before the southern

mountains became popularly known as a vast unmapped repository of valuable cultural survivals—beliefs, sayings, manual skills, language, values, and other intangibles."[4]

"Historically," continued Whisnant, "the fact that so many women missionaries to the mountains focused on culture is important for two major reasons. In the first place, their culture-bound cultural goals and programs had a substantial and long-lasting impact upon *indigenous* culture in the mountains. But equally important, culture (as the women defined it in limited and romantic tones) became a diversion, a substitute for engaging with the political and economic forces, processes, and institutions that were altering the entire basis of individual identity and social organization in the mountains."[5]

Whisnant's charges of "systematic cultural intervention" are based on his presumption that "someone (or some institution) consciously and programmatically takes action within a culture with the intent of affecting it in some specific way the intervener thinks desirable. The action taken can range from relatively passive (say, starting an archive or museum) to relatively active (like instituting a cultural revitalization effort). It can be either positive (as in a sensitive revitalization effort) or negative (as in the prohibition of ethnic customs, dress, or language). Moreover, a negative effect may follow from a positive intent, and vice versa."[6]

The "missionaries" who revived Appalachia's crafts were both positive and active.

In Berea, Kentucky, new Berea College President William G. Frost recognized the quality and potential market value of handweaving, and conceived the unique work/study system first called "the Fireside Industries" and now internationally known as the Berea College Student Crafts Program. Frost began his study of Appalachian handcrafts in 1893, during a summer-long horseback tour of students' homes in Kentucky, West Virginia, Tennessee, and North Carolina. In those homes Frost saw the

handmade baskets, chairs, crockery, and woven goods which he determined had market potential with Berea's New England supporters. That same year Frost asked a local weaver to produce six coverlets, identical in color and design, and received from the weaver what Frost called his "first lesson in weaving":

> President Frost, in order to make so many kivers we will have to raise more sheep, shear them, pick and wash the wool, card it and spin it, then collect the bark and sich to color it. Then we will have to have the loom all set up, fix the warp and beam it, then get a draft and thread the warp for the pattern we want, then tie up the loom, and then we will be ready for the weaving. It would take we'uns nigh one year or more afore we could have that many kivers wove. It's no child's play to weave a kiver, President. [7]

That weaver's eloquent explanation is chronicled in Allen H. Eaton's *Handicrafts of the Southern Highlands* (1937, reprinted in 1973), considered to be the only comprehensive published work on southern Appalachian crafts. Eaton, under the auspices of the Russell Sage Foundation, first came to Appalachia in 1926, invited by Olive Dame Campbell to speak at the annual Conference of the Southern Mountain Workers. Eaton, a native of Oregon, was more than a historian to the Appalachian handcraft revival; he was a vital part of the move to establish the Southern Highland Handicraft Guild in 1930.

But, over thirty years before Eaton's arrival, Berea College's President Frost had begun another Appalachian craft tradition. According to Elizabeth S. Peck and Emily Ann Smith:

> In 1896 the first Homespun Fair was held in Berea, its purpose being to stimulate production. Commencement Day was the ideal time for such a fair because several thousand people would be wandering around the campus looking for interesting sights. For the next twenty years this Homespun Fair, usually held in Lincoln Hall, was a source of great encouragement to mountain weavers (and whittlers). Cash prizes were offered for home-dyed, homespun, hand-woven cover-

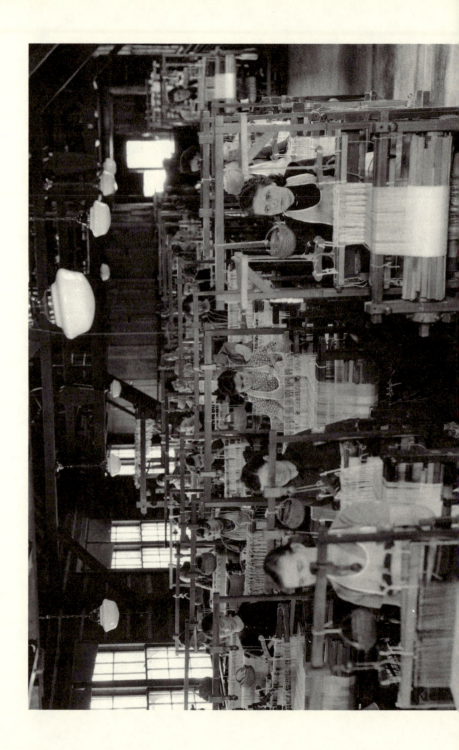

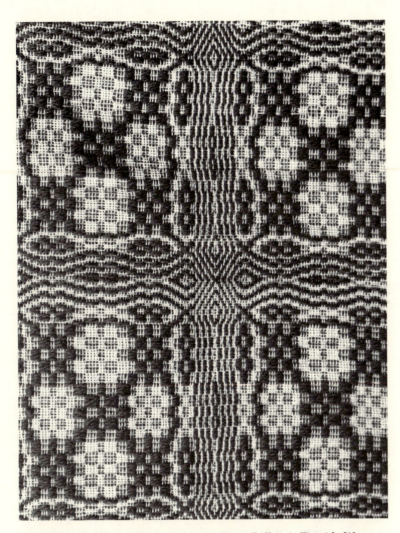

1. (Opposite page): Student weavers in Berea College's Fireside Weaving, about 1920. This program, one of the earliest efforts to preserve and market Appalachian crafts, began in 1893 and continues today in this same studio. Photo used with permission of Berea College.

2. (Above): Intricate handweaving patterns in a traditional coverlet show why Berea College President William G. Frost was told in 1893, "It's no child's play to weave a kiver." Photo by Alan Ashe, used with permission of the Southern Highland Handicraft Guild; quotation from Allen Eaton's *Handicrafts of the Southern Highlands*, 61.

lets, for blankets and counterpanes, linen and linsey woolsey by the piece, home-made rag carpet, hand-knit socks and mitts, splint-bottomed chairs, hickory-split baskets, and handmade axe handles. The dye used had to be homemade, with the recipe for it given in writing for each color. [8]

A Works Progress Administration (WPA) mural in Berea's post office, painted by Frank Long in 1937–38, commemorates Appalachia's first craft fair. The concept lives in the literally hundreds of craft fairs and festivals which are today presented across the region.

Dr. Frost recruited Susan B. Hayes to help with his hand-weaving project, planted twelve acres of flax for the making of linen thread, and by 1899 had generated enough business to require a full-time employee. In 1900, a Berea coverlet won a medal at the Paris Exposition, and the 1903 sales through the "fireside industries" totaled over $1,500.[9] In 1911 Frost hired Anna Ernberg, a native of Sweden, to take charge of the Fireside Industries. [10] Mrs. Ernberg's Swedish designs were to influence Appalachian weaving for the next fifty years or more, as young weavers trained at Berea spread across the region as teachers and producers.

A contemporary of William G. Frost was Frances L. Goodrich, an employee of the Presbyterian Church's Women's Board of Home Missions, who began work in 1895 to revive the hand–crafts—especially weaving—in the mountains north of Asheville, North Carolina. Inspired by the gift of a "Double Bowknot" coverlet, vegetable dyed and perfectly woven, Goodrich started Allanstand Cottage Industries (named for Allen's Old Stand, an overnight stopover for hog drovers traveling from Tennessee to South Carolina) and in 1908 opened a retail showroom in Asheville. The Allanstand Shop has survived, operated since 1931 by the Southern Highland Handicraft Guild, and is now part of

May I Be There to See?

1855 BEREA 1909
+++++ +++++

COMMENCEMENT

WEDNESDAY, JUNE 9

REV. J. F. HERGET, D. D. - SUPT. J. G. CRABBE,
Cincinnati Frankfort

And Other Great Speakers

Student Speeches and Exhibitions. Corner Stone Laying.
Music by Big Brass Band, Etc., Etc.

COMMENCEMENT WEEK

JNE 6. Sunday, 10:45 a. m. - - - - - - - -	Sermon to Graduates
7:30 p. m. - - - - - -	Address to Christian Societies
JUNE 7, Monday, 7:30 p. m. - - - - -	Concert by Harmonia Society
JUNE 8, Tuesday, 7:30 p. m. - - - - - -	Address to Literary Societies

HOMESPUN FAIR
EXHIBIT AND PRIZES

Homespun Coverlids with Kettle Dyes, Linen, Baskets, Chairs,
Ax-handles, etc. See list in THE CITIZEN.

Get Ready for the FALL TERM, SEPT. 15

Find out what you can do; write to the College Secretary

MR. WILL C. GAMBLE, Berea, Ky.

3. The 1909 Berea College commencement poster also advertised the
"Homespun Fair," first held in 1896, a tradition for twenty years. Photo
used with permission of Berea College.

the Southern Highland Folk Art Center on the Blue Ridge Parkway.

Of Goodrich's gift of Allanstand to the guild, Jan Davidson wrote in his introduction to the 1990 reprint of Goodrich's 1931 book, "*Mountain Homespun*'s central dramatic incident, the gift of the Double Bowknot, caught the attention of feature writers, who retold it frequently and compared that gift to the gift of Allanstand, thus making the blessing of the guild the final step in conferring the management of crafts from the family, to the saintly woman, to a corporation directed by northerners, to a coalition with other production centers."[11]

Others were working during the early 1900s to foster the Appalachian handcraft revival. Mrs. George Vanderbilt was starting up Biltmore Industries in Asheville. Just down the road, in 1924, Clementine Douglas opened the Spinning Wheel craft shop. The settlement schools—Hindman and Pine Mountain in Kentucky, the Pi Beta Phi School in Tennessee, the Crossnore School in North Carolina, and many others—instituted active craft programs. These are detailed in Eaton's study, but two deserve special mention here.

The John C. Campbell Folk School, incorporated in 1925 in Brasstown, North Carolina, was based on Olive Dame Campbell's studies of Danish folk schools and her question: "How can we keep an enlightened, progressive, and contented farming population on the land?"[12]

Mrs. Campbell and Marguerite Butler spearheaded the development of the Campbell Folk School, which incorporated all manner of handcraft activity, including the famed Brasstown carvers. Of the carvers, Eaton wrote that "the pattern set by the Folk School whittling has been the greatest single influence in the development of amateur and other small carvings throughout the country."[13]

This "whittling with a purpose" began soon after the school was established and Mrs. Campbell visited the little general store in Brasstown. Although most of the citizens were farmers who owned and cultivated tracts of land, there were days when adverse weather conditions made it impossible for them to work. During these periods they were accustomed to gather at the community store. These "sons of rest," as they called themselves, spent many hours at the store idly whittling away on a stick of wood or cutting into the very bench on which they sat. Even nails driven in the whole length of the bench by the store's owner, Fred O. Scroggs, failed to stop them."[14]

Mrs. Campbell didn't stop the whittlers; she "enlightened" them. According to David Whisnant, Mrs. Campbell and others of her ilk—educated, urban missionaries to the mountains—imposed their own values and traditions on the mountain people and created false "Appalachian" traditions to suit the marketplace and to satisfy personal egos. "Mrs. Campbell's cultural work," wrote Whisnant, "while more sensitive to the political-social-economic context than that of most of her peers and co-workers, nevertheless partook of many of the ironies and confusions that have characterized most organized cultural work in the mountains."[15] Though I agree with much of Whisnant's thinking, and sometimes resent the superior, almost racist views of some early mountain workers, I accept the reality of the time frame and situation and—within the craft world—I believe that without the "missionaries" much of the tradition would have been lost. Whatever their reasons for doing what they did, the Olive Campbells and William Frosts saved a valuable handcraft culture by creating a marketplace.

At the Appalachian School in Penland, North Carolina, Miss Lucy Morgan was developing a handcraft program which would become, in 1923, the Penland Weavers and Potters. Again, Berea College entered into the picture. Lucy Morgan went to Berea to learn how to weave. As she recalled, "Mrs. Matheny, whom I met

at Berea, was teaching the women in her community to weave and was selling their work for them; as they brought it in she would pay them for it by the yard. Why couldn't I do the same thing at Penland? I suppose I would say, if I had to put my finger on the time and place, that the idea of establishing an institution such as the Penland School of Handicrafts was born then and there."[16]

Current students in Penland's highly contemporary, experimental, and sometimes controversial craft program would likely be surprised at their school's beginnings. For the past twenty years Penland's faculty, students, and directors have been known to openly deride Berea College's conservative, production-oriented craft programs.

Penland, the Campbell Folk School, and the Pi Beta Phi School were destined to become major craft training centers. At the same time, private enterprise was beginning to see the market potential for handcrafts.

In Berea, in 1921, a frustrated physics professor, D. C. Churchill, and his wife Eleanor founded Churchill Weavers with one loom in a shed on the outskirts of town. Churchill's patented flyshuttle looms, developed while he was a missionary worker in India, gave the weavers a vastly increased production capacity. Mrs. Churchill's design and marketing ability—and her plucky personality—quickly built the fledgling business into a major production center. The Churchills were the first to successfully combine handcraft skills with volume output, and Churchill Weavers still is a leader in this aspect of the craft world.

O. J. Mattil's Woodcrafters and Carvers Shop in Gatlinburg was helping to build a new industry there. "O. J. Mattil revived furniture making in the Smokies," wrote Eaton, by "establishing the Woodcrafters and Carvers Shop which has given considerable employment to men and boys in the community."[17] Earlier,

Mattil had taught agriculture and woodwork at the Pi Beta Phi Settlement School and other Sevier County schools, and many of his students not only worked for Mattil but opened woodshops of their own. Later, in Asheville, jeweler Stuart Nye and businessman Ralph Morris, Sr., were to apply production principles to the crafting of silver and copper jewelry and build the Stuart Nye Silver Shop into a lasting unit.

Family potters reached out for new markets. At Bybee, north of Berea, the Cornelison family's Bybee Pottery (the oldest continually operated pottery west of the Allegheny Mountains) found a growing demand for their functional crockery, and so did the potters of Western North Carolina and North Georgia. Most of the market was "outside"—a source of ready cash, which was in short supply within the region.

Encouraged by the progress and interested in the income-producing potential of crafts, the leaders of the Appalachian craft revival began to see the need for an organized, regional program, a cooperative designed to bring much-needed cash income into the mountains and, at the same time, preserve the ancient culture.

Allen Eaton described the next step: "Two days after Christmas, in 1928, a small group of people, mainly from the mountain sections of North Carolina, Kentucky, and Tennessee, came together at the Weavers' Cabin on the top of Conley's Ridge at Penland, North Carolina, to talk over the handicraft situation in the mountains and to take the first steps toward the formation of the Southern Highland Handicraft Guild."[18]

Present for the meeting were Eaton and delegates from Allanstand Cottage Industries, Berea College, the Brasstown Handicraft Association, the Cedar Creek Community Center, Crossnore School, the Spinning Wheel, and the Penland Weavers and Potters. Olive Dame Campbell of the Campbell Folk School

and Berea College President William J. Hutchins told the gathering about programs at their schools. And Dr. Mary Sloop of the Crossnore School spoke on the economic value of crafts but added that "it is their character building qualities which concern us most."[19]

There was agreement: a cooperating organization was needed. Or, as David Whisnant might say, there was a need for an institution to consciously and programmatically take action within a culture with the intent of affecting it in some specific way. The new guild was to affect preservation, marketing, training, and that intangible character on which the mountain craft world builds its success.

Since most centers represented at Penland were also active in the Conference of Southern Mountain Workers (established in 1913 by John C. Campbell and later known as the Council of the Southern Mountains), those present resolved to present the matter of a handcraft organization to the next meeting of the conference.

A formal resolution was unanimously adopted:

> That we organize ourselves into an informal association whose function may be described by some such name as the Southern Mountain Handicraft Guild; that a committee be appointed by the chair to present to the Russell Sage Foundation the urgent desire of this group that the Foundation advise them with reference to the best form of organization; and, further, that the Foundation conduct an early survey of the handicrafts in the schools and homes of the Southern Mountains as a fact basis for the association's wisest development; that the committee be empowered to take such steps between now and the Conference of Southern Mountain Workers in Knoxville, April 2-4 (1929), as seem best to advance the development of the Guild and its work.[20]

This slightly stuffy paragraph, drafted while a snowstorm raged outside a tiny cabin, is the basis for all subsequent develop-

ment of the Appalachian handcraft industry. Helen Dingman of Berea, who chaired the meeting, reported later that "we met on a mountain hilltop literally and the freedom and friendship of the group as they talked over the mountain handicraft situation—the hopes and fears and practical problems—made it a real mountaintop experience."[21]

The new guild was much discussed at the seventeenth Conference of Southern Mountain Workers in Knoxville. The next organizational meeting was held December 28, 1929, at the Spinning Wheel in Asheville. Present for this session were Frances L. Goodrich, Olive Dame Campbell, Dr. Mary Sloop, Lucy Morgan, Wilmer Stone, Clementine Douglas, Evelyn Bishop, Helen Dingman, and Allen Eaton.

Eaton described the new guild's membership structure:

> Three types of membership were agreed upon: $1.00 for individual craftsmen; $5.00 for friends wishing to advance the purpose of the guild; and $10.00 for producing centers. Representatives from the producing centers were to constitute the voting members, and each center will have one vote. All applicants (for membership) would require approval of the admissions committee and be voted on by the entire guild membership.[22]

There have been only minor changes to the Southern Highland Handicraft Guild's basic format—a rare, truly cooperative effort—over the past half-century. The dedicated workers who planned the concept planned it exceptionally well, and they all helped implement their creation. Eaton's history of that creation and of the guild's early years is essential reading for anyone interested in Appalachian crafts or in how simply and effectively such a major regional movement began. In *Handicrafts of the Southern Highlands*, Eaton downplays his own impact and crucial role in the guild's development. His presence, however, must certainly have added confidence to the work of those who gathered in

Penland and Asheville; Eaton and the Russell Sage Foundation provided a strong continuity to the effort. It is unlikely that the Southern Highland Handicraft Guild would have so quickly grown and succeeded without Eaton's influence and hard work. His close connection to the organization lasted until his death in 1963.

Over the past fifty years, friendly internal arguments have sputtered over whether the guild was formed in 1928 at Penland or in 1929 in Asheville. The answer, officially, is that the Southern Highland Handicraft Guild was formally begun in Knoxville, Tennessee, in the spring of 1930.

2.

The 1930s

The Handicraft Guild, Southern Highlanders, and Eaton's Survey

During the 1930 Conference of the Southern Mountain Workers in Knoxville, Tennessee, the first representative, comprehensive showing of Appalachian handcrafts was presented. Notices of the exhibit had been sent to twenty-four known craft centers, but eight more centers also responded with works. According to Allen Eaton, this proved there was widespread interest in the guild and "also was a good illustration of the way news travels in the mountains without the aid of letter writing or newspapers."[1] Eaton described the exhibition, which

> was held in a semicircular room completely lined with beaverboard, making a suitable background for the many exhibits of furniture of mountain design and construction, as well as carefully styled pieces from some of the schools and better work shops of the region. There was a large collection of baskets, brooms, elaborate and beautiful examples of hand weaving, hooked rugs, and of modern adaptations of mountain handicrafts. For the first time these objects were arranged, not as separate displays from different centers, but in a way to assure the greatest harmony for them as a whole. At the entrance to the hall was a special group consisting of one object from each center represented. This arrangement not only presented a striking group of mountain handicrafts but expressed the principle for which the guild stood—a cooperative effort of all the centers to advance the work of the entire region.[2]

This description could very well have been written about any of the Members' Exhibits, which were to be a handsome part of the guild fairs until recent years. Eaton delivered the report to the 1930 conference, which led into the organizational meeting of the new guild. "This afternoon we are to complete the work begun a little over a year ago," said Eaton, "bringing into closer association the several handicraft centers of the Southern Mountains." At length, Eaton detailed the organizational history and the need for such an effort, as well as the value of crafts to the region, concluding that "we will without delay resolve ourselves into a meeting of the Southern Mountain Handicraft Guild."[3]

The 1930 exhibit was "a surprise to members of the guild as well as to visitors, for with few exceptions the centers themselves had little idea what the others were producing."[4] Open sharing of information, trust, and a genuine cooperative effort became the working principles of the new guild and of the entire early Appalachian craft revival. The centers meeting in Knoxville adopted the guild's constitution and by-laws, though legal incorporation was not to come for another fifteen years. The guild's first president was Marguerite Butler of the John C. Campbell Folk School. Miss Stone of the Hindman Settlement School was vice-president, and Helen Dingman of Berea was the secretary-treasurer. Other members of the first board of directors were O. J. Mattil, Lucy Morgan, and Clem Douglas. These officers did not take their new duties lightly: when I went to work for the guild in 1965—thirty-five years later—O. J. Mattil was again serving on the board, Marguerite Butler Bidstrup was still at the Campbell Folk School, Lucy Morgan had just hired Bill Brown to run Penland, and Clem Douglas was still a major force in all of the guild's activities.

The guild met again in 1930, in Berea. The first marketing committee was appointed, a lending library of craft books was

proposed, and plans were made to stage an exhibit of pioneer crafts. In a more practical vein, the guild made provisions to protect and preserve a madder bed discovered near Berea "with plants still vigorous."[5] That madder bed (madder root is used for a red dye) surfaces again in Eaton's reports, but its ultimate destiny is not disclosed.

The work that was to occupy the guild for the next fifty years began in earnest in 1930. The pioneer crafts exhibit was presented in 1931 at the Mountain View Hotel in Gatlinburg, accompanied by an exhibit of modern weaving from the St. Louis Handicraft Guild. Even in its first year, the guild was pulling in opposite directions, beginning a mixed effort of preservation and change which was to forever create some degree of controversy.

A major step in the guild's development came in 1931, when Frances Goodrich gave the guild full title to Allanstand Cottage Industries, including the Asheville showroom, and marketing became the new organization's strongest asset. Clem Douglas donated her services to oversee the transition of Allanstand into a guild showroom, and the shop was to continue in a downtown Asheville location until 1982, when it was moved into the new Southern Highland Folk Art Center on the Blue Ridge Parkway. The acquisition of Allanstand moved the guild headfirst into selling members' work and assured the organization's survival.

In the fall of 1931, the guild invited the American Federation of Arts and the American Country Life Association to cooperate in the collection and circulation of an Appalachian craft exhibit. The Russell Sage Foundation agreed to help assemble the show. The Country Life Association offered a premiere during their 1933 meeting, and the federation agreed to circulate the exhibit nationally. The presence of Allen Eaton was again making things happen for the new organization.

By spring 1932, the guild membership was up to twenty-five

centers and a twenty-volume library was ready for use, maintained and circulated by the guild secretary. The Cherokee Indians were accepted as guild members in 1932. During the 1932 fall meeting, Doris Ulmann donated fifty of her photographs to the guild. But that particular meeting, held at Pine Mountain Settlement School in Kentucky, is better remembered for the trip in and out. A small logging railway hooked up a boxcar to take the delegates over Pine Mountain, but the engine ran off the tracks three times going and three times returning. Some terrified passengers walked or rented horses, but those who were brave enough to stick with the little train were treated to a record return time. The seven miles took only two hours.

"At the 1933 spring meeting of the Guild held on March 31 at the Hotel Farragut, Knoxville, the word 'Highland' was substituted for "Mountain' in the Guild's name."[6] This was no small change. The more elegant term *highland* better described the lofty goals and image preferred by the guild's founders and directors. Over subsequent years there have also been efforts to change the term *handicraft* to *handcraft* or simply *craft*, but sentiment and historical significance have prevailed. In recent decades *handicraft* has become more associated with a lesser level of craftsmanship and is seldom used by craft professionals except as a derogatory term.

The "Exhibition of the Southern Highland Handicraft Guild," first shown at the 1933 convention of the Country Life Association in Blacksburg, Virginia, included 586 pieces from thirty-three handcraft centers. From Blacksburg the show traveled to the Corcoran Gallery of Art in Washington, D.C., then to museums in Brooklyn; Decatur, Georgia; St. Louis; Scranton, Pennsylvania; Norfolk, Virginia; Milwaukee, and finally to Berea to help dedicate Berea College's new art museum. (Fittingly, forty-five years later, the premiere exhibition in Berea's newer art gallery was

"Southeast Crafts '78," a regional exhibit compiled by the American Crafts Council Southeast Region and the Kentucky Guild of Artists and Craftsmen.) The 1933 exhibit's sponsors were Mrs. Herbert Hoover, Mrs. Calvin Coolidge, and Mrs. Franklin D. Roosevelt.

In 1934 the guild discussed production of low-cost crafts for the National Park Service and came up with a recommendation that "the cheap souvenirs manufactured in the cities and sold in the parks be discouraged in those [national parks] of the Appalachians."[7] That particular argument was still raging fifty years later. The guild has had some success in the national parks along the Blue Ridge Parkway, but the overall system still sells cheap souvenirs. In Kentucky's excellent state parks system, a seeming natural for the quality craft market, crafts get little prominence despite repeated promises from governors and commissioners. The taste of the overall traveling public, and of the administrators who run the parks' concessions, has not greatly changed since 1934.

After proposing crafts in the parks, the 1934 annual meeting shifted to a meeting with Bertha Nienburg of the Woman's Bureau of the U.S. Department of Agriculture, who asked for the guild's cooperation in implementing the bureau's plans for craft employment of women in rural Appalachia. During the same session, L. L. Campbell of the Tennessee Valley Authority (TVA) asked the guild's cooperation in a series of small economic development enterprises. A committee chaired by Berea College President William J. Hutchins was appointed to confer with both agencies.

A year later the TVA and the guild joined forces to create Southern Highlanders, Inc., a new craft marketing program funded by TVA. Clem Douglas was chosen to direct the program, and soon plans were underway to open a craft shop at a TVA

dam in Norris, Tennessee, and to study ways to assist with craft design and production. Though the guild helped create Southern Highlanders, Inc., and many craftspeople belonged to both groups, the two were distinctively separate organizations for the next fifteen years.

Allen Eaton does not mention *why* the Tennessee Valley Authority chose to sponsor a regional craft marketing program. The decision probably was as simple as fulfilling the agency's assigned role in regional development, but it could have been a subtle effort to help offset and defuse the bitter resentment of the families and communities displaced by the TVA lakes. Both TVA and the National Park Service (which displaced the families living in what is now the Great Smoky Mountains National Park) certainly *needed* better public relations at the time, and Southern Highlanders, Inc., helped create good will. At any rate, the TVA officials came to the right organization at the right time. The fledgling guild needed the TVA cash and clout, and the unusual partnership got off to a fast start.

During November and December 1935, Southern Highlanders, Inc., conducted a successful sale in Rockefeller Center in New York City which led to the opening of a salesroom in the concourse of the International Building in Rockefeller Center. Soon afterward there were Southern Highlander stores at the Norris and Chickamauga dams and in the Patton Hotel in Chattanooga. The guild's own Allanstand Shop was thriving. Eaton reported in 1935 that "the showroom of the Southern Highland Handicraft Guild in Asheville is the largest single outlet that serves the majority of the centers in the highlands."[8] Mr. Eaton would surely be pleased to see a current financial statement from Allanstand; 1987 sales totaled $950,211, and in 1988 the shop broke the million-dollar mark. In 1967, by comparison, the guild reported total shop sales of $372,330, then considered a remarkable accomplish-

ment. The 1987 shops sales reached almost $1.5 million, an almost 400 percent growth in twenty years.

The TVA leapt into the crafts movement with enthusiasm. "Since the TVA's purpose was to improve conditions in the Tennessee Valley," wrote Helen Bullard, "it was natural it should go beyond the mere employment of local people. It offered them training in various skills and made it easy for them to study by hiring four separate work crews and assigning each crew to work only five and a half hours a day. The woodworking course was one of the most popular. TVA brought O.J. Mattil over from Gatlinburg and set up a big shop in which about two hundred people a day worked on furniture for their homes."[9]

Helen Bullard's study, quoted above, also reprints the statement of operations for the Southern Highlander shop in New York for the month of August 1936. Total sales were $688.50, and expenses were $636.45; rent was $65.00 a month.[10] The massive TVA effort was to continue for another fifteen years, with emphasis on marketing and production. The ultimate effects of TVA's involvement were primarily—in my perception—to spread the Southern Highland Guild's territory out of the mountains to include much of Tennessee west to Memphis, to bring a new emphasis to the business of selling crafts, and to bring production centers such as Churchill Weavers into the guild when the two organizations merged. Before that merger, Churchill Weavers had been denied guild membership, a fact Eleanor Churchill never forgot; the guild, according to Mrs. Churchill, saw the newfangled looms as too commercial for a craft organization. Even a life membership given to Mrs. Churchill much later did not alter her resentment.

In 1936 the guild *was* making changes in its membership structure. The by-laws were amended to allow individual craftspeople not connected with craft centers to vote and serve on committees.

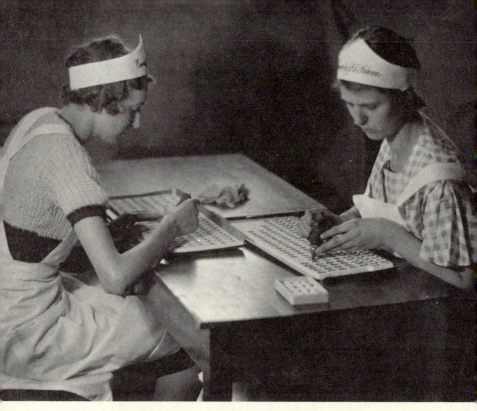

4. A rare signed Doris Ulmann print shows Berea College student workers decorating tea sugars in the college's Candy Kitchen, ca. 1935. The Candy Kitchen was closed in 1970. Photo used with permission of Berea College.

That decision effectively shifted the guild's emphasis away from production centers and opened the doors to new directions. Individuals brought about change much faster than the centers did; individuals gradually shifted the guild's focus from preservation to contemporary education and marketing.

It is important to note that, despite its increasing levels of activity and rising importance as a regional organization, the guild at this stage employed no administrative personnel. There were paid workers in the Allanstand Shop, and Southern Highlanders, Inc., was staffed, but the guild relied on its volunteers for overall administration. Not for another dozen years was this to

change with a full-time staff member being hired. In all craft or–
ganizations, there are those who argue that paid staff members
take over and bend the organizations the way they want them to
go, and there *is* truth in that assumption, but the end results de-
pend entirely on just who is hired.

During the spring 1937 guild meeting, Allen Eaton made a
presentation on "Handicrafts in Mountain Life," an outline of his
conclusions from the study he had just completed for the Russell
Sage Foundation. Eaton's survey was to become, very shortly,
Handicrafts of the Southern Highlands, illustrated by Doris Ulmann's
photographs, which is still the Bible for all who would study
Appalachian crafts. Eaton's book is a history, a sociological study,
an art text, and an astoundingly perceptive and farsighted sum-
mation of what had been done and what was still to be done.

In this report, Eaton touched on the role of Berea College:

> Outstanding in its contribution to training in the handicrafts is Berea
> College where the Fireside Industries and the Wood Craft Shop, as
> well as other branches of the student industries, have afforded hun-
> dreds of mountain boys and girls opportunity to earn a part or all of
> their way through school. In addition scores of students have gone
> out into the mountains and to communities far outside the region to
> teach the skills learned. Berea has probably furnished more weaving
> teachers for the Highlands than all other schools in our country com-
> bined, and for many years has supplemented this service by making
> looms which have been widely used both in the area and outside it.[11]

The Berea College tradition hovers always with those of us
who now run the Student Crafts Program. The college's impact
on the craft world since 1890 is awesome and humbling. During a
late-1960s guild fair in Gatlinburg, Tennessee, we counted to see
how many of us there were either Berea graduates, faculty, or
former employees. We numbered about thirty-five, including
some we hadn't known about until we started searching. The

heritage is one we cannot take lightly. Every day we walk through history as we work, and the Berea College tradition of service to the region is part of every decision we make.

Not everyone would view Berea College's contributions to the Appalachian craft world so positively. Even today, there are few products in the Berea College Crafts Catalog that can be clearly labeled "Appalachian" in design and heritage, and much of the famed "Fireside Weaving" focus was, for years, Swedish—the direct result of Anna Ernberg's early influence. Berea's approach from the beginning was tempered by economics more than by art or tradition, by the necessity for creating student employment and selling the products to finance that program. As a technical training ground for weavers and woodworkers, Berea excelled from the beginning, and those graduates who spread the skills across the region have added to the impact.

Berea College faculty and staff have provided much of the administrative strength behind the Southern Highland Handicraft Guild; Business Manager Larry Bibbee, for example, served as the guild's treasurer for many years, juggling finances to keep the organization afloat. But it is true that Berea College has been more of an agent for change than for preservation, more of a training and production center than a hub of philosophical thought about craft design and evolution. Berea is a liberal arts college, with crafts incorporated into the business and student labor divisions; the school's enormous impact on the Appalachian craft world has, ironically, been incidental to the primary purposes of the institution.

But in 1937, Allen Eaton was reporting on the current status, which included strong direct contributions from Berea College, and then he took time to look ahead. In a chapter titled "Future of the Handicrafts in the Highlands," he perceptively outlined the problems and possible solutions that every subsequent craft ad-

ministrator has dealt with. Even today, Eaton's assessments are surprisingly valid, timely, and accurate—the business and development concepts that provided the basis for the organized craft effort in Appalachia:

> The whole situation presents a strong challenge to everyone concerned with handicrafts or the general welfare of the mountain people.

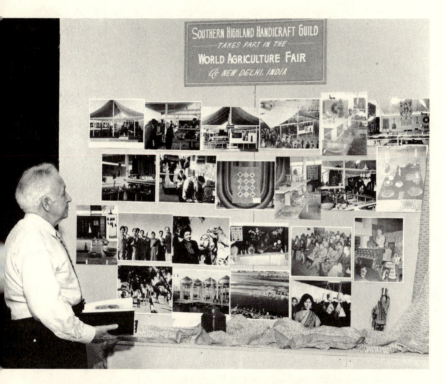

5. Allen H. Eaton, author of *Handicrafts of the Southern Highlands*, is shown at the 1960 Craftsman's Fair with photographs of the guild exhibit he arranged and delivered to New Delhi, India. Eaton's work with the guild spanned five decades. Photo by Edward DuPuy, used with permission of the Southern Highland Handicraft Guild.

These home, community, and school industries, together with small agriculture, will form the economic base upon which countless families will build. In the proportion that they [the handicraft industries] are supported will public relief *with its unwanted and undermining influence* be reduced. We must think of the handicrafts not only as a means of making a living but as a way of life.[12]

Eaton added a list of "Helpful Forces":

1. There is continuous economic pressure on the Highlander to make things for himself and to earn some money to support his standard of life; this need provides a stable basis for the home industries which does not exist in other places.

2. The life of the average Highland family is so simple, and cash needs so small that a good standard of life can be supported on what they raise, plus small earnings from handicrafts. [Note that even today the primary cash flow of craft income in Appalachia, particularly from the sale of traditional works, is supplemental income instead of full-time employment. And today those needs are not nearly so simple.]

3. Most own their own home, an inducement to craft development.

4. The Highlanders are accustomed to work with their hands and often acquire unusual skill and taste.

5. The tempo of life gives time and opportunity to encourage creative work. [No more. We now have much the same tempo and troubles as the rest of the country.]

6. There is abundance of materials for handcraft purposes.

7. Instruction and training are improving.

8. Organizations are assisting.

9. Increasing tourist traffic is bringing buyers into Appalachia; better highways and park systems are helping.

10. There is, outside the mountain area, a wide and sympathetic interest in the Highlander and his work.

11. And finally there is throughout our country a great body of consumers with a high average buying power, who can be counted on to sustain a considerable output of handicrafts if they are of a good standard and have meaning for the people who buy them.

We use Eaton's thinking from comment number eleven almost every day in our marketing of Berea College crafts; we work very hard to provide items of good quality with meaning to the consumer.

Eaton's "Opposing Forces" segment could have been written yesterday:

> A clear recognition of the forces that operate against such a development is also important. Among the first of these is the attitude of many people toward the handicrafts. They are likely to judge them in terms of their income only. Also many people feel that handicrafts are out of date, a step backwards in the march of progress. And far too many think of them not as requiring the skill, taste, and judgment that come from training and experience, but something which anyone can do if he is told how, and that he should do only if there is nothing else. These and other prejudices are strong in the public mind, and they are not easily broken down.[13]

Eaton went on to warn Appalachia's craftspeople against production shortcuts that might diminish quality, and he stressed the futility of trying to directly compete with machine-made, mass-produced goods. Eaton pointed out the foreign competition, where cheaper labor meant lower prices, but recognized the quality of much of the imported craftwork and suggested that mountain craftspeople see that the foreign handcrafters are "helping to teach" them what they "need to know most, that the only advance for handicrafts is in the continuous improvement of quality of design, materials, and workmanship."[14]

Eaton dealt, sometimes wryly, with a series of "Proposals Offered That Create Difficulties." First was the proposal to speed up production with modern machinery. Eaton offered tentative approval, but said that when such machinery is introduced, it must be "on a basis that" craftspeople "can afford and become accustomed to" without lessening their skill or undermining the quality of their work.[15]

The second proposal was to establish working centers to take the production out of the homes. This would be physically impossible, concluded Eaton, given the terrain and isolation. "In addition to these physical difficulties there is a strong feeling that the fireside industries must remain in the home and not be turned into small mountain factories."[16]

Third, regarding selling through department stores, Eaton rejected the marketing advice of conventional business wisdom and championed the individual approach: "Under the present circumstances it seems very doubtful that the regular channels of trade organized to respond to mass production can be utilized to market handicrafts to any great extent."[17] Eaton remains correct about this; even today, the department stores are a minor factor in crafts marketing. Crafts are usually not trendy enough to fit into larger stores except in boutique areas or in special promotions, and few craftspeople can afford the payment cycle of sixty to ninety days common to most large stores.

Fourth, on employing only the designs of experts, Eaton offered limited approval but preferred an advisory service on styles, colors, and trends: "The environment and temperament of the Highland people combines to encourage new expression in various kinds of work, and a little good teaching leads to much independence and inventiveness."[18] In other words, a little good teaching goes a long, long way. Allen Eaton had considerably more respect for the native culture than did most of his contemporaries.

The fifth proposal was to standardize the product and cut the sentiment. Standardize *excellence*, argued Eaton, but not product. He wrote that, if permitted only one recommendation from his entire study of Appalachian handcrafts, it would be "to leave wide open the doors of experimentation for all those who participate."[19] While Eaton disdained tawdry sentiment in crafts marketing, he shrewdly observed that there is "no work so good but

that some knowledge of the person who is doing it and the attendant circumstances will help make it more significant."[20] For those who sneer and point to Appalachia as a major culprit in the type of marketing Eaton recommends, take a good look at how the successful national-level individuals market. They make absolutely sure the potential customer knows as much as possible about the artist and the attendant circumstances. As is so often the case with Allen Eaton's advice, it is correct.

Eaton summarized his years of Appalachian craft experience with five general observations:

1. That everyone cannot do handicrafts well;
2. That three distinct elements are involved—design, production, and distribution—and all must be worked out together;
3. The key to the solution is greatly widened cooperation;
4. A new type of business technique may have to be worked out for production and distribution;
5. Handcrafts must be utilized as a social, educational, and general cultural force for the Highlands as a whole if they are to have complete development.[21]

After fifty years and millions of dollars spent on surveys and consultants, no one has been able to improve much upon these five general observations. Careful study of Eaton's writings, particularly by federal planners of the early 1960s, could have prevented much waste and frustration. As it is, Eaton provided a solid foundation and the working guidelines for the Southern Highland Handicraft Guild and all other following development, and he detailed a future effort that has not yet been fulfilled.

Nonetheless, in 1937, Eaton's *Handicrafts of the Southern Highlands* created little excitement outside the small circle of leaders who were working to build the Appalachian craft industry. The guild members at the 1937 meeting discussed Eaton's reports at length, then put them aside and got on with their business at hand, "mapping out a plan by which the handicrafts in general

could be improved and advanced."[22] Had they but known it, Allen Eaton had just handed the guild members all the map they would ever need.

Obviously, my opinion of Allen Eaton is one of admiration. Even David Whisnant, who questioned much of the missionary work of 1920s–1930s Appalachia, seems to share that evaluation; Whisnant quotes Eaton at length in *All That Is Native and Fine* and does not accuse Eaton or the Russell Sage Foundation of attempting to manipulate local culture. Whisnant, however, does differ from Eaton in his interpretation of some events and the reasons for them.

"The early history of the guild," wrote Whisnant, "shows clearly that it was tied primarily to the folk school, settlement school, the crafts revival 'producing center' version of handicrafts in the mountains; that it was able to establish itself quickly as the major arbiter of design in mountain crafts; and that it became a more forceful *agent for change* than conservator of local traditions."[23]

By working with TVA, the national parks, and other such agencies, the guild "placed itself in a position to approve or forestall most major public and private efforts in the area of mountain crafts."[24] The guild did this very quickly, almost immediately. "Having achieved the credibility implied by these working relationships," continues Whisnant, "the guild had gained considerable power to certify or discredit any mountain craftsperson through its admissions committee. That power could by no means be taken lightly by native craftspeople."[25]

That very "power to certify or discredit" is still very much present, still the most controversial aspect of the Southern Highland or of any other juried guild. The jurying process—embodied by the Standards Committee—was and is essential to the guild's success and survival. Without jurying, the fairs and gift shops

would be flooded with junk, credibility would be lost, and the guild would be just another souvenir-stand market. All craftspeople would suffer.

But, *with* the jurying process, there are opportunities for error, personal prejudice, elitism, and a multitude of procedural red tape sure to discourage all but the most determined of applicants.

In theory, a Standards Committee (the modern name for the old Admissions Committee) consists of knowledgeable, open-minded, representative craftspeople. In practice, the membership of this committee is almost always university/contemporary/nonproduction people; seldom will you find a native, self-trained craftsperson voting. The obvious result of such one-sided appointments is a bias against almost anything traditional and anything produced in quantity. I doubt whether today Berea College, the Stuart Nye Silver Shop, or any other of the larger production centers would be approved by the Southern Highland Guild Standards Committee. The very centers who started it all could not, today, participate. The Crossnore School, a charter member of the guild, dropped its membership after 1950s fire damage to facilities and has only recently been able to regain its exhibiting-member status.

I do not advocate the acceptance of pseudo–folk artists into the craft guilds. True working folk craftspeople are rare, maybe extinct by some definitions, but there are still self- or family-trained production craftspeople. Those whose work is of excellent technical quality, but whose designs are traditional, are those who are often unfairly excluded from the guilds.

David Whisnant's *All That Is Native and Fine* earned scathing responses from much of the Appalachian craft world, but many of his accusations are well founded. The very credibility that made the Southern Highland Handicraft Guild such an early success also opened the doors to a degree of cultural manipulation.

The result, according to Whisnant, is that today several million tourists a year tour the Folk Art Center near Asheville and "accept as authentic and traditional 'mountain handcrafts' the guild-produced items whose lineage leads far more often to the craft-design programs of major universities [and to the folk and settlement schools] than to mountain-bred potters, metal workers, or chair-makers and the patterns handed down to them from the past."[26] The truth is that very few "mountain-bred" craftspeople who would meet Whisnant's expectations even exist.

The accomplishments of the Appalachian craft world of the 1930s cannot be denied or belittled. The enormous effort, the immediate results, the cooperation between government and the private sector, the emergence of the craft marketplace, and the true regional cooperative approach have never been duplicated. Not until the frantic 1960s would activity in the Appalachian craft world again be so concerted and so visible, but before that could happen two more decades of hard work had to set the stage.

3.

The 1940s

The First Craftsman's Fair

The Great Depression had relatively little effect on the more re-
mote areas of Appalachia. A self-sufficient people, used to mak-
ing do, simply endured. In rural Appalachia there were few jobs
to be lost, few capitalists to suffer from the stock market collapse.
For most, an already hard life just got a little bit harder. The
Roosevelt programs, such as the Civilian Conservation Corps
(CCC) and the Works Progress Administration (WPA), created
work for some young men. My father's first "public works" job—
meaning, in Eastern Kentucky, working off the farm—was in a
CCC camp, and the schools we attended were built by the WPA.

That the Southern Highland Handicraft Guild actually thrived
in an economically depressed era simply reflects the craft market-
place as it was to largely be through the early 1960s. The custom-
ers for handmade products were primarily older, wealthier
people, and the market was essentially recession-proof. It was a
small customer base, but one that did not reflect national eco-
nomic trends to any significant degree. Not until the last three
decades, when the craft market expanded to the younger middle
classes, did sales begin to follow economic patterns.

World War II, however, did bring significant change to Berea
College. Between July 1943 and October 1945, a total of 782 sail-
ors, a V-12 Navy unit,[1] helped shake loose the college's restrictive
social rules and "perhaps marked a psychological watershed of
change for Berea."[2] Dean Louis Smith warned : "Berea must be

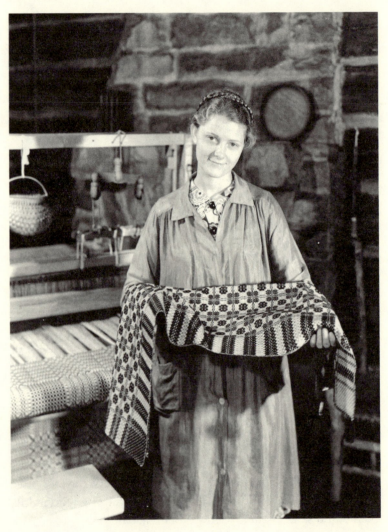

6. Olga Beck, a 1946 Berea College student weaver, displays a coverlet woven on looms that are still in use in the same building. Photo used with permission of Berea College.

and become. If we hold only to what has been, we achieve a high level of obsolescence and produce in all likelihood ill-prepared mediocrities."[3] Those wartime changes not only made life much more enjoyable for all of us who went to Berea College later, but marked a change in some areas of emphasis that eventually had an impact on the crafts. More interest in craft as art began to emerge at Berea, and the "psychological watershed" that included more interest in change than in preservation filtered down to the craft areas and was reflected in the more contemporary efforts in the ceramics and weaving classrooms.

Mary Ela, head of Berea's art programs, preceded that "watershed" of thinking in her 1940 "Made by Hand" address to the fall meeting of the Southern Highland Handicraft Guild. Ela spoke at length about the craftsperson's place in society, past and present, about the "machine-made" emphasis of the United States in 1940, and about a perceived danger of the craft industry leaning too far toward making cheap souvenirs for tourists. "Who has the courage to stop whittling trinkets and to focus his energy upon the wood sculpture which is stirring in these mountains?" asked Ela. "Who is as concerned with handicraft today as with the remembrances of what handicraft was, yesterday? Who dares to experiment with new materials, and who has the strength to find new and significant ways of handling a material as familiar as our native cotton?"[4]

Ela's concern that the growing Appalachian tourist market would contaminate the craft was tempered by her awareness that a production line was necessary to the crafts producer's survival. Her solution was good design and integrity of workmanship: "The craftsman's necessity for a big turnover of under-a-dollar merchandise need not mean that the merchandise be dull in design or non-functional in its character. Each thing we make can have a kind of life within itself. If this ceases to be true, and if the

craftsman allows himself to become a slave to repeating his under-a-dollar hits, he will lose his sensitivity and his strength for adventure and become incapable of meeting the needs of people who demand that there be rightness and beauty in every thing they buy."[5]

Mary Ela urged the guild members to look to the future boldly and to not be afraid of new directions. "The fear of change," said Ela, "can come between us and our strength. It imposes upon us our fear of experiments, our fear of competitive machines, our lack of faith in new markets and in a new world. Fear of change is a futile rebellion against a law of life, and a retreat from life unto death."[6]

To a large degree, it took World War II to bring change to most of Appalachia. I am a "war baby," born just before my father volunteered for Navy service in 1943. I vaguely remember a world, or have perhaps only been told of it by my mother, where fighting-age men were missing and where shortages and rationing prolonged the useful life of mules and sleds, sorghum molasses, and the need to grow or shoot your supper.

Many mountain families left for the wartime factories of the North. Harriette Arnow's classic novel, *The Dollmaker*, best exemplifies the difficulty of relocating from the Kentucky hills to a Detroit housing project. The fictional Gertie Nevels is still Appalachia's best-known woodcarver, a determined and resourceful woman who whittled to feed her family, and a substory within the novel is Arnow's accurate depiction of the craftsperson's personality. When Gertie studies her block of wild cherry wood, she waits for whatever is in it to come out. "There was only the top of a head, tilted forward a little, bowed, or maybe only looking down, but plainly someone there, waiting to rise and shed the wood and be done with the hiding."[7] Like G. B. Chiltoskey, like Edd Presnell or Bill Crowe, Gertie waits for the shape inside the wood to make itself known.

But not everyone left the mountains after World War II, and not everybody was a woodcarver.

The young men who came home to Appalachia after the war changed almost everything. They brought electricity, passable roadways, consolidated schools, industry, and a new, confident attitude. They were impatient now with the old mountain ways and the slower pace, so the ambitious young veterans set out to modernize the mountains.

To most of this newly confident wave, there was little about the Appalachian craft world worthy of saving or supporting. Handwork represented what they were trying to put into the past. The young post–World War II individual craftspeople who were to change the craft world were enrolled in the School for American Craftsmen at Alfred University or were busy building the strong new national contemporary craft movement. In the mountain craft groups there was no sudden new influx of aggressive youth and energy; the same people kept on working with the same solid results they had shown from the beginning.

Good background reading for understanding the forties Appalachian craft movement is Smith G. Ross's *Come, Go with Me: How to Be Independent and Enjoy Rural Living*, a very personal study of how handcrafts were incorporated into a larger effort to improve the quality of life in a remote Kentucky county. Ross started teaching in rural Eastern Kentucky in 1928, worked with the National Youth Administration during the 1930s, and was hired by the U.S. Department of Agriculture (USDA) after World War II.

One concern of the USDA and Smith Ross was to find a way to slow the out-migration of mountain families. "Aside from the benefits of having a garden, pigs, milk cow and chickens," wrote Ross, "what could a rural family do and still retain or regain the type of independence and self-reliance practiced by their ancestors as late as eighty years ago? Some type of supplemental in-

come would be needed. That was the great drawback. Lack of cash income was the reason so many families had to migrate. It was the search for supplemental cash income that led to the founding of Kentucky Hills Industries."[8]

After seeing local people still using early craft skills, "an idea dawned on us. Why not use the old line craftspeople to teach other mountain families to produce and sell the home accessories for which early Kentuckians had been so well known?"[9] In March 1946, with a loan from the Veterans Administration, Smith and Elma Ross opened a small shop in Pine Knot, Kentucky, where they "either made what we sold, or our neighbors helped make it."[10] The foreword to *Come, Go With Me*, incidentally, is written by Harriette Simpson Arnow, who concludes that the Rosses have "effectively settled the question as to whether or not certain facets of the mountain culture are worth saving."[11]

Though still in operation forty years later, Kentucky Hills Industries lost much of its unique life-force when Smith and Elma Ross retired. A series of full-time managers failed to carry on what the Rosses started, mostly because of a lack of understanding and spirit, and now Kentucky Hills Industries functions more as a project of the Save the Children Federation than as an independent craft cooperative.

After the war, the Southern Highland Handicraft Guild was looking to the future. Fred McQuiston, associate director of the General Education Board of the Rockefeller Foundation, attended the guild's 1943 meeting in Asheville and was impressed with the people and the organization. On March 8, 1944, a grant of six thousand dollars was approved, with Berea College as fiscal agent because the guild's incorporation was not legally complete, to conduct a survey of the region's craftspeople. Marian Heard's handwritten notes still survive: Heard was the survey director, on leave from the University of Tennessee to serve as the guild's first director, and she was joined after a month by Clem Douglas.

The survey committee, in addition to Heard, included Olive Dame Campbell, Winogene Redding, Charles Churchill, Louise Pitman, and Lucy Morgan. Heard and Douglas traveled sixteen thousand miles in six months; their findings led to a three-year grant of fifteen thousand dollars yearly from the General Education Board for a joint Southern Handicrafts Guild–Southern Highlanders educational program. "For the next five years the board financed an experiment in adult education that not only did much to improve every phase of craft work in the mountains during the years immediately following the war but had a lasting effect upon the standards of crafts and craftsmen."[12] Problems with incorporation and tax-exempt status delayed actual receipt of the forty-five thousand dollars from the Rockefeller Foundation until 1947, but the guild got its programs underway with four thousand dollars from the guild and thirty-five hundred from Southern Highlanders and its director, Marian Heard. An office was opened in Gatlinburg, in O. J. Mattil's Woodcrafters and Carvers Shop, and guild records were consolidated for the first time.[13]

Probably no other investment in the craft world has had a more widespread, lasting impact than did the Rockefeller grants to the guild. Heard and Douglas traveled the entire region, located many craftspeople in need of added training and access to markets, then followed up on those needs with workshops and individual assistance.

Allen Eaton's survey provided the framework for the guild's creation and development, but the Heard-Douglas survey and subsequent programs provided the detail and direction. The Rockefeller funds financed a number of "firsts": the first guild office and staff, the first workshops, the first Craftsman's Fair of the Southern Highlands, the very first impetus toward the activity that built today's active educational and marketing programs.

The guild's first major educational program was a workshop

at the Penland School held September 14 to 21, 1945. Instructors for the week-long session included Winogene Redding, Murray Martin, Isadora Williams, Louise Pitman, and Margaret Decker,[14] all guild members (all of whom were still active, by the way, when I joined the guild staff in 1965), and one interesting guest speaker.

Anni Albers was from the controversial Black Mountain College, established in Black Mountain, North Carolina, in 1933, a free-spirited institution that drew a talented, outspoken faculty whose thoughts and actions outraged the conservative little Carolina community.

David Whisnant, contrasting Black Mountain College and the John C. Campbell Folk School in *All That Is Native and Fine*, wrote that "If Black Mountain [College] people shared any estimate of the local people and culture, it appears to have been one of contempt. Students seem to have in the main shared Peggy Bennett Cole's feelings that coming across Black Mountain teacher Josef Albers in '[a] hillbilly setting, in the Southern Baptist convention country of the Tarheel State was like finding remnants of an advanced civilization in the midst of a jungle.'"[15]

"As for local tastes and traditions, Albers' wife Anni, who was a weaver, found local weaving uninteresting because it 'simply reproduced set patterns from the past.'"[16] Yet Anni Albers lectured on color and design at the first guild workshop in 1945, starting a pattern which over the years has brought hundreds of outstanding national-level craftspeople to the mountains for lectures and workshops. Most of them have gone home with a new respect for the Appalachian culture and craft traditions, and many of them have moved their own studios to the mountains.

Obviously not all of Black Mountain College's faculty shared the disdain for local culture David Whisnant would have you think existed. Poet Jonathan Williams collects Edsel Martin carv-

ings and has used mountain speech patterns in his poetry. In 1966 Williams wrote a flattering article about Appalachian crafts for *Craft Horizons* magazine. Black Mountain College would certainly have found many friends among the more progressive guild leaders, and the workshop series started by Marian Heard continues—with its mix of "outside" and "inside" teaching—to this day.

In 1946 Clem Douglas reopened the Spinning Wheel, which had been closed for the war effort. But the world had changed, and the work Douglas preferred—the teaching, designing, and association with her workers—had to give way to a conventional gift shop. In 1948, Douglas sold the shop to Esther Bloxton, former manager of Allanstand.[17]

Marian Heard went back to her teaching at the University of Tennessee in 1947, and Ed Davis was hired as the guild's director (with Jean Hemphill as education director), and the office was moved to Asheville. In 1950 a two-year terminal grant of seventy-five hundred dollars, to be matched dollar-for-dollar by the guild, was approved by the Rockefeller Foundation, and Amy Woodruff was hired as education director.

In its use of the oft-delayed grant funds, the guild was frugal. When Bob Gray came to work for the guild in 1961, he found some fifteen thousand dollars of the original 1947 grant still in the guild's coffers, gradually being expanded to cover annual operating deficits.

As the guild was beginning its expansion, more of what David Whisnant might term "cultural politics" was happening in Berea. Noted furniture collector, photographer, and author Wallace M. Nutting left his designs, samples, and the use of his name to Berea College: since 1945 the Nutting Collection has been housed in the Log House Sales Room, with some pieces in daily use on the campus. The collection is Pilgrim American, New England,

very formal. Berea's woodworkers still do reproductions from Nutting's samples. Native Appalachian furniture design would be much ruder—slab tables, rustic setting chairs, hickory-bottomed rockers—and Berea's reputation as a furniture center stems from the Nutting influence.

Ed Davis left Berea's Woodcraft and the guild's New York shop to become the Southern Highland Guild's new director and to help put together the first fair in Gatlinburg, a 1948 event that Allen Eaton wrote about in a Christmas letter:

> For some time I had been urging the Southern Highland Handicraft Guild to hold in Appalachia a regional Craftsman's Fair, similar to those which had done so much for the handicraft movement in New Hampshire in recent years. Toward the end of July, following the summer workshop, they held their first fair in Gatlinburg; so I stayed to see it, and do what I could to help. My special job was to look after the photographing, and we got a fine record of the event. The fair was held in the stone building of the Settlement School, on the green, and under eight or nine large tents. It was carefully planned, well managed, and visitors were thrilled with it.[18]

The fair was a recommendation from the Heard-Douglas survey, probably largely influenced by Eaton's urgings. The guild members voted during their 1947 meeting to stage the first fair; Marian Heard's passionate pleas helped members overcome the fear of failure and take the large gamble which was to ultimately cement the guild's survival. The 1948 overall fair chair was Ed Davis, with Allen Eaton and Olive Dame Campbell as advisory chairs, Marian Heard and Clem Douglas heading up committees, and *marketing delegated to the Craft Education Office*.[19]

I emphasize that last fact to point out that "education," as originally perceived by many of the early guild members and still seen that way by many, is a function of teaching craftspeople how to sell—or, in this case and many subsequent programs, to

sell for the craftspeople. The Internal Revenue Service was ultimately attracted to these efforts and was to essentially rule that selling is not an educational function, a matter to be discussed later along with how the IRS has mandated various restructurings of the guild.

7. The Cornelison family of Bybee, Ky., unpacks for the first Craftsman's Fair of the Southern Highlands, held July 1948 in Gatlinburg, Tenn. The family operates Bybee Pottery, the oldest continually operated pottery west of the Allegheny Mountains, dating back to 1811. Part of the original potting shed is still in use, and clay is still dug from the same nearby vein, in use for six generations. Photo by Clem Kalischer, used with permission of the Southern Highland Handicraft Guild.

Marian Heard defined the first Craftsman's Fair succinctly by saying that it "will bring together the craftsmen and the best of their crafts for the purpose of portraying through demonstrations, exhibits, and markets the value of a beautiful piece of handwork and its influence on the lives of the people in the southern mountain area."[20] No one has ever said it better, before or since.

That first "Craftsman's Fair of the Southern Highlands," co-sponsored by the guild and Southern Highlanders, Inc., opened the doors to today's booming craft fair culture in Appalachia, and the fair was indeed so well planned that little about it—except the location—was to change drastically for the next three decades. The guild had taken Berea College's "Homespun Fair" concept, already fifty years old, and turned it into a regional marketplace.

The first fair was held from July 26 to 29, 1948. Admission was fifty cents for adults and fifteen cents for children; altogether, some sixty-two hundred visitors spent seventy-five hundred dollars. The bottom line was a loss of twenty-two hundred dollars.[21]

The guild's 1988 annual membership meeting focused on the fairs, forty years later, and the members present debated how to or whether to change things. When asked, during a small group session, how the guild managed to stage its superb Members' Exhibits of the forties, fifties, and sixties, Marian Heard's matter-of-fact explanation was "We worked our tails off."

The 1948 fair organizers did indeed work with uncommon fervor, a trait that was to endure and build the guild's fair into one of the nation's finest events. The fair was held again in Gatlinburg in 1949 and 1950 before the guild grew weary of battling the elements and moved to Asheville's new convention center.

An issue discussed throughout the forties—a merger of the Southern Highland Handicraft Guild and Southern Highlanders,

Inc.—was close to being completed by 1948. The merger had been proposed as early as 1940, and the first formal committees to study the issue were appointed in 1943. The conclusion of these committees was that a merger was unlikely because of a complicated stock investment situation through TVA. In 1948 the U.S. government relinquished its claim to ten thousand dollars worth of preferred stock in Southern Highlanders, Inc.,[22] and opened the doors to the final merger.

But some more basic problems arose. Carroll Churchill pointed out that Churchill Weavers was a member of Southern Highlanders, Inc., but had been turned down by the guild because of the use of flyshuttle looms. The ultimate compromise was to amend the guild's by-laws to include acceptance of all Southern Highlander members as voting members of the guild.

As mentioned in the previous chapter, the merger also expanded the guild's territory to include much of flatland Western Tennessee (all of the state but thirteen counties in that section, a fact Miss Isadora Williams tried vainly for years to change; she wanted *all* of Tennessee included). Though the merger was not to become official until 1951, Churchill Weavers was finally assured of acceptance into the guild. The members were there, demonstrating on patented looms, at the first Craftsman's Fair. Other fair demonstrators in 1948 included Berea College's woodworkers and weavers, Blenko Glass, the John C. Campbell Folk School, G. B. Chiltoskey, Ed DuPuy, and Lucy Quarrier.[23]

In a 1973 interview, Ed Davis recalled the first three Craftsman's Fairs. "We lost our shirts on the first one, broke even on the second, and the third year we earned enough to pay off all our debts, and it's been skyrocketing ever since. The first year we had it in tents, and it was really a fair. We had enough prestige that the governor of Tennessee came over and officially opened the fair. You don't get that for nothing, and we got it without any

money. He came because he was interested. Oh, I tell you, we were riding high that year."[24]

Riding high. Surely they were, the organizers and participants who staged such a huge success, from Ed Davis and Allen Eaton to every member who took part, and there was no doubt the fair would continue. Anybody who has run an outdoor fair can vouch for the logistical problems of the guild's first three shows, and would agree that a roof, bathrooms, walls, and air-conditioning make the long days shorter and the confusion less dominant. The impending move to Asheville's new auditorium was inevitable.

As the forties drew to a close, the Southern Highland Handicraft Guild was the major factor in the Appalachian craft revival. In marketing, education, influence, visibility, numbers, and leadership the guild stood alone. And so it was to be for another decade.

4.

The 1950s

Marketplace Expansion

My daughter listens to popular-again 1950s rock music and asks, tongue-in-cheek, what it was like to live in "the olden days." I spent that decade as an elementary and high-school student in Fleming County, Kentucky, a remote farm community far removed from the world of Appalachian crafts. I was more interested in Elvis than in handwoven coverlets, more concerned with the success of the Cincinnati Reds baseball team than with whatever was happening in Berea or down in the hills of Tennessee and North Carolina.

A lot *was* happening down there. The fifties were expansion years for the Southern Highland Handicraft Guild, a decade of both success and failure, a somehow surprisingly active period of bold effort and aggressive marketing.

The merger of the guild with Southern Highlanders, Inc., was finally completed in 1951. In the now long history of federal craft funding, Southern Highlanders is probably the most successful effort, the one that has had a lasting impact on the Appalachian craft world. Without TVA support, the Southern Highland Handicraft Guild's development certainly would have been much slower, and perhaps would have never happened. TVA's firm emphasis on marketing offset the purely educational thrust of some guild leaders, and the federal clout opened doors that would have been closed to the fledgling guild. TVA was to reenter the craft world on a much lesser scale about twenty-five years

later, but never again with the all-out effort of Southern Highlanders, Inc.

The guild/government associations that began in the thirties—close working relationships with the TVA and the National Park Service—were a key to survival and growth. The best, most current example is the Folk Art Center on the Blue Ridge Parkway near Asheville. Supported by the Appalachian Regional Commission, built cooperatively with the National Park Service, the Folk Art Center's roots date back to the guild's beginnings.

When the merger with Southern Highlanders was complete, the guild used its own funds to hire an executive director. Louise Pitman—who had come to the John C. Campbell Folk School in 1928 and who missed the first guild planning meeting only because she had to stay in Brasstown because everybody but she and Mrs. Campbell had the flu—accepted the position she would hold for ten years. My mention of Pitman's missing the guild planning session, and the comment in chapter 1 on the friendly arguments over when and where the guild was started, reflect the pride these early leaders took at being part of the beginnings, being personally present when the work and the excitement started.

Much of Louise Pitman's work was to be less than exciting. Later she was to laugh and say, of the work she did both when she first came to the mountains and for the next thirty years, "If there was one thing I hated to do it was do up packages and if I had known I would have to do up packages for the next fifty years—first at the school, and later with the guild—I'd have gone back to New Jersey!"[1]

The year before hiring Louise Pitman, the guild had made still more changes in its retail markets by subleasing shops in Big Meadows and Skylands, Virginia, on the Virginia Skyline Drive, from the Virginia Skyline Company. At the same time, the guild

8. An early 1950s Craftsman's Fair committee during a meeting in Asheville. *Left to right*, Clementine Douglas, chairperson, founder of the Spinning Wheel; Margaret Roberts, manager of the Allanstand Shop; Ralph Morris, Sr., guild president and owner of the Stuart Nye Silver Shop; Marian Heard of the University of Tennessee; and the guild director, Louise Pitman. Photo by Ewart Ball, Asheville *Citizen-Times*, used with permission of the Southern Highland Handicraft Guild.

entered into an arrangement to supply merchandise to a shop in Washington, D.C., operated by former Skyline Company manager Florence Ring. This shop used the guild's name in return for a 2 percent sales commission, an arrangement that lasted until 1961.[2] The lease arrangement for the Virginia Skyline shops was to last until 1963, when the National Park Service ruled that a prime concessionaire such as the Virginia Skyline Company could not sublet parts of its operation. That ruling led to the 1964 purchase of Guild Gallery in Louisville, Kentucky, and the Virginia Skyline's need for guild members' work was a major factor, in the late sixties, in the opening of the guild's wholesale warehouse.

In 1951 the guild itself became a National Park Service prime concessionaire when the Parkway Craft Center was opened in the

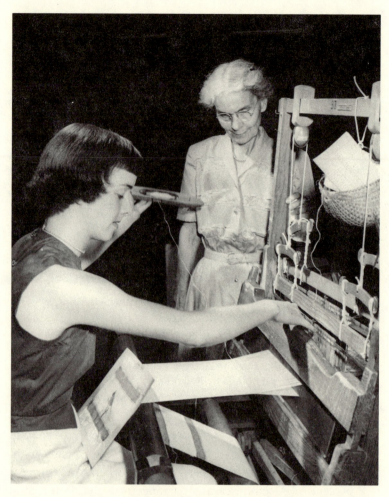

9. (Above): A Berea College student demonstrates handweaving during the 1951 Craftsman's Fair in Asheville. Demonstrations have been an essential element of every guild fair. Photo by Edward DuPuy, used with permission of the Southern Highland Handicraft Guild.

10. (Opposite page): Fannie McLellan demonstrates vegetable dyeing at the entrance to the 1954 Craftsman's Fair in Asheville. For many years the dyepot, Bea Hensley's forge, Shadrack Mace at the drawhorse, and the cutout figures above the marquee were the Asheville fair's trademarks. Photo by Edward DuPuy, used with permission of the Southern Highland Handicraft Guild.

Moses Cone Mansion near Blowing Rock, North Carolina. Open
May through October, the Parkway Craft Center has been the
stable base of the guild's marketing effort for over thirty years, by
far the highest-volume outlet until it was finally surpassed dur-
ing the 1980s by the new Allanstand Shop in the Folk Art Center.

The lease for Parkway Craft Center included, in partial lieu of
rent, perpetual craft demonstrations. Staff lived in the mansion,
upstairs, until the 1988 season. The center houses the guild's
Frances Louisa Goodrich Collection of pioneer crafts and thrives

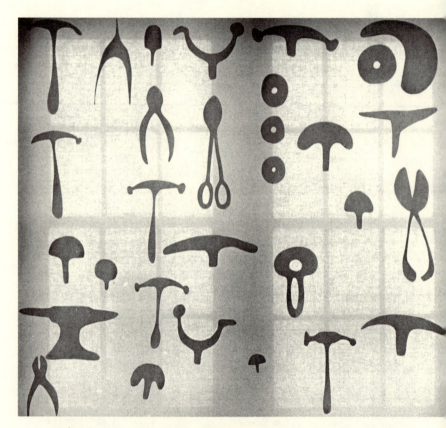

11. This silkscreened cloth panel, depicting tools used by craftspeople, was designed for a Southern Highland Handicraft Guild Fair ca. 1955. Photo by Edward DuPuy, used with permission of the Southern Highland Handicraft Guild.

on a customer base of Blue Ridge Parkway tourists and affluent summer residents of the Boone and Blowing Rock resort community.

At this writing there are plans to restore the Cone mansion as a historic museum and to shift the craft marketing operation to a "new" complex nearby. In 1966 we walked the grounds of a

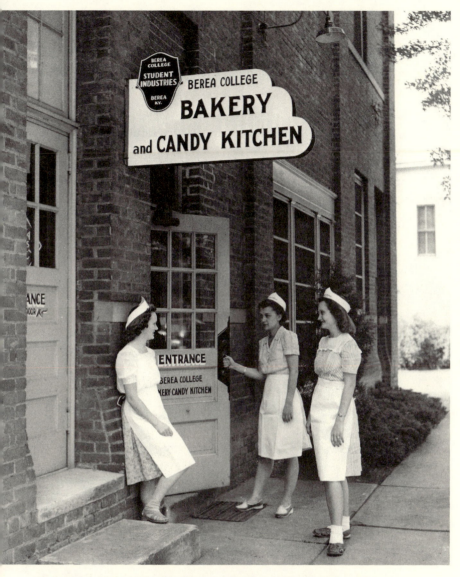

12. Student workers outside the door to Berea College's Bakery and Candy Kitchen in the 1950s. The Trades Building is in use today by the college's Press and Wrought Iron Program. The connecting Bruce Building is office and warehouse space for the current Student Crafts Program. Photo used with permission of Berea College.

proposed "pioneer village," just down the road from the Parkway Craft Center, and now it seems that the project is finally about to happen.

Not all shop operations were as successful as the Parkway Craft Center. In 1954, weary of long-distance management, an annual deficit, and employee dishonesty, the guild closed the New York shop. The next year, closer to home, the guild opened Guild Crafts in a building constructed by Ralph Morris, Sr., next door to the Stuart Nye Silver Shop on busy U.S. 70 in Asheville.

Guild Crafts included administrative office space for the guild; this was to be headquarters for the operation until 1968. The full basement under the shop became meeting place, shipping room, archives, warehouse, and busy supply center for the entire program until activity finally overflowed in the late sixties. U.S. 70E was Asheville's major tourist artery until I-40 opened in the early 1970s, so the market was strong at Guild Crafts from the very beginning.

Also in 1955, the guild opened a "shop" in Knoxville, Tennessee, actually a department within Rich's Department Store. This outlet was to last but two years; efforts by the guild's many Tennessee members to locate a retail store or craft fair in Knoxville have consistently failed. The Appalachian craft market is primarily supported by tourists, who perhaps viewed Knoxville more as the traffic jam en route to Gatlinburg than as a place to purchase crafts.

North of Knoxville, in Berea, the fifties brought a centennial celebration to Berea College, a busy time which included the staging of Paul Green's outdoor drama "Wilderness Road," the story of Berea's struggles to survive during the Civil War. "Wilderness Road," originally produced from 1955 through 1958, did much to expand Berea's visibility and craft marketplace.

The Log House Sales Room, built in 1917 to house the weaving

studios, was now enlarged for total use as a retail shop. A craft shop was part of Indian Fort Theater, the two-thousand-seat amphitheater built just east of Berea which today is used primarily as a site for three annual craft fairs. Busy U.S. 25 was, at the time, the major north-south artery, and traffic was channeled to the front doors of the Log House Sales Room, the Boone Tavern Gift Shop, and the theater store. For the next fifteen years, until I-75

13. Called the "Log Palace" when it was built in 1917 to house Berea College's Fireside Industries, this three-story structure was enlarged in 1954 and now is the Log House Sales Room, primary outlet for Berea College Crafts. Since 1945, the house has held the Wallace Nutting Collection of Early American Furniture; in 1990 the Florence Ridgway Collection of furniture reproductions was opened. Photo used with permission of Berea College.

bypassed the town, the three-story Log House was a familiar, welcome, air-conditioned sight to weary travelers fighting traffic on the Michigan-to-Florida roadway.

Two of the Berea College students working in the "Wilderness Road" production and in the college's pottery shop were Charles Counts and Hugh Bailey, both destined to become very important members of the Southern Highland Handicraft Guild during

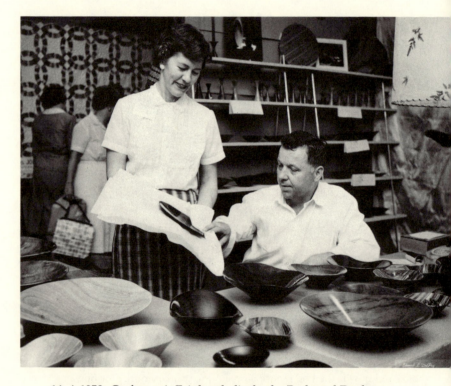

14. A 1950s Craftsman's Fair booth display by Rude and Daphne Osolnik, Berea. For over thirty years, woodworker Osolnik and O. J. Mattil coordinated fair setup; Osolnik was chair of the Berea College Industrial Arts Dept. for forty years. Photo by Edward DuPuy, used with permission of the Southern Highland Handicraft Guild.

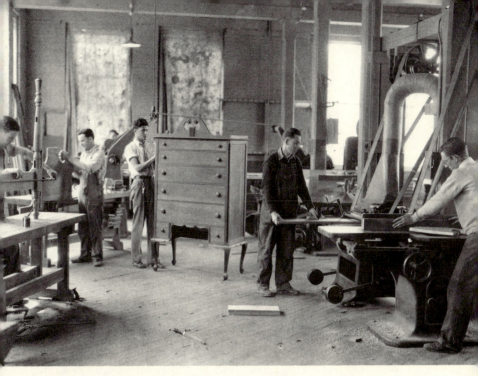

15. Berea College Woodcraft, ca. 1950s, in the building now used as a warehouse for finished crafts. Photo used with permission of Berea College.

the next decade. Another Berean, faculty member Rude Osolnik, was already making an impact on the Appalachian craft world. Osolnik, a woodworker ahead of his time, headed Berea's Industrial Arts Department and had—since 1950—worked with O. J. Mattil to supervise the setup of the Southern Highland Handicraft Guild's fairs. The fair, after three years under the tents in Gatlinburg, had moved over the mountains to the new Asheville Auditorium.

Unlike most modern craft shows, for which the promoter simply marks off booth spaces and lets the craftsperson do the work, a 1950s–1960s Craftsman's Fair of the Southern Highlands involved a complex construction job, the building of almost a small city within the auditorium walls. Booths were built and painted, provided with lights, electrical outlets, shelves, skirted tables, and a sign—everything except for the guild member and his/her

products. The Members' Exhibit, under the construction supervision of O. J. Mattil, was a separate unit, changing from year to year, located on the auditorium's entry level. As more props, electrical equipment, and construction materials were acquired, the guild finally purchased two huge trailers that were used for storage and then docked at the auditorium at fair time.

Temporary workers and guild volunteers worked three or four twenty-hour days building the fair backdrop, then added another hectic night and day tearing it all down. The same system, directed by Osolnik and Mattil, was still in place when I joined the staff in 1965 and was to largely continue into the early eighties before changing.

Booth fees were a percentage of sales. To collect the 20 percent, the guild did all the accounting, provided sales books and daily petty cash, deposited all the money, then paid members by check after the fair. What seems now to have been a cumbersome, overly complicated process was necessary at the time. Exhibitors of the fifties and sixties, unlike today's craft professionals, did not own personal portable booth displays, lights, and carpeting. Most, at least through the fifties, attended only the guild fair, which was essentially the *only* fair. There was no need for an exhibitor to build or purchase a custom display unit.

The very process of preparing for a fair and dismantling afterward added a camaraderie to the guild which is missing in current activities. Staff, members, volunteers, and temporary workers shared the effort and excitement, the sweat and splinters, the deadlines, and the satisfaction of the finished product. The strong feeling of family, of cooperative success, is the one thing "oldtimers" mention most often when wistfully recalling the earlier fairs. Today's guild fairs are much less personal, perhaps the price of growth and progress.

Sales at the guild fairs showed a steady but unspectacular

growth during the 1950s, with totals never quite reaching the $25,000 mark. Those totals sound absurdly low today, but in 1958 the guild's *total* gross sales (from four shops and the fair) were only $231,000.[3] In 1987, the figure for total gross sales was about $2 million.

In 1958 a now-familiar dispute erupted over fees for the use of the Asheville Auditorium, so the July 1959 fair was held in Gatlinburg's new civic center. As so often happens, difficulty created new opportunity. Gatlinburg was, if anything, an even better market than Asheville, even though the lack of air-conditioning in muggy July weather made the show a miserable experience.

The guild found itself in a good bargaining position. Both cities now wanted the fair, which was a strong drawing card for tourists, and the Asheville Chamber of Commerce offered free use of the auditorium. The obvious solution was a July fair in air-conditioned comfort and an October show in Tennessee; the fair's chairperson, Barbara McDonald, made that very recommendation for 1960, and the members' response was an overwhelming approval.[4] Since 1960 the guild has staged two annual fairs, in July and October, but not until 1965 was the dramatic upward sales spiral to begin.

Despite the solid levels of 1950s sales activity, the guild was constantly juggling finances, paying members immediately during the peak season but waiting, during slower times, two to three months until cash could be accumulated. One reason was the low wholesale-to-retail markup: 35 percent until 1955, 40 percent afterwards, finally to be raised to 50 percent in 1963.[5]

The retail markup has always been a controversial aspect of the Southern Highland Handicraft Guild as well as any other member-controlled organization. The percentages quoted in the preceding paragraph are discounts from retail: if a producer

priced a piece at $10.00 retail, he/she would receive $6.50 with a 35 percent commission, $6.00 at 40 percent, $5.00 at 50 percent. The method is a leftover from the time of consignment selling; the more conventional structure now is to establish a wholesale price and let the retailer mark up as needed to cover operating expense and profit.

But one major reason groups such as the guild were organized in the first place was membership control over selling, both in the creation of quality markets and in the maintenance of equitable practices. Almost every current privately owned shop owes a debt of gratitude to the early work of the Southern Highland Handicraft Guild in actually *creating* the strong markets that now exist.

Most organizations do try, normally without success, to find a method of paying members a higher percentage on retail sales. But, since sales must usually support nonmarketing expenses and educational programs, lower markups don't work.

And, during the 1950s and since, not all of the Southern Highland Handicraft Guild shops have been profitable. One or more outlets have always operated at a deficit. Until recent years—and the changes brought by the Folk Art Center—the guild's financial pattern was to operate retail stores at break-even and use income from the fairs to sustain the overall program.

In *Crafts in the Southern Highlands*, a 1958 Southern Highland Handicraft Guild publication, Emma Weaver wrote about the economic impact of crafts:

> How much do guild handicrafts contribute to the economy of the area? Of the gratifying 35 percent of the members who filled out a recent questionnaire, total income for 1956 was $51,816. These were individual craftsmen; many of them hobbyists with little or no income from their crafts. Projecting this figure to 100 percent gives $148,028. The producing centers were queried as to how many dollars

they paid into the hands of workers who supplied them with labor or articles. The total of the 10 percent who reported was $60,729. Projecting this to 100 percent gives us $607,290; a most conservative estimate as among those who did not report are some of the largest producers with a national market for their wares. It seems safe to conclude that the amount paid into the hands of craftsmen in the southern mountains for guild-approved work would be in the neighborhood of a million dollars. It should be added that the sales of the 35 percent of individuals who reported were about 50 percent to guild shops and 50 percent to other outlets. The total paid out by guild shops to individuals and producing centers in 1956 was $140,000.[6]

Nine years later, in 1967, Bob Gray was to report guild shop sales of $372,330 and project total member sales of over $10 million.

But the 1950s were not altogether devoted to marketing. Guild education programs of the decade were largely headed by Marian Heard, she of the incredible energy, talent, and force whose love for crafts and for the guild is still a remarkable inspiration to younger leaders.

In 1958 Heard's Education Committee reported on three workshops: a four-day weaving session at the Pi Beta Phi Settlement School in Gatlinburg, woodworking at the John C. Campbell Folk School, and a one-day seminar on salesmanship led by Orie Sherer of Massachusetts.[7] At the same time, it was announced that Bernice Stevens had been hired to "teach in community and home workshops; contact those rejected by the jury; contact possible members—especially in areas where guild membership is weak; serve as a craft consultant; hold exhibitions and give talks."[8]

Stevens described her early experiences in an interview with Robert Stanley Russell: "We were running on a shoestring. I took a cut in salary to come down here. For the first two or three months I went around and got acquainted with the craftsmen, and then I held workshops. In those days we had no place to hold

workshops except the guild office. We had them in churches, schools. . . ."[9]

Bernice Stevens, who first came to Appalachia to do research and author a chapter on crafts for *The Southern Appalachian Region: A Survey*, was to direct the guild's educational programs until 1963. In her study, "The Revival of Handicrafts," Stevens was to recount the early history and present the results of her own survey.[10] This crucial book was to be published in 1962, and will be discussed more in the following chapter.

As the busy decade of the 1950s ended, Louise Pitman was recommending to the guild's board of trustees that a new director—her replacement—be carefully selected and given explicit responsibilities. Said Pitman : "The guild is at present a loosely knit organization. There is need to tighten and tie activities more closely together through a new director. His responsibilities must be defined. As the guild grows in size so the problems multiply."[11]

Louise Pitman's understated remarks accurately summarized the situation. After thirty years, the Southern Highland Handicraft Guild needed a more focused, more business-oriented management approach. Pitman could not have known just how much growth lay ahead for the next thirty years, but she had an obvious grasp of what was to come.

Her years of service to the guild spanned an important decade, and her work was crucial to the guild's growth. A contemporary of Pitman's said in 1989 that

> Louise was an excellent director for that time. At a later period, when crafts became big business, she would have been neither suited for nor interested in the job. She was a folksy, caring person for a folksy organization. She worked hard and never turned down a call for help—all on a minuscule salary. Both as part of the Campbell Folk School (seventeen years) and as guild director she did much to further the cause of crafts. While at the Folk School, Louise took home to

New Jersey, every year, a large exhibit of the school's craft work. Her mother staged a large invitational tea in her home and the crafts were displayed. Also, whenever the school was in dire financial straits, Louise's father came to the rescue with a gift or a loan.

As the era of Eisenhower, Elvis, and innocence drew to a close, the Appalachian craft world was on the verge of a revival which was to surprise even the most avid of craft supporters.

5.

1960–1965

Growth in Kentucky and Preparations for the War on Poverty

The sixties.

Vietnam. Civil rights. The War on Poverty. Hippies and other flower children. The Kennedys, Martin Luther King, the Beatles. Burning bras and draft cards, the sexual revolution, muscle cars and flower-petaled VW vans. Even in remotest Appalachia the turmoil, excitement, change, and turbulence touched our lives. Here in the mountains we had the Appalachian Volunteers, VISTA (Volunteers In Service To America), the OEO (Office of Economic Opportunity), and the ARC (Appalachian Regional Commission), the free-flowing federal dollars of the Great Society which forever changed, for better or worse, life in rural America.

The interstate highway system slashed modern new roadways through the mountains of Kentucky, Tennessee, West Virginia, and North Carolina. The Appalachian Regional Commission built highways, hospitals, sewer systems, industrial parks, and a reputation for pork-barrel politics. Kentucky, West Virginia, and Tennessee rushed to implement state-level crafts marketing programs; and federal funds financed an array of mostly disasters in craft making and selling. And the market for crafts, good and bad, started to explode in 1965.

Blissfully unaware of happenings in the craft world, I was a student at Berea College from 1961 through June of 1965. Maybe I

was too wrapped up in my personal "War on Poverty" to care much at the time about the bigger one; I was to write, many years later, for *Southern Exposure*:

> We were the last generation to grow up before LBJ's War on Poverty brought new expectations to Appalachia; we are conservative liberals, equally embracing tradition and futurism, young middle-aged workers who've seen our homeland cram a century of progress into three decades.
>
> My Berea College classmates were intelligent, committed, stubbornly determined to break away from poverty. Many of us were the first from our families to attend college or even to graduate from high school. We were at Berea because we were poor and Berea was cheap. We were a conservative lot, products of a heritage decreeing that brains plus hard work equalled success.
>
> I'm afraid we in-betweeners are the last of a breed, the final generation to have intimately known the old mountain ways. We lived in what our children study as history; we have adapted, adjusted, survived the rapid change. We're too young to be traditional mountaineers, too old to accept a radical line of thinking.[1]

I honestly didn't know or even care that the Kentucky Guild of Artists and Craftsmen was being born at Berea during my college years. The early sixties in Berea were not the frantic times which were to come in the latter part of the decade. I was more concerned with the racial struggles in America and the little war brewing in Southeast Asia than in the market for woodwork and whimmydiddles.

In 1962 the important study *The Southern Appalachian Region: A Survey*, was published, including Bernice Stevens's article on the craft situation, "The Revival of Handicrafts." Stevens's study covered seven states, but found, not surprisingly, that over 70 percent of Southern Highland Handicraft Guild craft production was done in North Carolina and Tennessee. Over half the craftspeople responding reported having lived in the area all

their lives, and 21 percent were college graduates.[2] I suspect that these figures would be misleading if applied to a greater geographical area. At that time in Eastern Kentucky, the percentage of college graduates would have been much lower, and Bernice would have been a little reluctant to report that "outsiders" were, even then, the majority.

As is usual, Stevens had trouble finding reliable sales statistics. She quoted the guild's 1956 survey results, then reported that the 189 craftspeople who responded at this time had sales of $129,450, which Bernice "projected" to an overall sales total of $649,989 for the entire guild. "The important thing," concluded Stevens, "is that crafts have an ever-growing economic value, definitely related to tourism and in-migration, and that value can continue to grow."[3]

Despite the early 1960s growth of the Southern Highland Handicraft Guild's Craftsman's Fairs, Stevens expressed doubts about the economic role of crafts and preferred to dwell on the other benefits. "Crafts are still not the road to riches for the individual craftsman or the guild," she wrote, "and it is a relief to turn from the economic values of crafts to the personal ones."[4] Stevens cited the value of crafts in therapy, recreation, and education, closing with a warning which, like Allen Eaton's earlier admonitions, should have been heeded:

> Crafts are not the quick answer to all the financial needs of depressed mountain areas. A craft is not learned in six easy lessons and its products sold cheaply and without effort. Education, whether of the father-to-son variety or the contemporary college or workshop kind, is essential.
>
> With intelligent planning and timely financial aid for a comprehensive educational program, crafts could become a more vital factor in the cultural, social, and economic life of the Southern Appalachian region.[5]

Rupert B. Vance, in the closing chapter of the landmark *Southern Appalachian Region: A Survey*, added that "the native handicrafts which have contributed to the attractions and to the commercial life of some of the region's major tourist centers cannot be expected to produce prosperity in distressed areas where no such trade exists."[6] Over the next decade, few were to heed the warnings of Stevens and Vance or the many others who were to repeat that same thought over and over. Though crafts have, since 1962, become much more of an economic factor in Appalachia, the skill and design ability necessary for success are not easily acquired. The debate, though, still continues.

I wrote, almost thirty years later:

> As a statewide industry, crafts are a significant economic factor. But for the lasting economic salvation of Eastern Kentucky, look somewhere else. Look to industry, light or heavy, and to the improved schools, water systems, and quality of life necessary to getting those industries to relocate.
>
> The crafts world will continue to grow, to better market its quality products and to better train craftspeople in business operations. But Eastern Kentucky needs more than crafts, flea markets, and yard sales to build a lasting, tax-paying economic base, and it's time Frankfort realized that.[7]

The Southern Appalachian Region: A Survey, edited by Thomas R. Ford, was called by Willis D. Weatherford, Sr., "the findings of the most comprehensive survey of the Southern Appalachians ever undertaken."[8] The survey, which stemmed from a 1956 meeting at Berea College, was funded by a $250,000 grant from the Ford Foundation. The study proved to be the solid forerunner of most of what was to happen in Appalachia for three decades and turned out to be, as hoped, not just a book of facts but of collected facts "actively applied to better the lives of the Region's people."[9]

In 1988, Berea College President John B. Stephenson was to host a meeting at Berea to explore the possibilities of a new regional survey, an update of the Ford study, an assessment of what had been done and what still needed to be accomplished in Appalachia. At this writing, no firm plans for such an effort were in place, but the effort was solidly underway.

The sixties, surveys or no surveys, started peacefully enough. Kentucky had just elected probably its last Eastern Kentucky governor, Bert T. Combs, who had promised during his campaign to bring economic development into his native mountains. As it turns out, Combs's biggest contribution to landlocked East Kentucky was the Mountain Parkway which bears his name. This then-modern highway from Winchester to Salyersville, despite the toll booths, was a most welcome sight to anybody who had to travel the mountains.

Governor Combs also initiated the Arts and Crafts Division of the Kentucky Department of Economic Development and—in a corollary development—helped establish the Kentucky Guild of Artists and Craftsmen. In a situation very much like that of the Southern Highland Handicraft Guild and Southern Highlanders, Inc., twenty-five years earlier, the Arts and Crafts Division was created to emphasize marketing and the guild to promote education. The two were to work hand in hand, and the ultimate result was very similar to what had happened with TVA and the Southern Highland Guild. The private organization survives, but the state-operated program disappeared.

Again in 1960, as it had done with the Southern Highland Guild in the 1920s, Berea College played a major role in the establishment of the new programs. Rude Osolnik and Lester Pross, an art professor, were on the new guild's first board of trustees, Pross as the first president. And the unique Kentucky Guild Train used a Berea College siding as home base.

Louisville enamelist and painter Virginia Minish was probably the person whose idea brought the Kentucky guild to life. In 1960, armed with a grant from Louisville publisher Barry Bingham, Sr., and the promise of two baggage cars and free in-state transportation from the L&N Railroad, Minish persuaded Governor Combs and the Kentucky legislature to provide eighteen thousand dollars for a one-year trial operation of the Kentucky Guild Train, a mobile gallery-workshop, an innovative concept far ahead of its time.[10]

That year-to-year operational grant of eighteen thousand dollars was to continue until 1968, when new Republican Governor Louie Nunn essentially sent word that the Guild Train, though a good idea, had outlived its usefulness. The administration asked the guild to submit a new proposal for craft development. The guild's somewhat arrogant reply was to say, essentially, that the guild was a better judge of what was good and needed in the craft world than was state government. Governor Nunn's predictable response was to cancel the funding and kill the Guild Train. The guild's board of trustees was quite correct in their assessment of just who knew more about what was needed, but very much in error in their politics.

At the same time that Virginia Minish was working in Louisville, Paul Hadley left Churchill Weavers to become director of the new Arts and Crafts Division in Frankfort, a typically over-reaching state government project geared toward economic development. The state project reached out madly in all directions, opening retail shops in remote areas of Appalachian Kentucky and then closing them almost as quickly as they were opened. Production loans, a wholesale warehouse, and an air of excitement and hoopla—unequalled until Phyllis George Brown helicoptered buyers across the state in the early 1980s—were the division's trademarks.

The Kentucky effort was destined to fail—too much staff, no quality controls, politics, and the fact that Kentucky's governors cannot succeed themselves—but the very attempt itself was notable and pacesetting, the impetus for several other states to do the same. The other states, quite frankly, were more successful in directly running craft marketing programs, but Kentucky's was the first and to date none of the similar projects has achieved any better long-term results.

But, just as Southern Highlanders, Inc., helped establish the Southern Highland Handicraft Guild further south, the Kentucky Arts and Crafts Division *did* help successfully create the Kentucky Guild of Artists and Craftsmen. A related development was the 1963 publication of *The Development of Kentucky's Handicraft Industry*, prepared by Lawrence Lynch and William Evans for the Spindletop Research Center in Lexington. Potter Charles Counts, the vocal leader of much 1960s–1970s craft activity, was later to call the survey a "good analysis of what needs to be done to create jobs and generate income in Kentucky through expanded craft centers."[11] The now-elusive study was an optimistic report which probably helped guide several operations to failure by recommending too much expansion. Statistics on organization, production, and potential markets, however accurate they may be, are useful only if someone is making a quality product.

Virginia Minish enlisted much help to create the unique Kentucky Guild Train. Rude Osolnik and James Hall of the Berea College Industrial Arts Department refurbished the workshop car, which also included living quarters. The gallery car was renovated in Louisville. The two units were joined in Hazard, Kentucky, in September 1961, to be dedicated by Governor Combs; then it spent the first year traveling in Eastern Kentucky.[12] John Dillihay was the first train director, to be succeeded later by Ed and Judy Brinkman, and finally by Jerry Workman.

In 1962 the Kentucky Guild Train drew 50,294 visitors in twenty-three stops,[13] the high mark of the visionary effort. That same year, the Guild Gallery was opened in the Mall on Shelbyville Road in Louisville.[14] A little further south, in Pine Knot, the work of Smith and Elma Ross was intensifying. Kentucky Hills Industries was incorporated in 1963, receiving a Farmers Home Administration loan of fifty thousand dollars to build its shop, which was finally dedicated in 1966. Kentucky Hills was to effectively use Office of Economic Opportunity and Department of Vocational Education funding to teach woodworking and pottery for the next several years.[15]

Kentucky Hills played an active role in regional craft organizations. They had been at the first Southern Highland Handicraft Guild Fair in 1948, selling, and the group joined the Kentucky guild in 1965.[16] Mr. Ross was the Kentucky guild president during part of my tenure as director.

In *Come, Go with Me*, Smith Ross offered some Allen Eaton–ish advice to those who would start a craft group in Appalachia:

(1) A mountaineer favors a type of work which permits him to retain his basic personal freedoms. He resents corporate control or any other action which restricts his religious or personal freedom.

(2) The mountain man prefers to live at home. He dislikes a job which separates the family.

(3) He likes to have a voice in the business where he works. The craft program is especially well adapted to this, for the workers own and control the business.

(4) The mountain person likes to have a say-so about the time he works, how much he works, whether he works. When regimentation can be kept to a minimum the mountaineer is more congenial and easy to get along with.[17]

Smith Ross was writing in 1977, not 1937, when he expressed these cautions about the mountain personality, and someone should have been listening.

In 1963 the Kentucky guild sold its struggling new retail outlet to the Southern Highland Handicraft Guild, which was itself undergoing changes during the early 1960s. The sixties brought a new wave of leadership to the region's oldest craft organization. Craftspeople like Persis Grayson, Charles Counts, Eric Picker, Hugh Bailey, Margaret Bolton, Earl Huskey, Ellen Jones, B. S. Dunlap, and Ralph Morris, Jr., emerged to join forces with the still-active leaders of the thirties, forties, and fifties. The mix of well-educated natives and skilled craftspeople moving to the area was still working well for the guild, but in 1960 Louise Pitman had recognized the need for stronger management and marketing skills in the director's position.

In 1961 the Southern Highland Guild hired Robert W. Gray as director, a move to bring the organization's management into a much more businesslike system. Bob Gray is a Florida native, a civil engineer, a former U.S. Marine, a woodcarver and potter who studied at the School for American Craftsmen before coordinating the craft programs at Old Sturbridge Village. For the ten years prior to coming to Asheville, Gray had been director of the Worcester (Massachusetts) Craft Center. There was a bonus in hiring Bob Gray: his wife, potter Verdelle Gray, brought her creative talents to Asheville and worked as a guild volunteer—more as an unpaid staff member—for the next twenty-five years.

Bob Gray was a tenacious, matter-of-fact, well-organized administrator who never backed away from a difficult situation, a tough businessman who had to implement some unpopular decisions early in his tenure as guild director. Controversial staff changes and the increase in retail shop markups stirred up bitterness that was still brewing when I arrived four years later. Then, in 1962, Gray had to deal with one of the earliest Internal Revenue Service challenges to the previously accepted sales role of a nonprofit organization.

The IRS ruled that selling crafts was not an educational function, and that sales had to be separated from the nonprofit activity. In response, three wholly owned subsidiary corporations were established, one for each state where the guild was active; then the three were combined in 1965 into Blue Ridge Crafts, Inc. In 1972 the name was changed to Crafts of Nine States, Inc.[18]

This somewhat complicated structure was duplicated by dozens of similar nonprofit agencies. Essentially, the dual organizations operated on paper only, and the bookkeeping function created lots of extra paper. Income and expenses were methodically divided between corporations. Guild fairs were actually run by both corporations: the guild did educational programs and collected admission fees, and Crafts of Nine States ran the sales programs. Profits from marketing, after taxes, went to the guild (which owned all stock in the subsidiary corporation). Except for some minor changes dictated by revised laws, this structure did not change from 1962 to 1988. Late in 1988, the guild made minor revisions to its bylaws and was given approval by the IRS to again operate as a single nonprofit corporation.

As mentioned in the previous chapter, a 1963 National Park Service ruling forced the guild to pull out of the two shops on the Virginia Skyline Drive. The inventory from those two small shops was used to open Guild Gallery in Louisville. Bob Gray got another dose of unpleasantness when the Southern Highland Handicraft Guild took over the Kentucky operation. Louisville members of the Kentucky guild, located well outside the Southern Highland Guild's mountain service area, did not easily give up their prestigious marketplace, and much of the inventory in the shop was of such low standards that it was unsalable. Much as I was to do with Berea College's Louisville shop over twenty years later, Bob Gray had to get rid of the junk.

The Southern Highland Guild operated the Guild Gallery in

Louisville until 1969, when it was moved to Bristol, Virginia. The troubled shop, which was never profitable in either location, moved to Abingdon, Virginia, in early 1989. The Kentucky guild obviously did not feel they had sold the *name* when they sold the shop; in 1970, they were to open a new Guild Gallery in Lexington.

In 1964 a new cooperative gallery, the 12 Designer Craftsmen, was opened in Gatlinburg, Tennessee, on Roaring Fork Road. The shop included the work of such craftspeople as Jane Glass, Bernice Stevens, Lynn Gault, Fred Smith, Don Lewis, Tina McMorran, Alice Zimmerman, Fannie Mennen, Peg Boarts, Sara Young, and—for one year—Charles Counts. Superb in quality and display, the 12 Designer Craftsmen was perhaps too good for its location, but it operated successfully for fourteen years. The shop was a true cooperative effort, with shared expenses and management, founded on the concept that a craftsperson should be "sold" along with his or her work and should have some control over how that work was displayed. Each participant had an area of the shop for display and individual information; bagged with every purchase was a folder with information about the craftsperson whose work was being sold. The shop was to eventually close because one member died, another moved away, and several were ready to retire. In true cooperative fashion, the members divided up everything—cash register, display units, adding machine, bags and boxes—and went home.

In 1963 West Virginia joined the ranks of state-level craft support, creating both the West Virginia Artists and Craftsmen's Guild and the Department of Commerce's Arts and Crafts Division. Probably the most heavily funded and staffed of all such state programs, headed first by Carl Little and then by Don Page, West Virginia's operations concentrated more than others did on marketing. The Mountain States Arts and Crafts Fair in Cedar

16. Southern Highland Handicraft Guild leaders prepare for an early 1960s fair. *Left to right*, Dr. Fred Smith, Bernice A. Stevens, Charles Counts, Louise Pitman, and Persis Grayson. Photo by Edward DuPuy, used with permission of the Southern Highland Handicraft Guild.

Lakes, near Ripley, was started in 1963 and attracted twenty-five thousand visitors in 1965.[19]

On December 7, 1963, Appalachian crafts leader and author Allen H. Eaton died. Aileen O. Webb, founder of the American Crafts Council, wrote of Eaton: "It was not so much his deeds that endeared him to all who knew him but dedication to his beliefs, his love of beauty, and his simpleness of purpose, his clarity in appraising others, and the humbleness and sweetness of his spirit. The world has a need of men like Allen Eaton, and

those of us who knew him and loved him are richer for the experience."[20]

But it was not Eaton's *Handicrafts of the Southern Highlands* that was drawing national attention to Appalachia in 1963. The book of the moment was Harry Caudill's *Night Comes to the Cumberlands*. Caudill's book, subtitled "A Biography of a Depressed Area," contained a foreword by Stewart Udall as well as Caudill's own controversial assertion that "street orphans, debtors, and criminals" and "honest men who could not pay their debts, pickpockets and thieves who were worth more to the Crown on a New World plantation than dangling from a rope" were our Appalachian ancestors.[21] Obviously, according to Caudill, these people were the only ones poor, desperate, and tough enough to settle and stay here in the rugged mountains.

Caudill's chapter on "The Case for a Southern Mountain Authority" is generally considered a major reason for the creation of the Appalachian Regional Commission. Citing the Tennessee Valley Authority as a good example of what was needed in Appalachia, Caudill recommended a new authority to attack the ills of the mountain region and bring progress and prosperity to these descendants of the scum of London. *Night Comes to the Cumberlands* is probably the most widely read, most talked about, most influential book ever written about Appalachia. And in March 1965, President Lyndon B. Johnson signed into law the Appalachian Development Act, declaring it the "truest example of creative federalism of our times."[22]

Johnson's Office of Economic Opportunity was already working busily to create the Great Society, and now a new effort, theoretically a joint state-federal program, was to leap headfirst into the War on Poverty in a thirteen-state region. The Appalachian Regional Commission's geographical definition of Appalachia went far beyond Harry Caudill's recommended southern

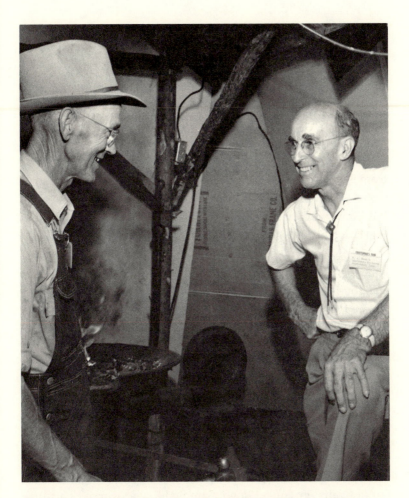

17. O. J. Mattil, *right*, with blacksmith Oscar Cantrell at a guild fair in Gatlinburg. Mattil's Woodcrafters and Carvers Shop was where many Tennessee woodworkers were trained under TVA educational programs. O. J. served several terms as guild president and was in charge of fair setup for over thirty years. Photo by Edward DuPuy, used with permission of the Southern Highland Handicraft Guild.

mountains. Politically defined Appalachia, it turned out, was a much larger, more urban, more affluent region. The work of the new agency was to be a mix of success and scandal. The Appalachian Regional Commission (ARC) was not to actively enter the Appalachian craft world for another ten years, but when it did, the initial effort helped prove how wrong President Johnson had been when he declared that the "pork barrel is gone."[23]

In May 1965, less than a month away from my graduation from Berea College, I was trying to figure out just how an English major was supposed to make a living. That was when I first met Bob Gray; an hour later I went stumbling across campus wondering how to get to a place called Asheville, North Carolina. I stayed in Kentucky long enough to greet my newborn son and collect my diploma, moved to Asheville in mid-June, and was to stay there through July 1970.

I had no job title when I went to Asheville, but was Bob Gray's "leg man," with primary responsibility for writing the guild newsletter, *Highland Highlights*. Part of the reason I was untitled was the fate of my predecessor, a merchandise manager who obviously stepped on toes and became unpopular enough with the guild members to get his job discontinued. I inherited his desk. On it was Edsel Martin's carved wild boar, the treasured gift that stays with me wherever I go.

In 1965 the guild staff was Bob Gray, myself, secretary Carol Smith, and part-time secretary Jo Tutt. We shared three rooms in Guild Crafts on Tunnel Road. Sam Stahl, who worked part-time to promote the guild fairs, operated from his home in Tennessee. Except for the time spent reading Allen Eaton's book, I seldom sat down during those first few months. I delivered fair publicity materials all over Western North Carolina, got lost a dozen times on twisting back roads, and—almost accidentally—found my way to places like Little Switzerland and Brevard.

My first Craftsman's Fair in July was a memorable, bone-numbing experience, the first and last six-day, twelve-hour-a-day guild fair, a literal hands-on experience that gave me plenty of motivation, later, to streamline parts of the process. I did a little bit of everything that week, including, fortunately, working with Sam Stahl on the publicity. A few weeks later Sam left for a position at Berea College and left me his files, his guidelines, and his job of fair promotion.

Fresh off the farm, accustomed to hard physical labor, I plowed into that first fair eager and excited. Ten days later, I stumbled home with blistered hands and feet and dozens of new friends. During that first fair I met Bea Hensley, Homer Ledford, Miss Fannie Mennen, Shadrack Mace, Earl and Ray Huskey, Marian Heard, Isadora Williams, G. B. Chiltoskey, Fred Smith, Clem Douglas, Lucy Morgan, Charles and Rubynelle Counts, Floyd Wilson, Arvil Woody, and a list that goes on and on. O. J. Mattil, whose forward-leaning half-trot was his normal gait, worked me down into the concrete floor of the old Asheville Auditorium. That very first Southern Highland Handicraft Guild Fair is perhaps the richest memory of my life, the experience that set the tone and pace for my work in the crafts world.

Despite Persis Grayson's concern, as President of the guild Board of Trustees, that there wouldn't be enough work to keep me busy, the next few months were as hectic as the first. I wrote "Highland Highlights," hauled merchandise to Blowing Rock and Louisville, lined up newspaper and TV coverage for the October fair, and worked at the now familiar O. J. Mattil half-trot.

The October fair in Gatlinburg was another world. There were no handy hardware stores, paper suppliers, or printers in the resort community, so we literally traveled over the Smokies with everything we needed to set up and operate. Sales at the 1965 Gatlinburg fair were just under $50,000, then an all-time high, but

mostly the volume was an indicator of what was still to come. By 1975, total Gatlinburg fair sales would climb to almost $225,000.[24]

That 1965 fair in Gatlinburg also featured one of the most memorable, pioneering craft displays ever presented. The "Craftsman's House," part of the 1964 and 1965 fairs, was coordinated by B. S. "Sam" Dunlap, an effort that involved building rooms, prearranging specific pieces from guild members, and creating a total atmosphere to illustrate how crafts could be used in the home.

Sam's preparations spanned ten months. On-site construction was coordinated by O. J. Mattil and done in one long day. Sam and guild volunteers did the installation. After five days the house would be disassembled. The units themselves were recycled and used for many more years in different configurations. The "Craftsman's House" concept, years ahead of its time, was to be picked up and modified dozens of times later. The TVA, in 1978, did a version of Sam's house, a display in its Knoxville office complex featuring crafts from the region in a "house" created partly by panels with artwork drawn onto the walls. The same backdrop was used for the Members' Exhibit of the 1979 Southern Highland Guild Fair in Asheville.

The Kentucky guild's mobile gallery (the Kentucky Guild Train) and the Southern Highland Handicraft Guild's "Craftsman's House" were major influences on national-level displays of the past three decades. The Southern Highland Guild Fair exhibits—coordinated by people like Ellen Jones, Eric Picker, Charles Counts, and Verdelle Gray—were massive efforts, valuable educational and marketing tools that helped create the craft collectors' sales arena.

Back in Asheville after the Gatlinburg fair, I spent the final months of 1965 working on a new handbook for guild members, sorting through the artifacts stored in the Guild Crafts basement, helping

the shops through a busy Christmas season, and doing whatever else Bob Gray handed me. For the next five years the Southern Highland Handicraft Guild and the incredible explosion of activity in the Appalachian craft world was to keep me and everybody else involved busy dealing with a dramatic upswing.

6.

1966–1970

More of Everything, Everywhere

In March 1966 Charles Counts wrote for *Craft Horizons*:

> I see the crafts of Appalachia.
>
> Real and expressive "products of the people." The good, the bad,
> the indifferent. The new the old—but *there*, and an integral part of
> all that is a region. Some "colonial survivors" made by men who
> never involved themselves in a war, or a coal-boom-town, or
> factory jobs. Crafts born out of an agrarian seventeenth century
> attitude but real expressions of flesh and blood humans made in
> 1966. Made in Appalachia. By hand. By a man. A man who lives
> and cares and does the best he can.
>
> I see new things in Appalachia—new faces, new craftsmen, new
> schools, new ideas. Clean lines and simple forms.
>
> I see a land of beauty and hope, great natural beauty with a cultural
> heritage of several generations. I also see a land of ugliness and
> despair, of stripped-out mountains, resources plundered and
> people left to perish without hope or a chance to pull themselves
> up into an America of affluence and culture. Education and
> opportunity. I see this conflict, feel this turbulence.
>
> In seeing, who dares look to the future? Who knows? Who cares?
> Crafts, yes, products-of-*people*. Why? Who for? People. Made by
> hand, by machine, by automated people and machines. Regulated.
> Extruded. As in all America, *All-American*. For cash, for therapy, for
> "self-expression," for shows, for museums, forever. By artists,
> Artists, craftsmen, designer-craftsmen-computers, and the fusion of
> it all in the kiln of life.[1]

In the same issue of *Craft Horizons*, Jonathan Williams added:

> The town of Cherokee on the Qualla Indian Reservation is one of the outstanding abominations in the U.S.—a horrendous conglutination of bears in cages, junque shoppes, genuine Indians jogging around in pseudo-Navaho headdresses made in Hong Kong out of plastic, reptile gardens, and millions of decorticated modern American white folks (only) in duck-billed caps and air-conditioned automobiles looking (as far as the ends of their bony, blue noses) for the Lost America.[2]

Williams's colorful poet's language and smug sarcasm help introduce his lengthy article on "The Southern Appalachians," a survey-of-sorts which gives a good if sometimes irritating overview of the mid-sixties Appalachian craft world. This handsome *Craft Horizons* special edition also included Doris Ullman's haunting 1930s mountain photographs and Williams's poetic adaptations of mountain speech patterns, which are excellent.

Charles Counts's more questioning thoughts reflect the Harlan, Kentucky, native's concern and mixed hope and despair for the region. I share Counts's emotions even now, over twenty years later, as I look at his homeland and mine. We are torn always between reality and vision, hope and hopelessness, past and present. Charles Counts's background includes an Eastern Kentucky coal camp, the Oak Ridge atomic labs, and Berea College, a combination guaranteed to provoke thinking and concern for human welfare.

Williams, a native of more prosperous Western North Carolina, seems indifferent to the plight of a people, but does get down to some facts and provides a solid reading list of background material on Appalachia.

One current (1966) program receiving attention was Iron Mountain Stoneware in Laurel Bloomery, Tennessee, started in 1964 by Al Mock and Nancy Patterson with an initial loan of $260,000 from the Area Redevelopment Administration of the

U.S. Department of Commerce. Some 409 people applied for the forty-five jobs made available in 1965 at the Iron Mountain plant.[3] Al Mock told me that the selection process aimed to choose those *least* qualified, by prevailing employment standards, for the training. Unlike many of the federally supported craft projects of the era, Iron Mountain Stoneware is still operating, though now as a much more commercial factory—something which has happened before in the history of crafts as economic development.

The Three Mountaineers woodworking plant in Asheville is the prime example of a handwork shop growing into a factory. At one time Three Mountaineers was a small woodworking shop, a Southern Highland Handicraft Guild member, but success in the marketplace shifted the focus from quality hand-built furniture to mass-produced pine accessories. The plant retains much of the handcraft skills, but on a very commercial scale, and as the emphasis changed, Three Mountaineers voluntarily withdrew as a member of the guild. There are those in the craft world who have argued that other craft centers, such as Churchill Weavers, Stuart Nye Jewelry, and even Berea College Crafts should do the same, but in the latter three centers the work is still done by hand and the finished products reflect the skill of the craftsperson.

Of West Virginia's early craft efforts, specifically the fair at Cedar Lakes, Williams quoted noted glassblower Joel Myers (who had just moved to the state to be the new designer at Blenko Glass) as saying: "I have found [in West Virginia] a lack of anything really recognizable as crafts. They do not exist. It [the fair] was a miserable failure. Birthe, my wife, and I were so dazed that we even drank of that strange, nasty elixir sassafras tea. All this junk just plays on the ignorance and gullibility of urban natives and serves to debase the former craft achievements of a hard, proud people."[4] Joel Myers, unlike Allen Eaton and the earlier leaders of the Appalachian craft revival, saw no value in the folk

toys, carved spoons and pitchforks, and other products taken to the market by native craftspeople.

Jonathan Williams also touched on the changes at historic Penland School in Penland, North Carolina. The school's new director, Bill Brown, in his interview with the board of trustees, made it more than clear that he was not a typical business-manager type of administrator. Brown said "(1) I don't like boards of trustees; (2) I'm not an administrator, I can't say no; (3) I don't know how to count. But (4) if you want a guy who's a teacher and producer, who's anxious to have a go at this, then maybe I'm it?"[5] The Penland trustees obviously decided they needed Brown's flair and enthusiasm more than they needed a bookkeeper-custodian, and Brown brought a new life and new direction to Penland.

Bill Brown had his go at it, saying "I'm getting the best horses in the business and you'd better be ready to ride."[6] By 1966 Penland was thriving, drawing the "best horses" in the national craft world as instructors, bringing in exciting newcomers as residents, leading Jonathan Williams to suggest that "Penland begins to replace much that Black Mountain College stood for in its last phase."[7]

My introduction to Bill Brown came in February 1966, when Bob Gray convened a Southeast Regional Craft Conference in Asheville. Mostly I remember Bill Brown (and his advice that "design is the solution to a problem within given restrictions") and Susan Brown of the Kentucky Arts and Crafts Division, one of the most gracious people to ever work in the worlds of crafts and politics. In hindsight, the results of this early regional conference were perhaps predictable. The local newspapers reported that "foremost among the recommendations adopted in a total crafts program was the employment of a top designer—one of the best in the business—whose services would be used through-

out the Appalachian region."[8] To many of those present, obviously Appalachia's craftspeople were still in dire need of design assistance.

The entire Southeast did not rank much higher than Appalachia in the eyes of the American Craft Council. Nell Znamierowski, in a review of the Southeast's participation in a national showing, wrote that "there was little in this show that clearly could be called a pure product of the region." Znamierowski seemed to be grateful for that fact, and added that, of course, a participant in such an important exhibition would be only "the artisan who is aware of the world outside his regional boundaries."[9]

Bob Gray, a contemporary of these craft leaders, a visionary leader with almost twenty years of involvement in the craft world of the Northeast, did not share his fellow leaders' callous disdain for local culture and crafts. Mr. Gray, perhaps because of his Floridian and Southern roots, showed respect for excellence and character, whether it be in a cornshuck doll, a "woods pretty," or, in all likelihood, a cup of "vile" sassafras tea. His love for the mountain ways—the wry humor, colorful eccentricities, and skilled artisanry—has never dimmed. Perhaps Bob Gray's understanding of our culture helped him tolerate and educate the ignorant young Kentuckian who worked beside him, and maybe dealing with my strong regionalism helped Bob learn more about the people he served.

The people Bob Gray served were, despite the scorn of Joel Myers and the others, continuing to build on their strong traditions of basketmaking, quilting, carving, wrought iron, weaving, spinning, woodturning, and the making of functional pottery. Throughout the southern mountains, craft production was flourishing and expanding while largely maintaining the quality levels that built its reputation, and the growing interest in crafts

as a means of economic development caught the attention of state and federal planners everywhere.

In a very different vein from Jonathan Williams's critical essay was Charles Counts's *Encouraging American Handcrafts: What Role in Economic Development?* a concise and accurate booklet published in 1966.

Just who is Charles Counts, this strong new 1960s voice for Appalachia? A native of Harlan, Kentucky, Counts grew up mostly in Oak Ridge, Tennessee, graduated from Berea College in 1956, attended Southern Illinois University and the University of Southern California, then worked with Marguerite Wildenhain at Farm Pond (Wildenhain's California studio). With Rubynelle, an equally talented potter and fiber worker, Charles set up shop first in Oak Ridge, later relocating to Rising Fawn, Georgia, on Lookout Mountain near Chattanooga, Tennessee. Counts is the author of *Common Clay*, which brought early attention to the traditional potters of the Southeast, as well as hundreds of essays and articles. He is also a sociologist, teacher, activist, and, above all else, a thinker and a potter. In 1966 he was on the board of trustees of the Southern Highland Handicraft Guild and an active leader in the region's social and economic development.

Encouraging American Handcrafts was and still is one of the most helpful publications for anybody working in the Appalachian craft world. The background information alone is invaluable, ranging from an attempt to answer the question, "What is a handcraft?" to differentiating "Kinds of Craftsmen" as "Craftworker," "Traditional Craftsman," "Artist-Craftsman," and "Designer-Craftsman," each at a defined level of involvement.[10] In 1966, incidentally, no one had yet pointed out the existence of sexist language; "crafts*man*" implied skill and character, not gender. No chauvinism was intended, but these quotations are a good example of how times have changed.

Counts includes statistics, although, again, "comprehensive documentation is not available."[11] Sales figures from the Southern Highland Handicraft Guild shops show an increase from $237,371 in 1960 to $302,026 in 1964. The 1960 guild fairs generated $42,588, compared to $65,086 in 1964. The Qualla Arts and Crafts Mutual shop in Cherokee did $7,000 in 1946, $55,669 in 1964. Bob Gray reported that, could the guild deliver, wholesale orders of $200,000 would be available "tomorrow."[12]

Counts cited problems with high production costs, lack of design talent, lack of management and entrepreneurial skills, need for distribution facilities, inadequate training, lack of planning, and lack of effective leadership and organization.[13] He summarized his recommended solutions:

> *In production*: Provide technical assistance in production techniques, design, and business management.
>
> *In marketing*: Provide technical assistance and training in marketing techniques and encourage capable entrepreneurs to enter the field. Establish regional warehouses and showrooms to aid in distribution, and to serve as regional centers for information and advice. Publish a national catalogue of handcraft products.
>
> *In training*: Encourage craft schools and university art departments to provide courses in marketing techniques and business techniques. Institute programs for training craftworkers and encourage craft businesses to train new workers or retrain older workers. Improve teaching techniques and methods of selection. Establish standards for training. Improve vocational education in public schools. Schools like the Institute of American Indian Arts might be founded in other areas such as Appalachia.
>
> *Coordination*: Organization and coordination on a national level is needed [and was outlined in his next chapter; Counts recommended a National Advisory Board for American Crafts].[14]

Compare Counts's 1966 report to Allen Eaton's 1937 recommendations (discussed in chapter 2), and you'll find very little disagreement. Though the Counts study was financed by the

United States government, and ultimately an Inter-Agency Craft Committee was to be formed, the federal projects of the 1960s largely ignored the advice they had paid to have compiled.

Parts of the Eaton/Counts recommendations were rapidly becoming reality, especially the move toward a wholesale craft warehouse. Since 1963 the guild had collected orders every spring for the Virginia Skyline Company's shops, and since 1964 Bob Gray had been urging the guild to move more into wholesale marketing. In 1966, the prestigious New York retailer Georg Jensen decided to sponsor a sales exhibition of Appalachian crafts. Jensen buyers traveled across Appalachia placing orders, but the bulk of the work wound up being shipped from Asheville.

The New York *Times* announced the Jensen exhibit and quoted Bob Gray on the economics of some mountain crafts: "Pearl Bowling of Blaine, Tennessee, estimates that she makes thirty cents an hour for her cornhusk dolls, which take her an entire day to make."[15] Ten days later, the *Times* was to spotlight some more profitable-sounding craft operations. In an article titled "Appalachia Is Creating New Taxpayers," bylined from Parkersburg, West Virginia, Robert Wright reported on Iron Mountain Stoneware and other craft and economic development projects which were creating jobs and supplemental income.[16] Looking back today, it is obvious that neither Wright's optimistic predictions nor Pearl Bowling's thirty-cent wage was entirely accurate. Many of the new taxpayers became ex-taxpayers when the federal funding ended, and Pearl's "entire day" of working on a doll probably included the time she took to cook three meals, split firewood, carry water, build a fence, maintain her house, and keep up with all her other chores.

We were to continue supplying crafts to Georg Jensen—baskets, dulcimers, cornshuck dolls, birdhouses, brooms, and carvings—for several more years, and a second New York outlet, Brentano's, was soon added. Selling to the New York stores

brought back memories of the guild's own big-city retailing experiences, but this time around the guild was simply the supplier, with no long-distance management responsibilities, an arrangement that seemed to work much better by presenting smaller risks. Then as now, collecting payment due was the toughest job when dealing with a large national retailer.

In the midst of progress there came a shock. On May 13, 1967, an era of the Southern Highland Handicraft Guild's history ended. Gentle, funny, loving Clementine Douglas—who had coordinated the change of Allanstand to a guild shop, who had helped set the Southern Highlanders' marketing operation, who since 1924 had been a leader in the regional movement—was killed in an auto accident.[17] Clem was seventy-four and had been vivacious as ever just a few days earlier when she and I had discussed my interest in the guild's early history and the possibilities of our working together to better document the past and write this book.

But my work at the time was to shift more to the future. Even in 1966, we were crowded at the Guild Crafts building. Alan Ashe had joined the staff as full-time comptroller, meaning that now five of us shared three small offices. Downstairs, wholesale distribution and such space-consuming projects as meetings of the Standards Committee, collection of fair supplies, and whatever other projects happened to be underway jammed the facility to overflowing.

Our sales were booming. In 1966 the Gatlinburg fair sales broke the $50,000 barrier and then went to $60,000 in 1967.[18] Asheville fair totals were lower, but the percentage increases were very similar. Shop sales in 1967 were over $370,000, and Bob Gray—at the 1967 annual meeting—"projected" the total market for Appalachian crafts at over $10 million. Already we were buying and reselling almost the entire production of craftspeople such as Charlotte Tracy, Josie Revis, B. S. Gilliland, Edsel Martin, and Jim

Sheppard. We simply ran out of room to work, and in June 1968, the guild's board of trustees approved the expenditure of up to $60,000 to buy or build a new office-warehouse facility.[19]

We found an almost-new metal building with eight thousand square feet of space (used originally to service fire extinguishers) in Oteen, North Carolina, and the purchase was approved in July.[20] Building renovations were of the shoestring variety; efforts by staff and volunteers converted the raw metal building into a fairly warm center for guild operations. We finished renovating the new Guild Center building in time for an April 1969 dedication, and our warehouse finally had a home. We hired Joe Patelidas away from the Asheville Auditorium when the warehouse operation got too big for just me.

The pioneering guild warehouse helped again verify that the relationship between crafts producers and retailers has never been the stable, cut-and-dried affair common to most business applications, as Allen Eaton implied in 1937 when he wrote that "it seems very doubtful that the regular channels of trade organized to respond to mass production can be utilized to market handicrafts to any great extent."[21]

Craft buyers, those who would resell in their own shops, have always found ways to purchase Appalachian crafts. Trips through Kentucky, West Virginia, Tennessee, and North Carolina were the common method, fact-finding missions with the intent of locating and making personal contact with the craftspeople who might or might not ship the order. The craft fairs have always been a prime target for wholesale. Enterprising shop owners have always worked through the crowds to place orders and even to pick up what was left at closing time. David Brooks from Appalachian Spring in Washington, D.C., and buyers from the Smithsonian Shops were early wholesale customers at the Southern Highland Guild Fairs, and David still is an excellent, educating buyer. The retail fairs are still an excellent source for much work,

especially the unusual and limited-production items that don't show up at the national craft wholesale markets in Atlantic City or Baltimore. Most Appalachian craft producers don't go to trade shows; you're more likely to find Berea College and Churchill Weavers than many of the individuals. The growing shop demand for crafts was sure to lead to efforts to supply the demand, and each decade offered a solution.

We had two reasons for opening the guild warehouse in 1968. One was the obvious customer demand, the ready market which we hoped would pay the bills, and the other, to me more pressing, was to create a market during the "off" season for craftspeople in dire need of income. We used up the guild's cash reserves and borrowed funds to buy during January and February; then we resold the work during the summer months. We were also a central supply for our own four retail stores, a move that freed each outlet from the need to maintain large inventories and amounts of cash for purchasing.

A West Coast shop opened by the former vice-chancellor of the University of Tennessee gave the new warehouse a good send-off with an initial purchase of almost $15,000, work collected and loaded onto a rented truck for the trip to California. The guild warehouse was to be closed, long after my departure, and the reasons were basic. The guild worked on only a 15 percent markup margin, by no means enough, and even that small charge was not passed on to guild-operated stores. The math is simple. An operating loss was inevitable, and the politics of the membership organization doomed the effort. Deciding just whose work to carry in the warehouse was a touchy effort, sure to cause some resentment in a membership organization. But the short-term warehouse did help create a better buyer-supplier situation and move the wholesale marketplace forward.

While we had been planning the warehouse in Asheville during 1967, other programs in other states had also expanded rap-

idly. In Kentucky, faced with the impending loss of state funding for the Guild Train, the Kentucky Guild of Artists and Craftsmen decided to stage a major craft fair, an upscale version of a smaller event which had been held in Berea since 1960. Berea College graduate Richard Bellando was hired as the guild's first director, and the first KGAC Fair was presented May 18 to 20, 1967, on the grounds of Berea College's Indian Fort Theater.[22]

That first Kentucky Guild Fair drew about five thousand visitors, posted sales of over $6,000, and, as seems inevitable, was hit by a severe thunderstorm. Above all, forced by the loss of state funding to become self-sufficient, the guild used the fair as a springboard to financial survival. A later secondary impact of the fair was to help draw the craftspeople to Berea who today have established a thriving marketplace. The quality of that first fair, pretty much open to all, was uneven, and in 1971 I was to have to deal with the necessary, unpleasant rejurying process.

The Kentucky Guild Fairs were an immediate success with the public, and 1968 marked the appearance of the colorful trademark striped canopies which added color and provided—once occupied by a resourceful artist with lots of plastic and Civil War battlefield ingenuity—surprisingly weatherproof shelter.

In 1968 the guild officially dropped the Guild Train, posted fair sales of $12,145, and then added $2,407 in sales during a Holiday Market in Lexington during December.[23] That early market was to encourage the guild in its subsequent opening of the new Guild Gallery in 1970.

Another event that began in 1967 was the Smithsonian Institution's Festival of American Folklife, which made its debut in July. Among the Appalachian craftspeople participating were Southern Highland Guild members Bea Hensley, Edd Presnell, and Golda Porter. The festival was to then switch to its system of featuring individual states.

In 1976 it would be reported that "in 1967 Alice M. Kaplan and

Roy Moyer of the American Federation of the Arts conceived the idea that outstanding designers could provide imaginative styling to the traditional crafts of Appalachia."[24] Actually, Kaplan and Moyer "conceived" the idea about thirty years after others had considered the very same approach, but this 1967 conception, unfortunately, gave us "Handex." There was a pilot study, technical assistance from Tennessee woodworker Don Ward, and designs from New York architect-designer William Katzenback. A five-year program was eventually financed, in 1970, by the Social Rehabilitation Bureau of the Department of Health, Education, and Welfare, and a New York showroom opened in 1971. "Some," according to the same 1976 article, "envisioned a self-supporting program at the end of five years, which would perhaps employ two thousand people or more in twenty or more workshops in the Appalachian area."[25]

Handex attempted to gather Appalachian crafts producers together in an overly ambitious production and marketing effort. The initial concept was for large orders to be secured and divided up among the region's many craft centers for production. That idea went nowhere. Ten different groups would produce ten different versions of the same item at ten different quality and price levels. Undaunted, Handex came back with the approach that designs would be provided to the craft centers for production. That *might* have worked a little better, had there been a decent designer involved. As it turned out, Handex wound up making furniture from wormy chestnut and barn siding, and eventually turned the whole project over to Berea College.

There are still a few splintered samples of Handex furniture around, living proof that a designer unfamiliar with the characteristics of dead, dry, worm-eaten wood shouldn't create furniture. Wormy chestnut, while beautiful to many, is too brittle to be used in load-carrying capacities. While Berea did sell the Handex line for several years, most production was done off-campus, and

the idea was essentially shelved when the free supply of wood ran out.

In the spring of 1968 the Southern Highland Handicraft Guild held its annual meeting in Cedar Lakes, West Virginia, site of the Mountain State Art and Craft Fair. Distance and poor highways cut down on attendance, and mostly I recall the fantastic food served and the two hours Carl Little spent trying to hire me to work in West Virginia's craft program. Such offers were plentiful. Inexperienced as I was, I was one of the few people around in 1968 with any experience at all in craft administration, and that fact drew job queries from Tennessee, Kentucky, and even nearby in North Carolina.

In 1968, in addition to our work on the new warehouse-office complex, we added Tom Gilmartin to the staff as education director, a position that had been vacant since 1963. Tom's duties were to range from exhibits to workshops to writing a column for *Highland Highlights*, and his flamboyant style quickly earned him both friends and critics. I welcomed the new life Tom brought as a younger co-worker with a daring if undisciplined approach, and Tom fit immediately into a small and hardworking staff.

We *were* working. The fairs, the shops, and the guild's visibility increased in volume almost daily. From just $45,000 in 1965, sales at the Gatlinburg fair jumped to over $100,000 in 1969. The Asheville fair's sales grew from 1960's $22,000 to over $45,000 in 1969. In our warehouse we were stocking and selling the works of members such as Ron Propst (then a resident at Penland), Ed Brinkman, Bascom McClure, Flossie Perisho, Eric Picker, the Village Craft Shop, Charles Counts, Fred G. Smith, and many more. The ease of central supply to our own retail made it simpler for many members to deliver in bulk to the warehouse and let us stock the retail outlets.

From the warehouse we also coordinated other programs. Joe Patelidas took over much of the extensive fair preparation, and

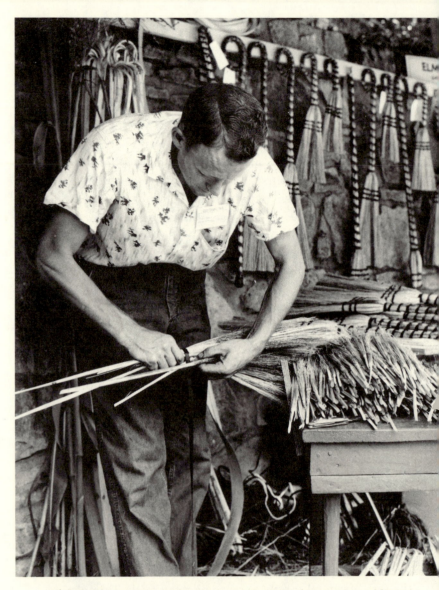

18. Omah Kear of Gatlinburg demonstrates broom-making during a late 1960s fair in Gatlinburg. Kear's Broom Shop is now well into the third generation of the Kear family. Photo by Edward DuPuy, used with permission of the Southern Highland Handicraft Guild.

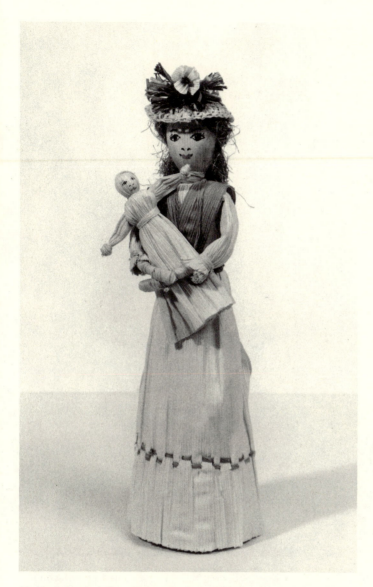

19. Cornshuck doll artistry at its finest, by Mae DesChamps of
Swanannoa, N.C. Mrs. DesChamps was the oldest of the famed Ritchie
sisters of Viper, Ky.; folksinger Jean Ritchie is perhaps the best known,
but three other sisters did shuck dolls similar to the one pictured. Photo
by Edward DuPuy, used with permission of the Southern Highland
Handicraft Guild.

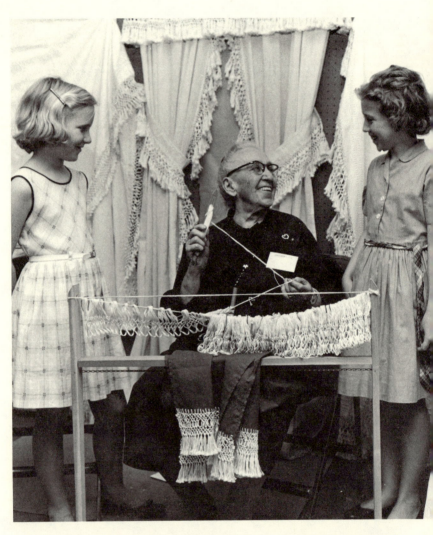

20. Mrs. Carrie G. Hodges of Boone, N.C., demonstrated knotting and fringing during the guild's 1969 fair in Asheville. Photo by Edward DuPuy, used with permission of the Southern Highland Handicraft Guild.

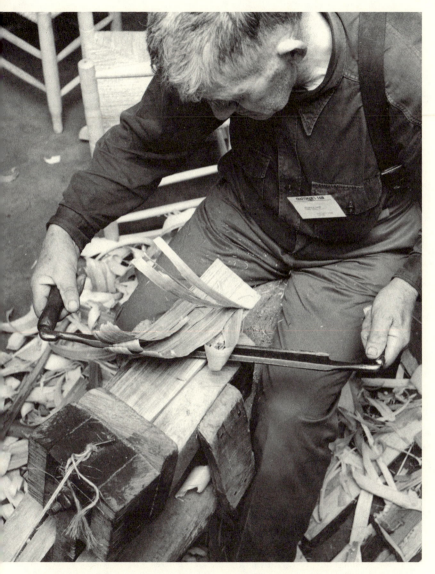

21. Shadrack "Birdie" Mace demonstrated chairmaking at the Asheville guild fairs of the 1950s and 1960s. Mr. Mace, shown here with his drawknife and horse, never traveled outside Madison and Buncombe counties, N.C., during his lifetime. Photo by Edward DuPuy, used with permission of the Southern Highland Handicraft Guild.

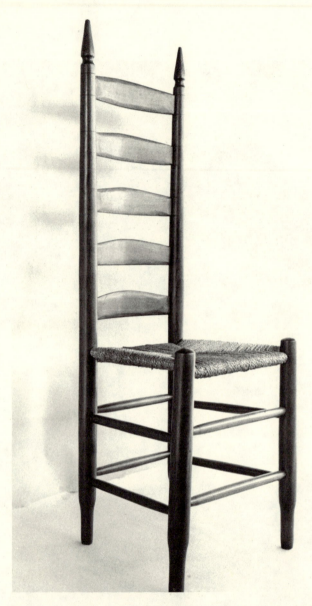

22. A Mace family walnut ladderback chair. The chairs were usually left unfinished, to be worn smooth by use, and had seats handwoven from cornshuck or seagrass by Pauline Keith, Shadrack Mace's daughter. Photo by Edward DuPuy, used with permission of the Southern Highland Handicraft Guild.

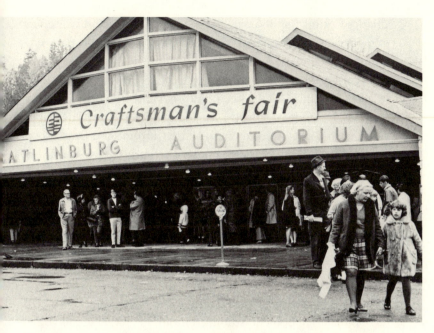

23. Entrance to the 1969 Craftsman's Fair in Gatlinburg. The Gatlinburg fairs, by then drawing thirty thousand visitors in five days, were the best markets of the era. Photo by Edward DuPuy, used with permission of the Southern Highland Handicraft Guild.

supplies were stored in the new building. Bulk purchase of gift and shipping boxes was made easier now that there was storage space, and the open second floor was a workplace for meetings and workshops.

For one workshop we borrowed six looms from Penland School, naively assuming, since all six were the same brand and same size, that the parts were interchangeable. They were not. I did not bother to label the pieces when they were dismantled for transport, and so I spent three frustrating days putting the looms back together. Still, the new building was a crucial factor in the growth of the guild, though we did get an uneasy warning from

Charles Counts that too much of the money and effort was going into space and equipment for staff and too little into new programs for members.

Other regional craft efforts were experiencing similar growth. In West Virginia, Kentucky, Tennessee, and in North Carolina, the massive federal effort was taking effect. The Blue Ridge Hearthside Crafts Association in North Carolina and Grass Roots Craftsmen in Kentucky are among the surviving examples of programs born during the War on Poverty, though current levels of operation in both places reflect the loss of funding.

Also in 1968, Jerry Workman—last director of the Kentucky Guild Train, now working for the Save the Children Federation—led his first workshops for crafts producers who would soon become Appalachian Fireside Crafts. In Tennessee, the Foothills Craft Guild started in 1968 in Oak Ridge.

I do not even attempt to fully cover the work of the OEO, EDA (Economic Development Administration), VISTA, ARC, and other initialed entities of the era. It was a time of high excitement in Appalachia, the debut of high-riding International Harvester Scouts and the IBM typewriter, well-meaning but often misguided volunteers, so much funding that nobody could really keep track of it all, and hundreds of craft projects based on the theory that sixteen weeks was plenty of time to train a self-supporting crafts producer and that "handmade" and "homemade" were interchangeable marketplace terms. I have not yet seen a government marketing effort that dared place the emphasis on quality instead of numbers (read "votes"), and the lack of standards killed off most such efforts early.

My late-sixties involvement in federal craft programs was minor. Bob Gray frowned on his staff members doing the lucrative hundred-dollars-per-day consulting the agencies wanted (and really needed, to be frank), and I was wondering, deep down, if any of the frantic effort was going to do any lasting good.

24. Ed and Judy Brinkman of Burnsville, N.C., examine one of Ed's porcelain clocks. Judy is a weaver; the Brinkmans directed the Kentucky Guild Train before opening their studio. Staff photo, used with permission of the Southern Highland Handicraft Guild.

I was at Fontana Village in North Carolina the week following the fateful Council of the Southern Mountains meeting when the "poor people" took over and forever changed the once-respected organization. Major Fetch, the Fontana manager, was fretting over the broken windowpanes some excited conferees had left behind and his having nobody there who could cut new glass. I spent the afternoon cutting out windowpanes, a handy skill left over from my lumberyard days, so we could have the guild's annual meeting as scheduled.

One constant of the world of craft administration is the jack-of-all-trades demand for such diverse skills as carpentry, photography, computer operation, writing, auto maintenance, accounting, public relations, graphic design, packaging, and politics. Few craft organizations can afford specialists, or even support staff, so directors and managers often wind up lifting boxes, sweeping floors, and trying to balance the ledgers.

During the late sixties a small group of craft leaders came to Berea for a combination of design workshops and an on-campus evaluation (requested by Berea College) of the Student Craft Industries. While Bob Gray, Flo Petit, and the others were busy teaching, I had my first-ever meeting with Eleanor Churchill, a long interview where I sat spellbound as this petite, elegant woman told me how she and Carroll Churchill came to Berea and started Churchill Weavers. They succeeded in marketing, said Mrs. Churchill, because she was too ignorant to know better than to march into a New York department store with an armload of samples and—usually—walk out with an order.

The Churchills and their new-fangled looms were eyed suspiciously by the craftspeople of the 1920s, and the businesslike operation brought local accusations of sweatshop labor. But over the past sixty years most Churchill Weavers employees have been loyal, long-term workers, a direct contradiction to any charge of problems with worker relations. Mrs. Churchill, a staunch Re-

publican opposed to any government intervention in business, *did* resent wage and hour laws, unemployment insurance, and all other state and federal controls, firmly believing that government regulations had—by the late sixties—destroyed the possibilities for private business development such as Churchill Weavers.

Mrs. Churchill was to talk at length, over the years I knew her, about the difficulty of being both business executive and mother. This strong, gracious woman could more than hold her own with the best of businessmen and politicians, and—though we came from vastly different worlds and viewed politics from extreme opposite directions—Eleanor Churchill and I became close friends. She was one of the few people who felt free to call me at 5:00 A.M.; she knew I'd be up and working and that I always wanted to hear what she had to say.

Incidentally, the evaluation and recommendations for change in Berea's craft industries done that week were essentially shoved into a desk drawer and pulled out in fragments, usually out of context, for several years. We have, since 1985, implemented much of what was recommended in 1969.

Throughout my five years with the Southern Highland Handicraft Guild, I was getting a thorough, practical education in graphics and printing from Hugh Bailey and the accommodating, chuckling staff of the Gilbert Printing Company in Asheville. Hugh and I collaborated on ten sets of Craftsman's Fair promotional materials. I wrote the copy, Hugh did the graphics and layout, and Gilbert did the printing. Hugh redesigned the guild logo originally prepared by Clem Douglas and implemented its use on letterhead, signs, business cards, invoices, truck doors, invoices, newsletters, and anything else we used. Hugh sort of got paid for his work; one memorable invoice we received said simply, "The wolf's at the door. Send $200."

Hugh, a native of the Virginia mountains and an avid old-time music fan, was also on the board of trustees of the guild during

the period. After one meeting long on aesthetic, cerebral deliberations, Hugh looked at me in the parking lot and laughed. "You and me," he grinned, "were the only two real Appalachians in that room." Hugh was essentially correct, joking about our accents and appearances, poking gentle fun at those who tended to forget that the guild had been created to serve mountain people.

Bob Gray and the guild's board of trustees saw to it that I participated in regional and national craft events. During the American Crafts Council/Southeast workshops in 1968, Charles Counts guided a two-car caravan (with guest instructor Paul Soldner in one) on a folk potters' tour of North Georgia. We visited, among others, Cheever Meaders, where all the potters threw a pot while I crawled back into the groundhog kiln to snap a picture of Meaders's pots being fired.

I went to Albuquerque and Santa Fe for the American Crafts Council National Conference, and my first meeting with many of the nation's craftspeople was a revelation. But most of my travel was much closer to home: Cherokee, Gatlinburg, Milton, Roanoke, Hickory, Berea, Knoxville, Kingsport, Bybee, Brasstown, Banner Elk, Bean Station. The big Chevrolet van had a V-8 engine, super-strong suspension, and the toughest tires available. For three years, at least once a month, I went to Louisville. To miss the school buses on the mountains I'd leave at three in the morning, follow U.S. 25 up through Tennessee and Kentucky, unload at Guild Gallery in Louisville, then cut back to Bybee to help pack pots still hot from the kiln and then on to Berea to carry skittles games down the fire escape. When we moved the Guild Gallery to Bristol, I drove the big truck, helped set the shop up, then mixed champagne punch for the opening reception.

But times, and people, change. I was then, and am now, a Kentuckian to the core. Though officially in line to become the guild's director someday, I chose to come home. Berea College provided the means. In June 1970, after some lengthy revisions of

my job description, I accepted a job as manager of the college's retail shops. Part of what interested me at Berea was the apparent new direction; Wally Hyleck was already there, starting the Ceramic Apprenticeship Program, and new craftspeople hired to start at the beginning of the 1970 school year were potter Jim Cantrell and weaver Astra Strobel.

I announced my decision to the guild's board of trustees the day before Bob Gray was injured in an auto accident on the opening day of the Asheville fair. I spent my last month with the guild acting as director, then moved to Berea in August of 1970.

7.

1970–1975

Glory Years, Growing Years

The over forty years of intense effort by people such as Allen Eaton, Olive Dame Campbell, Clem Douglas, Marian Heard, O. J. Mattil, Louise Pitman, Helen Dingman, Smith Ross, and the many others who gave so selflessly bore fruit in the decade of the seventies. The Appalachian craft world took the momentum of the late sixties and kept on going, growing, working, selling, organizing, educating, communicating, and constantly expanding. The seventies were the glory years, times when things were changing so fast and the market growing so rapidly that it was hard to remember the more moderate era of just a few years before.

State arts councils, the National Endowment for the Arts, the Appalachian Regional Commission, museums, galleries, and private entrepreneurs gave full acceptance to the crafts. The Tennessee Valley Authority reentered the craft world, the General Services Administration was to become a customer, and we were all—to take Ed Davis's words from 1948—"riding high."

I came back to Berea on September 1, 1970, with a newborn daughter and work habits based on five years of quick, firm decisions and aggressive, immediate results, and was not prepared to deal with Berea College's ponderous institutional system. My 1970 job at Berea was, on paper, very similar to my current position—to run two retail shops and the mail-order program, develop new products and new projects, and work with

regional craft organizations such as the Southern Highland Handicraft Guild and the Kentucky and West Virginia guilds, to be part of what appeared to be a promising new effort which brought Jim Cantrell to Berea as the first resident potter and the bold Astra Strobel to revive fireside weaving.

Robert Fleming, manager of the Student Craft Industries at the time, was a hardworking man unfamiliar with the craft world. And, it seemed in 1970, what Berea College really wanted me to do, despite the glamorous new job description, was to be simply an in-house shop manager. This was the era when Berea was shutting down its Candy Kitchen, bakery, creamery, and greenhouses, a series of decisions that seemed correct at the time but now appear to have been hasty.

I went back to the Southern Highland Handicraft Guild's Gatlinburg fair in October, this time in an eight-by-fifteen-foot sales booth, and for the first time got a taste of the exhibitors' viewpoint. Watching thirty-five thousand people struggle past your display, spending five twelve-hour days confined to a tiny corner, is not a vacation in the Great Smoky Mountains.

Back in Berea, the Kentucky Guild of Artists and Craftsmen was working, with an initial grant of $6,780 from the Public Welfare Foundation, to open a new Guild Gallery in Lexington.[1] After the opening reception, Richard Bellando resigned effective December 31 as guild director, and the guild promptly offered me the job. After meeting with Karl Warming, then business vice-president of Berea College, to discuss the situation, the job offer, and my feeling that my work at the college was less than had been promised, I resigned in late December and became executive director of the Kentucky Guild of Artists and Craftsmen on March 1, 1971.

A few months later, Berea College's new personnel director, Ray Wilhoit, came to my office to ask for help in convincing

President Willis D. Weatherford, Jr., to hire H. E. "Gene" Bowers as manager of the Berea College Student Craft Industries. Dr. Weatherford was worried that Gene's industrial background would prevent effective communication with the craftspeople, but we were able to convince him that Gene's record of making good use of young people and his sensitivity to all people would serve him well. Gene Bowers was to direct the Student Craft Industries through a decade of solid work, which included adding a wrought iron industry, developing the Ceramic Apprenticeship Program, adding a lapidary program, and maintaining financial stability.

During this period, Berea's Ceramic Apprenticeship Program was developing into a solid project directed by Walter Hyleck. John Eden followed Jim Cantrell in the resident potter position, and out of the early classes came such studio potters as Sarah Culbreth, Philip Hoyt Childers, and Teresa Deaver. Hyleck described the program: "The close relationship between student and master [teacher] is intended to generate more than an understanding of technique. Books contain literal descriptions of technique, but only the man and his object can communicate the intensity of the creative act."[2]

Inadvertently, Berea College speeded up the development of other retail operations in Berea. Through 1970 the college's Log House Sales Room had been the primary outlet for Rude Osolnik's woodturnings, but some administrators saw the presence of Osolnik's work as unfair competition and wanted it removed. Osolnik's prompt response was to proceed with plans he already had to build the Benchmark Gallery near the new interstate highway. Like many other mountain roadways, I-75 has had a major impact on Appalachia, and one direct effect has been the expanded craft market. In 1970 Don and Nancy Graham were building their Appalachian Arts and Crafts Shop from meager

beginnings in the old Council of the Southern Mountains Book-
store; Warren and Frankye May were looking to Berea as a site
for a woodshop and looking at purchasing the Upstairs Gallery
(already open but in other hands); and much more activity was to
come shortly.

My new job began with the Kentucky Guild Fair just ten weeks
away and no work done to prepare for it. During my first guild
board meeting I supported a proposal to rejury members during
the fair, a difficult but necessary action if the young guild was to
be taken seriously as a quality organization. Basically, my direc-
tions from the trustees were to coordinate the fair, keep an eye on
Guild Gallery, and do whatever else it is that a guild director is
supposed to do.

The "whatever" could be viewed many ways. The late Eugene
Joseph, then manager of Berea College Woodcraft and designer
for the Student Craft Industries, offered me some very astute
advice on that issue. Joseph said, essentially: "You can put on the
fair, check on the gallery occasionally, and sit on your behind the
rest of the time. They won't fire you if you show up for board
meetings. Or, you can stick out your neck and try to make the
guild come alive, grow, and become a truly statewide organiza-
tion. That'll make people mad, though. They don't like changes
or threats. The choice is yours, because nobody will ever get
around to telling you what to do."

Obviously, I chose to not sit around. A new—to me—aspect of
the Kentucky Guild was that it was an organization of *artists* and
craftspeople. That fact was a mixed blessing. The painters,
printmakers, and sculptors added life and variety to fairs, exhib-
its, and showrooms, but they added problems to marketing and
member services. The needs and markets of artists are very dif-
ferent from those of production woodworkers and potters. And,
though Kentucky has always been blessed with many superb

craftspeople, there were, and are, very few professional-level artists.

Early in 1970 I was meeting new leaders—including Jim Foose, Richard Jackson, Wallace Kelly, Clara Eagle, Emily Wolfson, Jane Samples, and Fred Shepard—as well as working with old friends from my Asheville years: Smith Ross, Jerry Workman, Walter Lee Cornelison, Eleanor Churchill, Dorothy Brockman, Trudy Thompson, and others. It was obvious then that the Kentucky Guild was split into small power groups: Berea, Louisville, and Murray were the clusters of influence, and one task that needed doing was to break down the cliques and foster statewide cooperation. The Murray State University members, maybe because they were so isolated, were the most professional of the clusters. In Louisville, Jane Samples was one of the leaders, and after some rocky beginnings, Jane and I became close friends. From my first day I fought the "another Berea boy" tag one member so casually applied to me, and I worked to remove the "Berea Guild" perception of the organization. One reality never accepted by many guild members and still a sore point is that Berea is, hands down, Kentucky's best craft marketplace. From my first days on the job I fought off attempts to relocate the guild fair and offices to other cities and, for almost ten years, fought to keep the guild's production members and centers as a valid part of the organization.

But, in early 1971, a bigger worry was the upcoming fair. Maggie Rifai was already working for the guild, and our offices were a tiny second-floor room. We finally located the tents, got out some late publicity, and went to Indian Fort Theater to stage a fair. Woodcarver Virginia Petty, a new member in 1971 who'd never participated in a craft show of any kind, still chuckles about her mild horror when she discovered that I'd never even *been to* a Kentucky Guild Fair, much less been in charge of one. Andy Smith, then a Berea College student, rounded up a crew of

workers who were to share ten years of sweaty labor, close friendship, fun, and bonds which still are strong. We erected forty-five tents; hauled in loads of boards, cement blocks, and old shipping pallets for display props; strung electricity from the tree limbs; set up a Members' Exhibit; and had it all ready before any exhibitors arrived.

A 1970s Kentucky Guild Fair was most like Miss Fannie Mennen's Plum Nelly Clothesline Art Show, which used to draw thousands of visitors to Lookout Mountain, "plum" out of Tennessee and "nelly" out of Georgia. The Plum Nelly shows, started in 1948 and continued for over twenty-five years until Miss Fannie decided to quit because of the traffic and the commercialism of her neighbors, helped establish a group of art and craft professionals and even led to a shop by the same name in Chattanooga. Like Miss Fannie's shows, the guild fairs created an arty, casual, colorful outdoor atmosphere of creative energy.

At 9:50 A.M. of opening day, 1971, the Kentucky Guild Fair was gorgeous. At 9:55 A.M. the cold rain came. We spent the next four days shivering around open fires and—to my surprise—greeting thousands of visitors. Ours were very loyal, very determined customers. Any show administrator who hasn't worked outdoors has not experienced true agony. To worry, to watch the best-laid plans and a year's worth of hard work get washed away, to dig trenches and avoid wet electrical outlets, is to live a precarious and unsettling existence. I was to survive—between the guild fairs and the Berea Craft Festival—twenty-two shows at Indian Fort, fifteen years of wondering when somebody was going to be killed by a bolt of lightening or a falling tree, or when a tornado was going to come through and execute mass mayhem.

But, when the sun is shining, the birds are singing, the guitars are ringing, and the corn mill is grinding, Indian Fort Theater is the world's most perfect craft fair backdrop.

By the end of 1971, I had told eight guild members that their membership rights had been revoked during the spring fair; staged a very unsuccessful Cave Country Fair in Cave City; replaced the Guild Gallery manager; initiated the first craft organization membership health insurance program in the nation; and revived *The Guild Record*, the newsletter first published in 1961. Then, as now, anxious craftspeople commented on my calm during the hectic activity. That was, and is, a surface calm; I prepare as well as is possible, expect the worst, and work twenty hours a day to make it look casual and easy.

During the winter of 1971–72, Jerry Workman and I met with the Cincinnati Junior League, sponsors of the new Appalachian Festival in Cincinnati, Ohio, to plan a cooperative Kentucky Guild–Southern Highland Guild–West Virginia Guild exhibit for the 1972 festival. During the years it was run by the Junior League, the Cincinnati Appalachian Festival ranked second only to the Southern Highland Handicraft Guild Fairs as a market for Appalachian crafts. Later, turned over to different management, the festival slumped into mediocrity. But the cooperative exhibit came about in 1972, one of the still-rare examples of such interagency cooperation. Joe Patelidas brought up the Southern Highland Guild work, Don Page came from West Virginia to help with the setup, and the festival was a huge success.

In 1972, my first full year as Kentucky Guild director, Jim Edgy and the Kentucky Arts Commission provided $5,000 for a traveling exhibit of works that were purchased from, not borrowed from, guild members. Tom Gilmartin and Cindy Bringle came to select the show during the 1972 fair, and parts of that initial collection are still in use in Arts Council programs. Later in the year another significant grant was approved, $10,000 from Governor Wendell Ford's contingency funds, essentially a reimbursement for services the guild provided on behalf of the state

and a precedent that other governors followed.

The Guild Gallery in Lexington was going strong, showing a profit even though it was still supported by funding from the Public Welfare Foundation, which paid the rent through early 1973. Sales figures for the early seventies show a steady increase. In 1971 we sold $43,838; the 1972 total was $52,811; 1973 was $63,731; and 1974 sales reached $73,121. The 1974 Kentucky Guild Fair posted sales of $65,913, up $10,000 over 1973.[3] In 1974 Berea College reopened the outdoor drama *Wilderness Road*, a positive tourism factor for the city but a logistical problem for the guild fairs. We had to use Indian Fort Theater during the massive renovations, then worry about possible damages to the facility for the next four years.

Always, we battled the heavy May rains. Sometimes they came and lasted for all four days; we survived with plastic, trenches, coffee, and lots of customer support. After one particularly soggy fair, we went out on Monday morning to face a jumble of wet sawdust and hay bales, twisted boards and broken cement blocks half-buried in the mud, ruts, wet paper, and a sewerlike smell being percolated by ironic bright sunshine. The director of *Wilderness Road* was there too, dismayed, and did not think it funny when I suggested that—since *Wilderness Road* was a Civil War drama—we simply leave the grounds the way they were, shoot a few mules to add realism, and call the place a battlefield. Somehow, as always, we had it all cleaned up before graduation on Sunday.

When shy, creative Martha Nelson first brought her "real babies" to a Kentucky Guild Fair, none of us knew we were witnessing the beginnings of a 1980s marketplace explosion. The "Cabbage Patch" dolls, which became a national rage, evolved from Martha's one-of-a-kind creations.

Martha Nelson not only conceived the "Cabbage Patch" doll,

she also created the marketing ploy which was to be so success-
fully used by Xavier Roberts. Each of Martha's babies came with
"papers," a name, and personal history; customers "adopted"
their babies. Georgia entrepreneur Xavier Roberts first saw
Martha's babies at the guild fair in Berea and tried to get her to go
into business with him. She refused, not wanting to see her indi-
vidual artwork turned over to mass manufacture. Roberts did it
anyway, and we all know the eventual result in the marketplace.
When I wrote Roberts (at Martha's request) to protest his use of
her designs and concepts, the response was a rapid, threatening
letter from Roberts's attorney who warned me that *I* would be
sued if I said more. Roberts was willing to pay royalties to Martha
Nelson, but she wanted the whole thing stopped. The courtroom
battle lasted for almost a decade and ended in an undisclosed
out-of-court settlement.

A "Cabbage Patch" predecessor, "Nettie," sits watching me
write, a wry reminder that the most successful ever craft-to-com-
merce transition was totally unwanted by the original artist.

Near Berea, projects like Possum Trot, the Job Start expansion
of a Jackson County craft group previously known as "Mountain
Toymakers," were going strong. Possum Trot's stuffed toys were
superb, clever, and—ultimately—too expensive and limited in
marketability to support a factory volume. The Possum Trot facil-
ity became a Laura Ashley factory for sewing children's clothing,
which closed in 1990.

In Berea and elsewhere, the Christian Appalachian Project was
trying to sponsor a successful craft project. They sold natural
Christmas wreaths, still their most enduring product, and funded
a woodworking shop in Mt. Vernon, but nothing was to really
make it until a 1980s broom factory. Another expensive Kentucky
project, funded by Governor Louis Nunn through the Kentucky
Office of Economic Opportunity, was grandly labeled the "Ken-

tucky Design Center." Nunn approved the funding during his final days in office despite objections from many in the craft community. Eleanor Churchill and I met with the finance commissioner and were assured that the project had no chance of being approved; then a few weeks later we read about the grant.

Headquartered in Berea during the early 1970s, the Kentucky Design Center was a very expensive farce, another half-hearted attempt to "upgrade" design by providing worse designs and a stale effort to take advantage of Berea's reputation for quality crafts to market trinkets. One idea with potential was a wholesale buyers market in Berea, but it fell short when the buyers came and there was nothing to buy, and the error was compounded by not telling anyone else in Berea what was happening. Angry buyers came to the Kentucky Guild office to complain, which was our first notice that there was anything happening. Again, politics entered the marketplace and fell woefully short.

Lynn Frazier, a former Nunn staff member who'd masterminded the Kentucky Design Center funding, was now working to use more state and federal funds to start Stanton Woodcraft, a major wood operation which was to last into the early 1980s before going under when the federal Co-op Bank foreclosed. Frazier, above all else a survivor, somehow found backing to repurchase some of the Stanton machinery and moved to Berea. He opened Chestnut Street Gallery in Berea with a branch in Lexington, then closed the Berea shop and went to Lexington as a full-time retailer. One key to the continued failure of government-funded crafts programs was graphically pointed out when former Grass Roots Craftsmen manager Jim Williamson asked me to be one of the required annual Office of Economic Opportunity evaluators. Grass Roots's funding included plenty of money for consultants, a four-wheel-drive vehicle, and personnel, but not one penny for inventory. Quilts were not made until *after* the

sale. I recommended, not altogether facetiously, that Jim stockpile quilts and carvings and show them on the books as a truck and two or three consultants.

While the Kentucky Guild and the nearby programs in the state were just beginning to grow, the Southern Highland Handicraft Guild was flexing its mature muscles and riding the crest of a sales wave no one would have believed possible just a few years earlier. Sales at the Gatlinburg fair were just over $125,000 in 1970, $160,000 in 1973, and almost $225,000 in 1975.[4] In Asheville, the fair reached almost $70,000 in 1970 and climbed to just under $100,000 by 1975. In 1973 the guild's wholesale warehouse was selling to over one hundred customers in thirty states, and in 1974 the operation had to refuse new customers because orders couldn't be filled. In 1974, total merchandise sales for the guild through two fairs, four shops, and the wholesale warehouse were $869,670, compared to just $285,000 thirteen years earlier in 1961.[5] That 1974 figure, impressive as it was then, pales in comparison to 1987, when the Allanstand Shop alone exceeded the 1974 total numbers by over $100,000. The growth of the guild's markets from 1965 to now is simply astonishing, a sales explosion which I doubt even Allen Eaton would have expected.

In 1973 fiber worker Jim Gentry joined the guild staff as education director and began another active period of workshops, information gathering, and exhibits. That same year the guild inherited over $116,000 from the estate of former member Olive B. Krauthoff to help support educational activities.[6] Also in 1973, a unique new Arts Marketing Program was introduced by Georgia College of Milledgeville, Georgia, including an internship period with the guild.

Unlike previous education directors, Jim Gentry's work was not confined to workshops and exhibitions, though those events were plentiful. Jim also functioned much as an assistant or associ-

ate director, assuming much administrative responsibility. Later Jim's role became even more crucial as Bob Gray's efforts were diverted more into fund-raising.

A Kentucky era ended in 1973 when Eleanor Churchill sold Churchill Weavers. Mrs. Churchill had, for many years, declined offers from potential buyers because she feared none of them would continue the business she and Mr. Churchill had founded in 1922. In a sense, the Churchill facilities and land were worth more than the weaving business, a fact that attracted speculators. But Mrs. Churchill handpicked her successors, Richard and Lila Bellando, and saw her weaving business continue.

In Tennessee, the Arrowmont School was thriving, and director Marian Heard recalled a conversation with Allen Eaton in which she'd lamented the ever-present chenille peacock bedspreads which were sold throughout the mountains. Mr. Eaton's gentle response was that "everybody had to have a thing of beauty and to some people the peacock bedspread was their thing of beauty."[7] Many Tennessee people were working to make "things of beauty," things more acceptable than chenille peacocks, available to the tourists.

The Tennessee Arts Commission's strong crafts program, directed by potter Lewis Snyder, began in 1972 and included, unlike most state art agencies, a staff crafts marketing director. Snyder was also working on a much larger proposal, the Tennessee Craft Center, asking state legislators to fund a school "designed 'to meet the needs of the working craftsperson,' structured along the lines of the apprentice-journeyman-master craftsman approach rather than the university approach."[8] Snyder was to later hastily white-out "Tennessee" and substitute "Appalachian" in his proposal and pull a major, bizarre, and highly controversial $5 million funding coup with the expert assistance of Tennessee Congressman Joe L. Evins.

The Tennessee Artists-Craftsmen's Association was active, sponsoring its first Nashville fair in 1972. Kathy Tate, Roy Overcast, and Sandra Blain were emerging new leaders in the Tennessee effort. Such federally sponsored groups as Cumberland Mountain Crafts near Crossville were already starting to fade.

A new organization of craft groups began in Knoxville in 1974, an outgrowth of the Commission on Religion in Appalachia. Nina and Ben Poage created MATCH (Marketing Appalachia Through the Church) and published the first *Appalachia Handcraft Catalogue*. MATCH was designed to serve low-income groups, not individual craftspeople, with member cooperatives located from Georgia to Pennsylvania.[9] MATCH was soon to move to Berea, change its name to "Marketing Appalachia's Traditional Community Handcrafts," and grow dramatically between 1976 and 1982.

In busy West Virginia, Don Page was "working with three thousand or four thousand West Virginians who were producing crafts."[10] Much of the West Virginia effort went toward fostering production groups such as Cabin Creek Quilts and Mountain Artisans with active, visible support from Governor Jay Rockefeller and his wife Sharon. Dick Schnacke, author of *American Folk Toys*, was selling the work of sixty craftspeople to five hundred stores and sixty major museums.[11]

But Don Page reported changes in the West Virginia culture: "A great number of the traditional craftspeople are passing away, people who did it full-time or for supplemental income or barter. The uniqueness is fading fast because we're homogenizing the world."[12] Page lamented the passing of the old-timers by saying, "The tree shakes a lot of apples."[13] Cheap land, state support, and a ready market drew hundreds of young craftspeople to West Virginia.

Back in Kentucky we were working, exploring, tackling new

ideas and building the market. In 1973 the guild's sales totaled $110,000. That summer, Kentucky was the featured state in the Smithsonian's Festival of American Folklife. Despite Ralph Rinzler's assertion that true folk artists don't work for the marketplace, Susan Brown took a display of Kentucky crafts to Washington, D.C., and reported brisk sales. Also in 1973 we were helping Louisville mortgage banker Rodney Beck prepare his Coffeetrees Gallery and Gift Shop, which was to open in March 1974. Coffeetrees was unique at the time, one of the first nonorganization shops to feature quality work from Kentucky artists and craftspeople. For the next ten years the Becks were to provide a solid outlet for guild members, and they deserve much credit for breaking into the entrepreneurial side of craft marketing.

In October 1973 we presented workshops in Bardstown featuring Budd Stalnecker, Hugh Bailey, and quilters from Appalachian Fireside Crafts (AFC). AFC was growing from a 1968 workshop in making wreaths into a thirteen-county, two-hundred-member craft organization which was to post sales of $140,000 in 1976 from its new $180,000 warehouse–training complex in Booneville, Kentucky.[14] AFC was also making plans, in 1973, to open a new retail shop in Berea in 1976.

I attended the World Crafts Council meetings in Toronto, Canada, in 1974, and in 1975 was asked to jury the Halifax Art Festival in Ormand Beach, Florida, then go on to Miami and judge the Grove House Invitational. In Florida I was to first meet Chicago artist Franz Altschuler and Miami clayworker Roberta Marks, and to begin a series of show judgings which were to take me across much of America—from State College, Pennsylvania, to Oklahoma City, from Kansas City to Atlanta, from New York to Orlando, from Paducah, Kentucky, to Harper's Ferry, West Virginia—as an "expert" on crafts. And, I guess I *was* as much of

an expert as anybody else. In a newspaper interview after judging Florida Craftsmen in 1977, I pointed out to the reporter that the major weakness in that traditional evaluation system was the judge. The reporter thought I was being cute, or modest, but I was serious then and still am.

In 1974–75 we worked with an Atlanta firm to sell over $12,000 worth of guild members' work to the Island Creek Coal Company for their new Lexington corporate headquarters. We agreed to work with a Louisville group to stage the Derbytown Arts and Crafts Fair, which lasted two years at Trevillian Park. During the 1974 annual meeting I presented a proposal for a 1975 Kentucky Guild Fall Fair, a concept which met with mixed response. (The idea was first suggested by Berea service-station owner Bob McMahan, who stopped me after a busy spring fair and asked why we didn't do such a profitable event twice a year.) Finally, approval for the fall fair hinged on at least fifty members signing up to participate. A location other than Berea was suggested, preferably the new Kentucky Horse Park being built in Lexington. The fifty exhibitors were no problem, but construction work at the Horse Park shifted the location back to Berea. The first KGAC Fall Fair, October 3 to 5, 1975, drew nine thousand visitors and posted sales of $35,000.[15] After that strong start, there were few further discussions about another location, and the fall fair is still in Berea.

Further south, two weeks later, the Southern Highland Handicraft Guild was to post five-day sales of almost $225,000, but this high-volume fair was to be the guild's last in Gatlinburg. In what I considered then and still feel was a major error, the guild decided to move the fair to Knoxville starting in 1976. There were, of course, problems in Gatlinburg. Lack of space was a major concern, and the oft-promised construction of an auditorium addition kept being delayed. Ever-greedy Gatlinburg was asking

25. Fran Merritt, *left*, longtime director of the Haystack Mountain School of Crafts in Maine; Garry Barker, center; and Illinois artist Win Jones juried a 1970s Central Pennsylvania Festival of the Arts. Photo from the author's files.

for a month-long fair to draw more tourist dollars, and several special taxes had been enacted just for the fair. The city and the guild, partners since 1948, couldn't agree in 1975, so the guild's fair committee and board of trustees voted to relocate to Knoxville, which boasted a new civic center, was already busy planning for the 1982 World's Fair, and wanted the guild badly enough to offer rent-free facilities.

From the traffic-and-sales viewpoint of craft marketing, five

26. Dorothy Tresner of Asheville made game birds, owls, and other "woods pretties" from pine cones and other materials gathered from the abundant forests. Photo by Alan Ashe, used with permission of the Southern Highland Handicraft Guild.

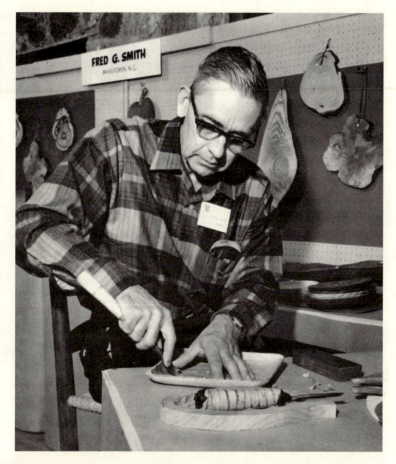

27. Fred G. Smith of Brasstown, N.C., shapes a tray from butternut (white walnut) during a guild fair. Photo by Edward DuPuy, used with permission of the Southern Highland Handicraft Guild.

days in Gatlinburg were probably worth more than five years in Knoxville. Perhaps if a year's profits had been allocated for intensive advertising of the change, the results would have been better, but some decision makers obviously felt that the guild fair was bigger than Gatlinburg. They were to learn quickly just how

28. Spinners at the Craftsman's Fair demonstrate the tall and short of hand-spinning. *Background*, using the smaller flax wheel, is West Virginian Billie Bannerman. Photo used with permission of the Southern Highland Handicraft Guild.

wrong they were, that the fair and Gatlinburg together were the big attraction and that tourists would not come off the highway into Knoxville.

In 1975 Jim Cantrell brought a new concept to the Kentucky Guild's board of trustees. The Eli Lily Foundation in Indianapolis was interested in starting a new magazine about Kentucky and Indiana art and crafts, and wanted us to work on a proposal. I made several trips to Indiana, did research and wrote up a grant

proposal, and was very interested in becoming an editor, but hesitated when Lily asked if I would commit to a five-year involvement. I had doubts, even then, and wavered, but a change of staff at Lily eliminated the interest in funding a magazine or any other craft-related project. The magazine concept was to be picked up later, privately, as *Kentucky Artist and Craftsmen*.

Another national craft magazine did succeed, however. *The Crafts Report*, started in 1974 by Michael Scott, author of *The Crafts Business Encyclopedia*, is the publishing-marketing success of the craft scene. Mike's emphasis has always been on the business of craft, and the more organized, market-oriented Appalachian craft world has fit naturally into the magazine's pages. *The Crafts Report* is also the best 1974-to-now history of the national craft movement. I've written probably fifty articles for Mike since 1974, including a short-lived column on craft administration in 1979, and I continue to rely on *The Crafts Report* as the primary source for information on craft marketing directions.

But the biggest Appalachian craft news of 1975 could be read in any regional newspaper. A power play by U.S. Congressman Joe L. Evins of Tennessee, then chairman of the Publics Works Subcommittee of the House Appropriations Committee, was to directly influence the Appalachian craft world for the next ten years. Evins took Lewis Snyder's Tennessee Craft Center proposal, threw in some pork-barrel highways, and totally bypassed the Appalachian Regional Commission's doctrine that the states, not the U.S. Congress, were to allocate ARC funds.

The Appalachian Regional Commission (ARC) funding bill presented to Congress in 1975 "included $2.5 million for a mountain crafts center somewhere in Appalachia and $4.7 million for the completion of 'long delayed' access roads in East Tennessee and in Tupelo, Mississippi. The Tennessee road was in Congressman Evins's hometown, and it turned out that the Mississippi

highway was in Jamie L. Whitten's congressional district. The Democratic Whitten just happened to be a powerful member of the Appropriations Committee. The arts and crafts center puzzled ARC staffers, as no such request had been submitted. It turned out that Governor Ray Blanton, D.-Tennessee, had asked Evins to 'earmark' funds, hoping that the appropriations would be taken off the top, and thus not taken from Tennessee's slice."[16]

It should be explained here that the Appalachian Regional Commission was a state-federal "partnership" in spending. When ARC divided up its funding, true regional projects were "taken off the top," with the costs shared by all states. The remaining funds were given to individual states for allocation. By getting funds earmarked from the regional appropriation, Tennessee would get its craft center and not have to pay the full cost.

The U.S. Senate, worried that such an opening would lead to numerous other special-interest abuses and aware that funding of a commercial facility was illegal under ARC guidelines, refused the request. "But Bob E. Jones, D.-Alabama, chairman of the House Public Works Committee, came to the rescue. Funds were added for 'the stimulation and development of the indigenous arts and crafts of the region.' The add-on was placed in a section exempt from the prohibition against spending monies in competition with the private sector."[17]

President Gerald Ford signed the ARC appropriations bill into law on New Year's Eve, 1975. By law, $10 million was allocated to the art and crafts program, but also by law $5 million was committed to the Tennessee crafts center. The denial to ARC staff members of any knowledge of the craft proposals left many of us with a wary skepticism of the Appalachian Regional Commission. If the commission's staff was that easy to bypass and deceive on the craft center issue, how well could they be handling the rest of their work? After predictable anger and jealousy at Tennessee's

aggressive funding action, the rest of Appalachia's craft organizations went into a frenzy to lay claim to the remaining $5 million.

As the first half of this tumultuous decade drew to a close, the Appalachian craft world was, in some ways, at its peak. But the coming five years were to bring much more activity, controversy, excitement, and change. What was already a big business was going to get much bigger, and many of us who were involved in the changes were to be ourselves changed.

8.

1976–1979

The Bicentennial, ARC's Craft Centers, "Counterpoint," and Burnout

In 1976 the United States celebrated its two-hundredth birthday with a slam-bang year of patriotic music and fireworks, tall ships, craft fairs at every crossroads, and tall oratory at every opportunity. We had a new president with a familiar soft accent and a vice-president whose wife was a potter. Joan Mondale's support of the craft world was to be a highly visible role, an amplification of Sharon Rockefeller's earlier work in West Virginia and perhaps the inspiration for Phyllis George Brown's Kentucky media blitz five years later.

In Appalachia we were dealing with Tennessee pork-barrel politics and a mad scramble for federal funds, at least for the money left over after the Appalachian Regional Commission gave Tennessee $5 million off the top for a craft center which was not even to be located in Appalachia. The Joe L. Evins Appalachian Craft Center, it turned out, was to be built in Congressman Evins's hometown of Smithville, Tennessee, near the new highway funded by the same appropriations act.

After a busy spring fair in Berea we were working, in 1976, on the Kentucky Guild's effort to dip into the ARC till, a $1 million "Kentucky Craft Center" proposal which was being well received in both Frankfort and Washington. I was at home, recuperating from knee surgery, when the region's craft leaders met in Wash-

ington to protest the Tennessee project, but I recovered in time to meet with the Kentucky Arts Commission's director, Nash Cox, and use Tennessee's funding success as leverage to help create a crafts coordinator slot on the Kentucky staff. Anne Ogden filled the job starting August 1, 1976. The "crafts coordinator" title was later to be discontinued, but the Kentucky Arts Commission's support—and Anne Ogden's quiet, helpful efforts—were to continue to strengthen Kentucky's craft world throughout the seventies and eighties.

Our "Kentucky Craft Center" proposal withered when internal support faded. Even by ARC's generous definition, still only 43 of Kentucky's 120 counties are defined as "Appalachian," and that created problems. ARC funds are restricted to projects serving the specific area. The guild's statewide emphasis led to the board's ultimate decision to drop the effort. After a look at creating a new organization of just Eastern Kentucky crafts producers, I concurred and complied. I do believe our proposal would have been funded, if for no other reason than that Kentucky had enormous clout within the ARC and our state officials were ready to support us. In Frankfort there were a few people who realized that any successful long-term state craft project would likely have to come from the Kentucky Guild or a similar group using quality as a working guideline.

But the Southern Highland Handicraft Guild's Bob Gray had already beaten us all to the punch. Mr. Gray had locked up $1.5 million of ARC's funds to support construction of the new Southern Highland Folk Art Center near Asheville. From "A Proposal to Establish the Southern Highland Folk Art Center" comes this elaborate statement : "Not only will the Center preserve our heritage, but it is through this heritage that contemporary man may experience new ways of seeing beauty and learning new ways in which that beauty may be expressed. . . . In our present age

providing a creative outlet for our people becomes more than fun—it becomes a vital necessity."[1]

Mr. Gray still had to raise another million, a difficult task which would bring him grief, but the cornerstone of the financing was now in place for building the center that had been his dream since 1962. The rest of the ARC money was to go to Georgia, Pennsylvania, Kentucky, and to the Southern Highland Guild—another $75,000 for educational programs. I thought then, and I think now, that ARC's leftover $5 million was much more effectively used than was the off-the-top appropriation that triggered the larger budget. Almost by accident and afterthought, the ARC funded some solid craft projects.

In Georgia, new plans were brewing because of the ARC funding possibility. As Bob Owens reported, "In 1976 three craftsmen from Appalachian Georgia with a record of leadership in the crafts were asked by the Georgia Council for the Arts and Humanities to formulate a grant request from the state of Georgia to the Appalachian Regional Commission."[2] John LaRowe, Charles Counts, and Bob Owens developed the concept, an intense plan for research, documentation, and technical assistance. "In 1978 funding from the ARC and CETA provided program and staff monies to survey the 35 Appalachian Georgia counties in order to identify the needs of craftspeople and to enhance craft production and marketing."[3] The two-year survey, directed first by Tom Gilmartin and later by Sue Ford, was to result in the 1979 publication of *Georgia Crafts/Appalachia*, a 168-page catalog and survey report, plus a supplemental 1980 version of the same catalog, and the creation of an organization called Georgia Mountain Crafts to carry on the effort.

Lewis Snyder's Tennessee success in fund-raising, somewhat ironically, spurred much better communication among regional craft leaders. Possibly, we just all wanted to keep an eye on each

other and the money. In August we gathered in Huntsville, Alabama, to discuss possible programs through the new Federation of Southern States Arts Agencies, and in December, Kentucky Guild President Marie Hochstrasser and I were in Miami to meet with the American Crafts Council Southeast Region (ACC-SE) assembly to seek and get that organization's approval for a major workshop and exhibition program in Kentucky for 1978.

We were also talking to Carole Sedestrom about the new "Winter Market," scheduled for February 1977 in Baltimore, the first major national craft wholesale show, and making plans to participate in the 1977 national gathering of the American Crafts Council in Winston-Salem, North Carolina.

Back home, the Kentucky Guild posted sales of $210,000 for the year, plus a $10,000 grant from Governor Julian M. Carroll's contingency funds and $3,500 from the National Endowment for the Arts to start a new "Designer-Sales" effort.[4] MATCH became MATCH, Inc., and moved to Berea; the Appalachia Shop by MATCH was opened in the Civic Center Shops near Rupp Arena in Lexington. An ambitious five-year plan was underway, soon to have a major impact on Berea and the region.[5]

On June 22, 1976, longtime regional leader O. J. Mattil was killed in an auto accident. Mr. Mattil's death came just one month before the Southern Highland Handicraft Guild was to kick off its Folk Art Center Fund Drive, a project which was to have been headed, as you might expect, by O. J. Mattil. For over forty years this remarkable man—stern but good-natured, demanding but loving, totally direct and honest—served the guild in every imaginable capacity, and for over thirty years he had chaired the guild fairs.

In 1976 there were people working on plans bigger than a region. The National Association of Handcraftsmen, Inc. (NAH), began a short life with the publication of the magazine *National*

Craftsman and the opening of a gallery in Maryland. Charles Counts and Lewis Snyder served on the NAH's board of directors; the advisory council also included Nina Poage, Don Page, and me (I was also on the editorial board). This alternative to ACC never really got past the starting gate. Begun in 1974 by J. Charles Burton and John Finney, the NAH didn't generate enough interest and response despite Charles Counts's accurate assessment that "I see something new emerging in the 1970s—something that represents a proper evolutionary trend in the American tradition."[6] The "something new" was not to include, for long, the National Association of Handcraftsmen.

Closer to home, another magazine ahead of its time, *Kentucky Artist and Craftsmen*, made a two-year effort "with a new devotion—the uniting of all artists, craftsmen, art educators, collectors, students, and devotees within the state."[7] The magazine certainly was good, well written and well received, but there simply weren't enough subscribers and advertisers to keep it going. Artists and craftspeople as a group are generally not readers, as the American Crafts Council demonstrated when *Craft Horizons* was changed to *American Craft*—with shorter, slicker features, fewer words, and very little thought-provoking commentary—and became much more successful.

But the ACC magazine was still *Craft Horizons* in 1977, when Guy Mendes wrote "Appalachia Revisited" for an issue also featuring Penland potter Cynthia Bringle and a remembrance of Black Mountain College. Mendes wrote, of the 1960s Office of Economic Opportunity and the War on Poverty: "Craft development of the whole region is promised. A market is being developed, and it is built more on sympathy than quality. Projects come and go, with only a few evolving into sound ventures."[8]

Less poetic and sarcastic than Jonathan Williams's survey eleven years earlier, Mendes's article zipped from West Virginia

to Georgia, to North Carolina, to Tennessee and Kentucky, a positive summary of a region hard at work but weary of the nation's birthday celebration. Mendes cites slight sales decreases and quotes me in his comment: "I think we got 'Bicentennialed' to death."[9]

None of us posted a decrease of the magnitude of the Southern Highland Handicraft Guild's October Fair in Knoxville. From a 1975 high of almost $225,000 in Gatlinburg, Knoxville sales plummeted to just $158,000. These figures came too late to be included in the Mendes article, which reports on the guild's growth, plans for the Folk Art Center, and busy sales efforts.

From the venerable John C. Campbell Folk School, new Director Esther Hyatt reported that "our crafts sales have increased from $29,305 in 1967 to $68,802 in 1976."[10] Yet there were stirrings of wistfulness, even in 1977. Said Rude Osolnik: "The fairs used to be more of a family thing. We had fun. Now it seems like everybody is after the old buck."[11] And I warned that "one of the biggest dangers is that, in order to keep the volume up, some craftspeople will devote most of their time to producing pre-set items. Then there's no time for experimentation, no time for craft."[12]

Clayworker Sandra Blain of the University of Tennessee saw a connection between Appalachian tradition and contemporary craft education: "Universities are stressing ideas—technique is not the thing. We're saying 'Let's work with ideas and not just technique, let's develop vision and the perception of what's going on around you.' But technical abilities are still important to the contemporary craftsperson here, probably because of the strength of the technique of the older people. In most other places of the country technique does not play a part in a university crafts program. They don't have the older people to look up to like we do."[13] In a similar vein were the thoughts of Ray Pierotti,

then with the American Crafts Council but soon to become direc-
tor of the Arrowmont School: "The rather unique thing about the
Southeastern craft movement is that it never died out as it did in
other parts of the country."[14]

In February 1977 there was a champagne breakfast in Balti-
more to celebrate the first Winter Market, a dazzling event which
opened the doors to large-scale wholesale craft marketing. Spon-
sored by American Craft Enterprises, a subsidiary of the Ameri-
can Crafts Council, the Winter Market was the pioneer event for
most of what's happening now in wholesale craft marketing.
In addition to sales, the event pulled together craft leaders from
all over the country, a happening almost as significant as the
market itself. Carole Sedestrom drew craft leaders from all over
America—producers, authors, administrators, educators, collec-
tors—for a gala hosted by Joan Mondale. There I finally met *The
Crafts Report*'s editor, Mike Scott, in person for the first time, plus
many others I'd read about, worked with via telephone or mail,
or simply heard about. The first Winter Market was an *event*,
the precursor of most that has followed. When it was over, I
asked Carole Sedestrom to come to Kentucky, and she was the
speaker at our 1977 Kentucky Guild annual meeting in Shaker-
town. Carole returned the request, and I was a juror for the 1978
and 1981 Winter Markets.

On May 1, 1977, the Appalachian Fireside Gallery opened in
Berea. Sponsored by the Save the Children Federation, the gallery
showcased the works of Appalachian Fireside Crafts, Kentucky
Hills Industries, and the Quicksand Craft Center—all regional
groups. The new gallery featured traditional crafts in contempo-
rary settings and provided a strong new market to supplement
an already busy Kentucky effort. In Berea we now had the Berea
College shops, Churchill Weavers, the Benchmark Gallery, the
Appalachian Fireside Gallery, and the Upstairs Gallery. In Lex-

ington, the Appalachia Shop by MATCH and the Kentucky Guild's Guild Gallery were solid outlets. In Louisville the Coffeetrees Gallery was going strong. Louisville wanted a Kentucky Guild shop enough for the the city's Downtown Development Corporation and private investors to offer financing, but part of the offer was the clause that the shop be "operated as a business." That meant no consignment, no democratic space allotments, and full markups maybe higher than 100 percent. The guild backed away quickly.

In May 1977 our spring fair posted sales of $78,487 for 113 exhibitors. Attendance was *down* to 16,500.[15] I emphasize *down* for a reason; a Berea craft fair ten years later would be considered a success with 9,000 visitors. Outdoor retail craft fairs in Kentucky are no longer the special events they were in 1977.

The TVA, during the Carter administration, was looking again at a regional development role in areas other than flood control and electricity. TVA staffer Miriam Wunderlin became a welcome new face and voice at regional gatherings, and TVA projects included a major exhibit in the Knoxville office complex along with plans—never really implemented—to purchase Appalachian furniture and accessories for TVA offices.

Early in 1977 the Kentucky Arts Commission approved an $8,500 salary assistance grant to the Kentucky Guild for the position of education director. In June we hired Andy Smith back from the Southern Highland Handicraft Guild, where he'd been since 1974. The reason for hiring an education director was the upcoming 1978 ACC-SE gathering in Berea. Walter Hyleck envisioned Appalachian tradition and contemporary craft direction working in a "counterpoint" situation; we not only did just what Wally suggested, we took the name—"Counterpoint"—plus National Endowment for the Arts funding ($15,000) and went at the massive project with an aggressive, what-have-we-got-to-lose at-

titude. We called Sam Maloof and David Leach and got immediate acceptances. Lloyd Herman of the Renwick Gallery agreed to jury "Southeast Crafts '78." I went to Chicago to a gallery to arrange for a Polish weaver. Plans were solid, work was underway, but before "Counterpoint" we had other things to do.

In June we went to Winston-Salem for the ACC National Conference. I trucked along an excellent Kentucky display, collected by the Kentucky Arts Commission, and participated in an ACC meeting staged with gracious Southern style. Charles Counts led Joan Mondale out onto the dance floor and I—according to Marie Hochstrasser's laughingly proud report to the guild's board of trustees—"spent most of his time hugging people." It was a time to greet old friends and make new ones. Appalachian leaders who were part of the program were Bob Gray, Tom Gilmartin, Charles Counts, and Marian Heard, and the conference featured the premiere of the "Young Americans" competitive exhibit.[16]

During the ACC conference in Winston-Salem, the beginnings of the North American Craft Administrators (NACA) were discussed. A formal organization of craft administrators seemed to be a logical, needed step, a sort of support group for beleaguered executives. Most such administrators work for a pittance of a salary, have no benefits or retirement programs, and have no job security beyond the whims (and the next meeting) of the governing body. The administrator is expected to both lead and follow, to take very little credit and all of the blame.

Eudorah Moore, former crafts coordinator for the National Endowment for the Arts, began her keynote address to the 1979 Southeast Craft Administrators Conference by saying: "I've just come from Penland, where I spoke with Bill Brown about the role of the craft administrator. Bill said there are four requirements. The first is that you have a sense of humor. Secondly, stay out of the office as much as possible. Thirdly, don't let anybody know

how worried you are. Finally, you must find out from the beginning that you cannot equate everything with money." Later, Moore added, "I regard the craft administrator really as the crafts' protagonist, or the heroic figure speaking for craft."[17] Most of us "heroic figures" wound up weary and working elsewhere.

But efforts to organize craft administrators on a larger scale have generally failed. The short-lived North American Craft Administrators suffered from a lack of common purpose. Differences in geography, finances, and job description—some were federal or state employees, some were educators, some were in marketing, some of us were supposed to do it all—kept the group from ever jelling. Ad hoc committees met after the ACC conference and tried to follow up, but in short order NACA went bust. Perhaps we were all too much like the people we worked for. A decade later a new effort, "Craft Organization Directors," is attempting to do the same but with a narrower focus and perhaps more chance for success.

Immediately after the 1977 ACC conference, I wrote a letter of official "non-application" for the position of director of the Joe L. Evins Appalachian Craft Center in Tennessee. The rumors that I would be taking the job were rampant in Winston-Salem, and admittedly there was some interest on my part. I was flattered to be approached, intrigued by the concept of a nonuniversity training program, but fully aware of my limitations. I am not an educator, but that very fact may have been the reason Lewis was interested. At that time the center needed an administrator, a politician and public relations specialist, a person who could get things done, more than it needed a professor of art.

Throughout the flap over the funding and operation of the Evins Center, I defended Lewis Snyder, and I still feel that he suffered deeply for trying to help. Lewis did what he thought the region's craftspeople needed and wanted, but some critics chose

to attack him personally. Those rocky beginnings have prevented the Appalachian Craft Center from ever beginning to reach its potential. The basic initial plan was solid, providing for: resident craftspeople and apprentices, continuing workshops geared toward production and marketing, marketing as part of the center, and a superb facility. It all seemed to be just what we wanted, or at least what we said we wanted.

The non-Appalachian location didn't help, and another negative factor was the reluctance of the more traditional craftspeople to either teach or attend workshops. The fame of Penland School and—to some degree—Arrowmont is based on providing an "experience" for out-of-the-area students. Few people from the region use Penland as a place for basic learning. The appeal comes from the atmosphere, the instructors, the mystique. Penland draws many participants who can afford to pay for an arty vacation in the mountains. The programs and instructors are excellent, but the clientele is not local. The Evins Center has never gained such a heady reputation, and the switch of administration from the Tennessee Arts Commission to Tennessee Technological University eliminated the nonacademic appeal of the original concept.

Despite the gala tempo of Winter Market and the ACC conference, we were working in Kentucky. In 1977 the guild participated in a Decorators Showcase—building an entire shop on the spot—and mounted a painting exhibit at the Lexington Opera House. We persuaded the Kentucky Arts Commission to use fair admission receipts as a basis for the new Challenge Grant Program and received a $7,000 award. Andy Smith was busy working on a new slide collection and brochure for the Designer-Sales Program, an effort to stimulate sales to architects and designers, a concept that never really worked despite a good effort, an idea that even now is being revived with small chance of success. We

staged another successful fall fair and afterward went to Knox-
ville to see if the Southern Highland Handicraft Guild's second
try there would draw a better response.

It did not. Sales dropped again, down to a total of $121,000,
and in 1978 the figure would be but $94,000. Already, the unsuc-
cessful move from Gatlinburg to Knoxville and the fund-raising
effort for building the Folk Art Center were causing rumbles for
the guild director, Bob Gray, the beginnings of a squabble which
would last for five years. In 1977 Jim Gentry's title was changed
from education director to assistant director, with more responsi-
bility for marketing and operations. In 1979 the guild was to
move the fall fair to Asheville, where there was no immediate
improvement: sales in 1979 were but $92,000. The good news for
the guild in 1978 was approval of a $125,000 National Endow-
ment for the Arts Challenge Grant for the Folk Art Center.[18]

In 1977, somewhat miffed that Appalachia was not represented
in "The Flowering of American Folk Art," a Whitney Museum
exhibit, a North Carolina group produced *Artisans/Appalachia/
USA*, a "new kind of catalog." The Appalachian Consortium's
photo-essay stories, mostly about Western North Carolina tradi-
tional and contemporary craftspeople, included these comments
from F. Borden Mace: "With only one or two exceptions (such as
the Southern Highland Handicraft Guild) the museums, galler-
ies, universities, and colleges in Southern Appalachia have gen-
erally failed to classify, catalog, photograph, and record the best
of Southern Appalachian folk art. If this new kind of catalog can
serve as a catalyst for our own institutions and others to record
for posterity the best aesthetic expressions of our people, then
our efforts will have been rewarded."[19]

Just how much reward Dr. Borden and the consortium experi-
enced is unclear; even today, documentation of the Appalachian
craft culture lags far behind the marketing effort. Probably the

Foxfire books have done more than anything else to stir interest in cultural preservation, and few can really agree as to just what "folk art" is. Elliot Wiggenton was in Washington for a meeting sponsored by the National Endowment for the Arts which I attended to study folk art preservation and stimulation; I don't remember any *results* of that conference, just that Joan Mondale was our host, and that there was a memorable dinner with Don Page, Bob Gray, and David Brooks (owner of Appalachian Spring, for years a major non-Appalachian outlet for mountain crafts).

The *Artisans/Appalachia/USA* catalog features such Appalachian "folk artists" as Penland clayworkers Ron Propst and Jane Pieser, along with Edd Presnell, the Brasstown woodcarvers, and others more traditional in approach. In Kentucky, Larry Hackley has done much work to collect and exhibit primitive woodcarving and sculpture. Charles Counts's book *Common Clay* documents traditional potteries such as Bybee, Cheever and Lanier Meaders, D. X. and Bill Gordy, and Norman Smith.[20] Perhaps the best documentation of all is Ed DuPuy's 1967 book *Artisans of the Appalachians*, a "vanity" publication. Profiling a large group of Appalachian craftspeople and administrators, it becomes a more valuable resource as time passes.

But it may very well be that Appalachia's folk art is still such a living part of the culture that folklorists are somewhat turned off. Obviously (except for Elliot Wiggenton's kids at *Foxfire*) it's more fun and easier to document from yellowed papers than from living, breathing, cussing, carving examples. Appalachia's folk crafts have been preserved—albeit in a somewhat evolutionized form—more by the marketplace than by documentation.

In 1978, probably my personal banner year in guild administration, it seemed we could do no wrong. We sold thousands of dollars worth of crafts to the General Services Administration (GSA), drew a record crowd to our spring fair, hosted a major

regional workshop-event in June, staged another great fall fair, then helped with the most effective craft workshop I've ever witnessed.

The GSA sent Bill Madison to Kentucky, North Carolina, and Tennessee to buy crafts under a unique program designed by then-GSA head Jay Solomon of Tennessee. Functional crafts for office use—wastebaskets, ashtrays, pencil holders, book racks, attache cases, and much more—were primary purchases, and Bill Madison's very presence added a new dimension to the regional craft world. The black West Virginia native was the perfect choice for the project. We entertained Bill in Berea, met him for dinner in Washington, and he came back for "Counterpoint" in June. But GSA's craft buying was not to last. *The Crafts Report* noted in 1979 that Jay Solomon "had stepped down as head of GSA, and that the craft purchase program was discontinued during the corruption scandals."[21] The article added, however, that crafts had not been part of the scandal.

A related discussion was with the operators of the Armed Services Stores, discount retail outlets on military bases. I ultimately concluded that this market, though huge, would not support the quality and price levels of crafts. At Ft. Knox, Kentucky, we did work with the Officers' Wives Club to stage a small but profitable craft market, but interest waned when the leaders were transferred to other installations.

The Kentucky Guild's spring 1978 fair drew a record crowd of almost nineteen thousand and posted sales of $89,693.[22] Barely a month later, one of the biggest, best remembered, most festive events in the history of the Appalachian craft world took place in Berea. "Counterpoint" was officially a function of the ACC-SE, cosponsored by the Kentucky Guild of Artists and Craftsmen and held on the campus of Berea College. Funding came from the National Endowment for the Arts, the Kentucky Arts Commis-

sion, Governor Julian M. Carroll, private contributions, and all matter of in-kind support, trades, and deals. We received crucial cooperation from every Berea College department and office, and for a week we enveloped the campus with activity.

Juror Lloyd Herman gave $5,000 in awards to "Southeast Crafts '78" participants, and a handsome catalog was printed (and delivered in Mary Rezny's Volkswagon just minutes before the opening reception). The series of workshops, speakers, demonstrations, and seminars was—even looking back today—literally awesome. We had David Leach, Sam Maloof, Roberta Marks, Yolanta Owidzka, Else Regensteiner, Kathy Kelm, Martha Nelson, Bill Helwig, Libby Platus, and others, plus keynote speaker Paul Spreiregen, who said, "Never have I seen so many with so much talent so willing to share."[23] American Crafts Council President Sam Scherr and staff member Lois Moran came from New York; participants came from all over. The Saturday-night party in my backyard featured a bluegrass band, Georgia potter Jerry Chappelle's barbecued chicken, 120 gallons of beer, unprecedented fellowship, and an all-night celebration to cap off a week of creative activity.

Heady stuff. Of "Counterpoint," Persis Grayson wrote for *Craft Horizons*: "Appropriately called "Counterpoint," the ACC-SE Regional Conference harmoniously blended old and new, professionalism and folksiness. Festive tents, a full Appalachian moon, flowing beer, new ideas, old traditions—the only things missing were handcrafted skateboards to speed up movement between these activities."[24]

Craftspeople still ask me about the huge log house (it belongs to Berea College) and—mostly—how such a small organization ever pulled off such a major event. The success of "Counterpoint" was part planning, part creative gambling, part funding, part luck and fate, and mostly hard work. It was the right event at the right place at the right time, and it was a week I'll never

forget. I remember David Leach adoring the fireflies in our backyard; Yolanta Owidzka's foul-smelling black Polish cigarettes; Sam Maloof's admiration for Berea College's woodworking traditions; the fabric sculpture that adorned a tree in our yard until it faded from weather; and my beagle pup Chopper straining at his chain to share in the wealth of food and friendliness. I remember young Mississippi woodworker Fletcher Cox, on Sunday morning, sitting enthralled in Rude Osolnik's living room talking with Osolnik, Sam Maloof, and Ed Moulthrop.

The international, the national, the regional, and the local crafts cultures came together for four unique days, a true "counterpoint" of culture, tradition, technique, and creativity. Much of the planning and work was done by Kentucky Guild members Marie Hochstrasser, Ed Dienes, Julia Duncan, Sally Wilkerson, Walter Hyleck, and Carole Pierce, with much assistance from Anne Ogden and Albert Sperath of the Kentucky Arts Commission. The Kentucky Guild staff—Maggie Rifai and Andy Smith, plus others hired temporarily—did the nuts-and-bolts work to near perfection. When it was over, we were physically and mentally exhausted. It took two days to clean up; weeks to tabulate, pay bills, and clear up correspondence; then it was back to work as usual. There was a fall fair coming up, and there was the Appalachian Mobile Wood Workshop.

In November 1978, the Appalachian Mobile Wood Workshop, funded by the Appalachian Regional Commission through the Southern Highland Handicraft Guild, took a bus load of production woodworkers almost two thousand miles through Kentucky, Tennessee, and North Carolina to tour individual wood studios, larger production shops, furniture factories, and even a mountaintop sawmill. Directed by Rude Osolnik, the workshop traveled to Stanton Woodcraft, Berea College Woodcraft, and Kentucky Hills Industries in Kentucky; the Village Craft Shop, Bill Davis's Dulcimer Shop, and a half-dozen other wood studios

in Gatlinburg; then to Woody Brothers Chair Shop, Henredon Furniture, Three Mountaineers, and Mastercraft in North Carolina; ending with a session at the Southern Highland Handicraft Guild offices.

The week-long trip was expense-paid for every participant, partial compensation for a week of lost production time. The learning never stopped: in the shops, on the bus, during meals, into the nights, the woodworkers swapped secrets and supply sources, helped each other solve problems, laughed, argued, shared, and parted close friends. The concept for the mobile workshop came out of a meeting in Asheville with Bob Gray, Rude Osolnik, Jerry Workman, Don Page, and me. We agreed that, far too often, full-time working craftspeople did not or could not participate in craft workshops, and that production craftspeople really needed to see full-scale shop operations rather than small teaching studios. Bob Gray found the funding, through ARC, for the unique and—unfortunately—not continued workshop concept.

I thought the idea would also be great for potters, so I applied for and received Kentucky Arts Commission funds to sponsor a Mobile Pottery Workshop in 1979 but never pulled it off. One problem was finding an acceptable workshop leader; in the Kentucky clay world there was no one like Rude Osolnik, a craftsperson of such stature that other egos wouldn't suffer, so eventually I canceled the project and returned the funds.

Another idea, mostly mine, came out of the meetings in Asheville funded by the Appalachian Regional Commission. *The Craft Administrators' Journal* was an effort to consolidate in written form the expertise that sat in the meeting rooms, to have printed guidelines available to help answer the questions we all dealt with every day. Authors who contributed included Merle Walker, Gerald Ely, Dan Overly, Michael Scott, and Bob Gray.[25] The journal was not a success, and was never updated as planned.

Once again, perhaps, we had evidence that communication in the craft world does not travel effectively when it has to be read.

I ended my "banner" year the usual way, helping Guild Gallery through the frantic Christmas season, coming back down to earth to take a pickup to Bybee for pots and to truck skittles games up from Berea. One constant of the craft world, at any level, is lots of lifting, hauling, and packing.

In April 1979 Bob Gray hosted the Conference of Southeast Craft Administrators at Black Mountain, North Carolina. Funded by the Appalachian Regional Commission and the Southern Arts Federation, the conference featured speakers such as Eudorah Moore, crafts coordinator for the National Endowment for the Arts, and Carole Sedestrom, president of American Craft Enterprises;[26] Lois Moran, Terry Weihs, Dan Overly, Don Page, Anne Ogden, Rude Osolnik, Jerry Workman, and a host of others gathered for an interchange of ideas and fellowship. This conference and much other activity were partially financed by the $75,000 ARC educational grant to the Southern Highland Handicraft Guild. Under this grant, Mr. Gray, Rude Osolnik, Don Page, Dan Overly, Jerry Workman, and I met often to discuss regional needs, and we even traveled to Pennsylvania to evaluate the ARC-funded programs at Historic Bedford Village. The grant that financed the Appalachian Mobile Wood Workshop also fostered much coordination among the region's craft agencies.

In North Georgia, the work of two years was being published. *Georgia Crafts/Appalachia*, a handsome catalog of craft products, also included the results of the survey which had occupied most of two years. Predictably, the craftspeople reported low individual income but a large overall impact on the economy. Survey findings included:

Crafts income was largely under $3,000 a year and was mostly supplemental rather than full-time.

Most craftspeople did functional work.

Crafts significantly stimulated the local and regional economy. The total annual figure in North Georgia was put at $1.1 million.

North Georgia craftspeople wanted regional programs in design techniques and marketing to improve their products and business practices.[27]

To begin filling those expressed needs, the Crafts Project sponsored the Southern Appalachian Conference on Crafts Marketing in August in Dahlonega, Georgia. Some 111 craftspeople registered to work with leaders including Lila Bellando of Churchill Weavers, John Cram of the New Morning Gallery, U.S. Department of Agriculture craft specialist Gerald Ely, Banks Godfrey of Piedmont Craftsmen, and me.[28] Much of the proceedings was videotaped for recurring use, and there was hardly a free second. The participants in this workshop were eager, questioning, and out to get their money's worth.

In September 1979 the Joe L. Evins Appalachian Center for Crafts in Tennessee officially opened its doors with over 100 craftspeople from eleven states participating in a three-day seminar on marketing and business cosponsored by the center and the Tennessee Artists-Craftsmen's Association. Speakers included Carole Sedestrom, Mike Scott, and Jerry Chapelle.[29] The center's studio equipment was not yet in place in 1979.

Back in Kentucky, during 1979, we were doing business as usual. I missed part of the week-long setup for the spring fair to serve as a juror for the Atlanta Arts Festival; the long preparation time was the result of a long-term perceived problem with our heavy use of Indian Fort Theater. For several years some Berea College administrators had been worried that the huge crowds were damaging the trees, and the new solution was to build an alternate fair site on the ridge just past the amphitheater. A great deal of college and guild labor and expense went into building

trails (and even a bridge), trying to reroute traffic, trying to shift a twelve-year traffic pattern with little success. Only the one fair was ever held in the alternate site. We balked and promised to move the event out of Berea if we had to go back onto the rocky steep hillside.

A sidelight of that 1979 fair was the presence of an elegant woman who asked permission to campaign in the parking lots. Martha Layne Collins was then running for the Democratic nomination for lieutenant governor of Kentucky. She won, was elected in the fall, going on to become governor in 1983 and provide solid, personal support to the crafts throughout her administration.

After the fair, I was in Frankfort often and finally persuaded Governor Carroll to dip again into his contingency funds, this time for $25,000 to pay off accumulated debts and to help start a new "Holiday Market" in Lexington. The Holiday Market was my idea for an expanded marketplace, one with a roof, a more elegant sales event which would tap the lucrative Lexington sales potential. The first year we posted promising sales; scheduling around Thanksgiving, University of Kentucky home football games, and other events in Rupp Arena was precarious but possible. In 1980 the guild went back but recorded sales of only $14,702 and therefore dropped the market.

Later in 1979, I was the speaker at the Kentucky Horse Park near Lexington when our state's new first lady, Phyllis George Brown, hosted her first official event, a luncheon for legislators' wives. I got an early taste of how Mrs. Brown was to work: on less than one day's notice we pulled together an exhibit, craft demonstrators, and my talk on the history of Kentucky crafts. It was a sign of what was to come during the early eighties, a media extravaganza which drew more attention to Kentucky crafts in one year than we'd been able to generate during the preceding twenty years. Beautiful, aggressive, quick to recognize the pub-

licity potential of the crafts, Mrs. Brown signalled a new era for Kentucky's craftspeople.

For me, all the speech-making, judging, and consulting trips were times to meet new people, learn, see the crafts of different regions and cultures, and to have some small input into decisions that would ultimately affect the craft world. As a juror I worked the Central Pennsylvania Festival of the Arts, the Kansas City and Oklahoma City arts festivals, Winter Market, the Dogwood Festival in Tennessee, the Rhododendron Festival in West Virginia, and many more; I was a consultant to the Ohio Arts Council, the New Mexico Arts Council, the National Endowment for the Arts, the Appalachian Regional Commission, the Tennessee Valley Authority, and dozens of other agencies. I don't have records and can't remember them all; after a while all airports and hotel rooms look alike. And, I'm sorry to say, so does much of the craftwork.

The people were special in every location. They were gracious, respectful, eager to learn and teach, and always—as is true in the craft world everywhere—they were alive and interesting. From cocktails with Joan Mondale to green chili in a Santa Fe bar, I loved it all. To work with Fran Merritt, Eudorah Moore, Elena Canavier, Don Page, Carole Sedestrom, Ray Pierotti, and the hundreds of others was invaluable. Larry and Roberta Marks welcomed me into their Miami home and took me on a cruise across the bay, and a gregarious Georgia potter rebroke my shattered little finger with his hearty handshake.

My favorite work outside Kentucky? North Georgia, hands down, where I've done lectures, marketing workshops, videos, show jurying, and served on panels, met great people and—I think—been of some real, practical assistance to many working craftspeople. Sue Ford's welcomes always made it even better, and in the late seventies and early eighties the North Georgia

craftspeople were almost family, warm and supportive in a way that recalled the late-sixties Southern Highland Handicraft Guild.

West Virginia, where the same family-familiar attitude ruled, was my other favorite place. In West Virginia *I* don't talk funny. It may very well be that I've just always felt more comfortable where people treasure the mountain culture. I'm a proud Appalachian, one who prefers our mountain ways; my travels across the United States brought me home knowing that, in many ways, Appalachia sets the national standards for the craft world.

Where else will you find a Berea College, a John C. Campbell Folk School, a Penland, an Arrowmont, the Southern Highland Folk Art Center, the strong state and regional guilds? Where but in Appalachia can you find a craft movement dating back to the 1890s and yet as current as tomorrow? We honor and treasure tradition, we fight over newfangled ways, but we always, always accept and support what is new. We have endured and grown.

But by the end of busy 1979, my high-flying role as director of the Kentucky Guild wasn't so much fun anymore. Working almost every weekend, juggling finances, fighting the same old internal battles every day, enduring the ravages of the weather at Indian Fort Theater, and playing the politics of survival wore me down and burned me out.

I had to take a hard look at reality. For nearly fifteen years I'd done nothing but work. Whether it was me or the Kentucky Guild I don't really know, but it became obvious that, as long as I was director, there would never be a strong, sustained effort from members to operate the organization. Probably I insisted on too much control, but there was also too large a degree of a "let Garry do it" mentality. I could not, during 1979, summon up the old energy and reckless enthusiasm. Just after Christmas I made my decision and informed the Kentucky Guild of my resignation effective June 30, 1980.

9.

1980–1985
Helicopters, the World's Fair, and a New Decade of Activity

During the 1979 gubernatorial campaign, Miss America took Kentucky by storm. The new Mrs. John Y. Brown, Phyllis George, "discovered" Kentucky's two-hundred-year-old craft traditions and spent the next four years hustling, flying buyers across the state, and garnering national attention for her efforts. Despite some sour-grapes objections that Mrs. Brown didn't know anything about crafts, the spotlight brightened, and all craftspeople reaped the benefits.

Mrs. Brown wrote, in her 1989 book *Kentucky Crafts: Handmade And Heartfelt*, "I have traveled from the mountains and hollows of Eastern Kentucky to the lake regions of Western Kentucky, from the largest cities and suburbs of Louisville and Lexington to the smallest farms in the Bluegrass to find these artisans. I felt an immediate emotional attachment to Kentucky and particularly to its craftspeople who had a purity, honesty, and earthiness about them that I had rarely found in the entertainment business."[1]

Governor Brown obviously wasn't paying attention to the First Lady early in his term. After abolishing the Kentucky Arts Commission, he realized he'd cost the state over $200,000 in National Endowment funding and quickly appointed a new "Kentucky Arts Council" as part of the Kentucky Department of the Arts. More importantly, Governor Brown created the Crafts Marketing Division as a separate branch of the same department, and the

new agency was responsible for most of the 1980s state govern-
ment activity. Lois Mateus was commissioner of the new depart-
ment, and Karen Horseman was crafts coordinator, but Mrs.
Brown was the centerpiece. Her celebrity status, glamour, and
the busy helicopter fascinated both Kentuckians and potential
craft buyers, and many major magazine articles about her were
rushed into print. Buyers from Bloomingdale's, Marshall Field's,
Shillito's, Neiman-Marcus, and Bullock's of Los Angeles criss-
crossed Kentucky, and "Oh! Kentucky" boutiques were the rage
on both coasts.[2]

As a long-term market, these department stores were not to
amount to much—as Allen Eaton had correctly predicted in
1937—but the visibility benefited us all. And, in time, the Crafts
Marketing Program would develop solid, lasting efforts.

Of major regional impact on this new decade was the long-
awaited opening of the Southern Highland Folk Art Center in
Asheville, North Carolina. Joan Mondale came down to help Bob
Gray dedicate his dream in April 1980. An elegant luncheon at
the Biltmore Estate, ceremonies at the center, and much celebra-
tion filled the day.

The fund drive for construction of the Folk Art Center had
started in 1976 and was to continue through 1983. The Appala-
chian Regional Commission provided the base $1.5 million, and
the National Endowment for the Arts added a $150,000 challenge
grant. The Kresge Foundation (providing $50,000), the Ford
Foundation ($30,000), the James G. Hanes Foundation ($10,000)
and the J. W. and Anna Hanes Foundation ($20,000) were major
contributors. The state of North Carolina (with $50,000 and a
continuing annual award of over $35,000) and Buncombe County
(two $12,000 grants) helped Bob Gray reach his goal.[3]

Guild members donated cash, works to be sold, and support.
Members and Asheville area businesses provided about $250,000.

Funding was not complete when construction was finished, so three Asheville banks formed a consortium to loan the guild $270,000 (at the then-prevalent interest rate of 20 percent). The guild's Reddick Road property was used as partial security for the loan, and Winston-Salem arts patron Philip Hanes guaranteed the rest. The National Park Service provided sixteen acres of land, assistance with the bidding and supervision of construction, and a $200,000 road-widening project to create the new entrance off the Blue Ridge Parkway.

The evening after the Folk Art Center dedication, I drove Eudorah Moore, crafts coordinator for the National Endowment for the Arts, on down to Gainesville, Georgia, where we served

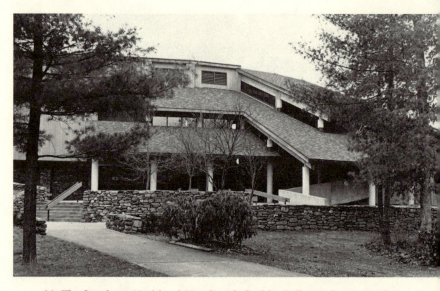

29. The Southern Highland Handicraft Guild's Folk Art Center on the Blue Ridge Parkway near Asheville. The center opened in 1980 and houses guild offices, the Allanstand Shop, exhibition and demonstration areas, an auditorium, and meeting rooms. Staff photo, used with permission of the Southern Highland Handicraft Guild.

30. Former Kentucky Governor John Y. Brown, *left*, and Phyllis George Brown with Marvin Traut, president of Bloomingdale's, at the 1980 opening of an Oh! Kentucky boutique in New York City. Photo used with permission of the Commonwealth of Kentucky.

as awards jurors for the new Georgia Crafts Program fair. A craft fair with greater impact was to be held July 3 to 7 in West Virginia; the 1980 Mountain State Arts and Crafts Fair, held at Cedar Lakes, drew 47,750 visitors, who spent a total of $282,500.[4] West Virginia events were major retail affairs—the Mountain Heritage Arts and Crafts Festivals, held near Harper's Ferry since 1972, draw appreciative and affluent customers from the Washington, D.C., area.

The July–August 1980 issue of *Hands On*, a Shopsmith publi-

cation, was built around Appalachian woodworkers and organizations. Pictured were woodworkers Homer Ledford, Rude Osolnik, Elsie Martin, and Edsel Martin, "whose one and only tool is 'a good sharp knife.'"[5] This quotation isn't quite accurate, because Edsel's bandsaw is an artist's instrument. Also featured is an interview with Bob Gray, who points out that "in the sixties and seventies, the crafts grew at 25 percent to 75 percent a year. Now it's down to 5 percent, and we'll probably not see much more growth than that in the next five years."[6] And, added Gray, "Craftwork is like any other profession—law, medicine, any of these—you need to learn everything about it before you hang your shingle out."[7] The same issue also includes a valuable, two-page section on "Turning Pro: How *Not* to Do It," full of advice for would-be full-time woodworkers. In 1982 *Hands On* returned to the region for a story on Rude Osolnik, "One Good Turner," which cited Osolnik's forty years of teaching at Berea College and quoted him as saying "I've turned on the lathe almost every day of my life since I was seventeen, . . . and I'm sixty-seven now. I've spun and turned metal, and worked with soapstone on my lathes. Rhododendron burls too, but you've got to watch for rocks and dirt."[8]

In May 1980, Bob Gray stepped aside as director of the Southern Highland Handicraft Guild to concentrate on fund-raising. Jim Gentry was named acting director, responsible for day-to-day operations. Gentry was to be made director in March 1981.[9]

I went back to Blue Ridge, Georgia, later in the spring of 1980, to teach an all-day marketing workshop, one of the few personal bright spots of that year. In my misguided effort to smooth the transition of Kentucky Guild directors, I had given six months' notice. From January to June 1980, about everything that could go wrong did. The Internal Revenue Service challenged our non-profit status, and my appeal took me to Washington, where the

staff people I met chuckled and wondered why anybody had even bothered to question such a small operation. But, a few months later, they were to revoke the nonprofit status anyway. My last guild fair was a four-day agony of rain, cold and relentless, a major financial and personal disaster which seemed to last for four weeks. When the fair was finally over, so was my work with the Kentucky Guild.

But I couldn't keep my mouth shut about the craft world. In March 1981, I wrote an article asking, "Has the federal money given to the arts done more harm than good?"[10] I suggested possible support for President Reagan's proposed 50 percent cut in National Endowment for the Arts funding, saying "Government intervention in *anything* assures mediocre results. The arts, freest and most spontaneous of all forms of expression, are restricted by guidelines and dulled by an evaluation system which starts with egotistic experts and ends with bureaucratic numbers and red tape." The Lexington *Herald-Leader* picked up and editorially endorsed those comments, and in some elements of the Kentucky art world all hell broke loose.

I later added fuel to the fire by praising Phyllis George Brown's contributions, saying "I was a skeptic, at first, and I still disagree with part of the image Mrs. Brown has projected for Kentucky's crafts. But I'm a firm believer, now, in the power of personality and the sincerity of the effort."[11] To those already offended that I would criticize the governmental arts funding, the support of Mrs. Brown was rubbing salt into open wounds.

Early in 1981, I was hired as warehouse manager for MATCH, Inc., the Berea-based regional cooperative. I had just written about MATCH a few months earlier for *The Crafts Report*, an article documenting the organization's new growth, funding from the Charles Stewart Mott Foundation and ACTION, and the impending renovation of Berea's old L&N Railroad depot as a Folk Art

Center to include a craft warehouse, showroom, and offices.[12] Now my job was to set up the warehouse, produce the new *Appalachia Handcraft Catalogue*, and—as it turned out—help open and close a shop in Cincinnati, open a shop in Berea, and serve six tortured months as acting manager of the Council of the Southern Mountains Bookstore.

In early 1981 the outlook for MATCH was upscale. Nina and Ben Poage had put together a package of loans and grants, including Kentucky Historical Society funds for building renovation and an Appalachian Regional Commission grant for my position. The pace of work was frantic: we built, equipped, and stocked the warehouse; set up a computerized inventory management system;[13] and produced a part-color crafts catalog (which still looks good). I didn't see the warehouse and catalog sales projections until after I was already at work. The expectation of over $600,000 a year was clearly out of reach, but we gave it a try.

While working for MATCH, I was asked to write a lengthy article on Appalachia's crafts for *Heirloom*, a glossy magazine published in Hong Kong. When my story on "Appalachian Handicrafts" finally appeared, it was in both formal British English and Chinese.[14] What I consider to be my best in-depth article about the Appalachian craft movement was, ironically, read only by people in China. Work on the present book also started in 1982, partly because of the *Heirloom* article and partly from the continual questioning I got from students and reporters. A $1,000 grant from Berea College's Appalachian Center helped finance early travel and research.

Two new craft shops were added to the Berea scene in 1981. Joe Osolnik, Rude's son, opened the Promenade Gallery near Berea College's Log House Sales Room. Joe had moved back to Berea in 1974 after selling his share of the Potter's Mark in Gatlinburg. Another potter with Berea connections, David

Westmeier, opened his new Featherbed Mountain Pottery show-room just outside of town. Dave had spent two and a half years working in Charles Counts's Rising Fawn studio, come to Berea as a student, then opened his own studio in 1976 in the basement of Churchill Weavers.[15]

In early 1982 the busy Kentucky craft world drew a lengthy article in the Lexington *Herald-Leader*. In her story, "Selling Kentucky Items Can Be Crafty Business," Sharon Reynolds cited the 1890s letter from a mountain weaver to Berea College President William Frost in which Frost was told, "It's no child's play to weave a kiver." "Nearly one hundred years later," wrote Reynolds, "Kentucky's crafts have been rediscovered, but a few voices crying 'déjà vu' in the wilderness are saying it's no child's play to create a lasting market for crafts."

Reynolds cited the work of Phyllis George Brown with the trendy large department stores, recounted sales efforts in Berea and Lexington, and noted that "A Crafts Marketing Division has been established" and that working with the division was "the Kentucky Art and Craft Foundation, a public, nonprofit foundation established by Mrs. Brown to promote Kentucky artists and craftsmen." A new Kentucky Craft Market was scheduled for March 1 to 2 at the Kentucky Horse Park.

The more cautious voices included mine: "My question is, will [the current boom] last when Phyllis George Brown leaves?" Production problems were cited, as was the craftsperson's reluctance to modify products to suit New York boutique buyers. Problems with craftspeople's business procedures were to be addressed in workshops at Prestonsburg and Morehead. (I was on the panel there, warning disbelieving producers that large department stores don't pay their bills for sixty to ninety days.)

Also in January, the *Kentucky Business Ledger* looked at the craft market in an article titled "Promoting Tradition outside Ken-

tucky."[16] Ron Cooper's report was very similar to the *Herald-Leader* story but with a now-familiar report on statistics: "There's . . . no way to tell how much the craft sales are meaning in terms of revenue to either artisans or the state. Because craftspeople generally handle their own transactions, industry and government spokespersons couldn't accurately estimate those figures." And they still can't.

To the south there was "belt tightening" in early 1982 as the Southern Highland Handicraft Guild shut down its craft warehouse and one of its retail shops. The new director, Jim Gentry, announced the changes, which also included staff reductions and a cutback in educational workshops. The warehouse had closed in late 1981, and now the venerable Allanstand Shop was closed in downtown Asheville and moved (in name) to the new Folk Art Center.[17] The guild was to come to Berea in April for its fifty-second annual meeting, where reports indicated that anticipated World's Fair traffic was expected to help the financial situation.

From Cincinnati to Knoxville, preparations for the 1982 World's Fair were keeping people busy. Knoxville's much-publicized greed had already hurt the fair, but early in the year *The Crafts Report* chronicled expectations in an article titled "Appalachian Craftspeople Hope to Share World's Fair Tourist Dollars."[18] At the fair site in Knoxville, a stiff $1,400 fee for two weeks of sales scared away most craftspeople, and promoter Audree Levy told *The Crafts Report*: "I lost a lot of money but I was glad to get out. Who needs all that aggravation?"

Complicated plans, sponsored by the Knoxville Arts Council, had been to sell crafts in Miller's Department Store, directly across the street from the fair entrance, but the arrangements fell prey to demands for more cash. Said Knoxville fiber worker Jimmie Benedict: "We had been trying to operate without money for the small producer who could not afford large booth fees. Appar-

ently there is no room for do-gooders in the money-grabbing area of World's Fairs. Our group is depressed and bitter. I think the best thing to do is leave town for six months."

Michael Scott asked me to visit the World's Fair for *The Crafts Report*, and his headline aptly summed up my review: "Beer Hall Is Best Reason to Visit Knoxville World's Fair Unless You Get a Kick from Guided Tours of Machinery."[19] I wrote: "Skip the Craft Fair part of the World's Fair unless you're into redwood signs and heavily scented candles, an array of boardwalk booths more suited to a shabby beachfront." The Folklife Center was a little better. There was mountain music, and the day I visited someone was barbecuing a goat.

Another project related to the World's Fair was the Berea Craft Festival. In February 1982, Rude Osolnik and Richard Bellando asked me if I'd be interested in helping with a new craft fair in Berea to take advantage of the traffic, a regional event open to craftspeople anywhere. We envisioned a one-time show, agreed to go ahead, incorporated as Berea Craft Enterprises, Inc., and went to work on what we called, that first year, the "Berea Craft Fair." Despite the World's Fair fizzle, the Berea fair was an immediate success. Craftspeople from a dozen states participated and asked us to continue the event; now the Berea Craft Festival is a major regional showcase. This was a new concept to me, operating a privately owned festival, but the difference made some decisions much easier and quicker, and we kept any profits. Our goal was to treat craftspeople the way we liked to be treated, and we did that successfully. My involvement lasted through the 1987 show, when I decided I'd finally had more than enough of working outdoor fairs.

But in 1982 the Appalachian Regional Commission grant for my MATCH position ran out, and I was asked to stay on and act as manager of the troubled Council of the Southern Mountains

Bookstore. For six bizarre months I juggled accounts and fought off foreclosure, then gratefully left.

James Seidelman, my replacement as director of the Kentucky Guild, resigned during 1982, and Maggie Rifai was made guild administrator. The organization chose to not have a director, a structure still in place. For the group of people involved, the less efficient process in use is probably a better system, and now success or failure lies squarely on the shoulders of the elected members who serve on the board and the committees.

Not all the flap of 1982 was happening in Kentucky. In Tennessee, John A. O'Conner resigned as director of the Joe L. Evins Appalachian Center for Crafts, and, as reported in *The Crafts Report*, "most other administrative staff, plus several members of the faculty, received termination notices in mid-June. Included was Bill Rummel, director of program services, who had been with the Craft Center project since it began seven years ago."[20] *The Crafts Report*'s front-page article cited the failure of the Tennessee Higher Education Commission to approve a Master of Fine Arts program, lack of a clear channel of management, and the absence of long-term funding as reasons for the center's difficulties: "As for the management problems, the Appalachian Craft Center seems to be pulled in three directions. It is officially a Division of the Tennessee Arts Commission, it depends for its funding on separate appropriations from the state legislature, and it is operated under contract by Tennessee Technological University." The Tennessee situation made Kentucky look good, but the national scene was unsure.

The same issue of *The Crafts Report* details a craft marketing recession. The 1982 Southern Highland Handicraft Guild's July fair reported a sales decrease of one-third, and the cornerstone Rhinebeck Fair reported a sales drop of a half-million dollars.[21] MATCH was floundering under a huge debt load, closing the Berea operations and cutting back to just the Lexington shop.

The Kentucky Guild reacted to the Berea Craft Festival's regional emphasis by expanding its membership territory to include "a fifty-mile belt around the state."[22] I had recommended the same concept several years earlier, and received a hostile reaction. Though not in the way I'd planned, I did help get the proposal approved.

In February 1984, I accepted a position as communications coordinator for Morehead State University's (MSU) Appalachian Development Center. The first week, I turned down a request that I coordinate MSU's Appalachian Craft Market, a one-day show that is part of the week-long Appalachian Celebration. I intended, except for the Berea Craft Festival, to be out of craft administration and into communications. Morehead was almost home. My family has lived in the surrounding counties for almost two hundred years, and they gave me a warm welcome. Working at MSU was a busy time of healing old wounds, meeting new friends, shifting gears, writing, and starting a new career.

In 1984 Robert W. Gray retired from the Southern Highland Handicraft Guild after raising over $2.3 million in less than ten years, $2.1 million for the Folk Art Center and a quarter-million for operating expenses. I've made no secret, ever, of my strong feelings that the Southern Highland Folk Art Center should bear Bob Gray's name. The drive to build the Folk Art Center pinched guild finances and caused difficulties for Mr. Gray; at one stage even *I* wondered if Bob could pull it off and, more importantly, whether the project was worth the effort.

To drive today to the magnificent center, to see shop sales of over $1 million annually, to visit the active exhibition area, to realize that the Southern Highland Folk Art Center has assured the guild's future, is to know that the answer to the question is a resounding "Yes!" Bob Gray built his dream, fulfilled his vision, created a living endowment that will sustain the organization well into the twenty-first century.

31. Georgia potter William Gordy at a guild fair in Asheville. Gordy is from the rich North Georgia pottery tradition. Photo by Robert Arnberg, used with permission of the Southern Highland Handicraft Guild.

32. Charles Counts entertains and educates a young visitor to a 1980s guild fair. Counts, author of *Pottery Workshop* and *Common Clay*, has been a guild leader since the mid-1950s. Photo by Robert Arnberg, used with permission of the Southern Highland Handicraft Guild.

Jim Gentry became the guild's director under very difficult circumstances, serving four years in offices shared with Bob Gray and working in Bob's larger-than-life shadow. It has not been easy for Mr. Gray to watch the changes in the guild's administration and philosophy, but I suspect that in many ways his adjustments have been less difficult than Jim Gentry's.

No guild director ever has an easy life, and today's high-vol-

ume sales make solid management even more crucial. The ideal craft guild administrator would have the hide of an alligator, the wisdom of Moses, the business acumen and luck of Lee Iococca, Lyndon Johnson's political skills, the arrogant generalship of a Douglas MacArthur, the steely nerves of a riverboat gambler, a private fortune, and the soul of a free-spirited artist.

The high turnover rate of craft administrators in organizations such as Blue Ridge Hearthside Crafts, Piedmont Craftsmen, and even the American Crafts Council is high. ACC presidents come and go in rapid-fire succession, and over the past two decades it has been Lois Moran—in a variety of jobs—who has provided the stability and continuity to the national organization. Finally, in 1988, the ACC board of trustees recognized that and made Lois— in her twenty-fifth year on the staff—executive director.[23]

It is the nature of an arts membership organization to periodically dissolve into back stabbing, bickering and wailing, and vicious infighting. One constant, the one predictable factor, is that paid staff will be blamed for any shortcomings of elected leadership.

In most organizations, the paid executive has both too much and too little power. The "too much" covers day-to-day operations, usually with little or no guidance from the elected directors. Far too often, the executive makes decisions on directions, goals, and image which should be made by a larger group from the membership. The other side of this coin is the elected officer who wants *total* daily involvement, who would like to direct every small detail without assuming any overall responsibility.

An executive's "too little" authority comes when every decision is subject to reversal, when continued employment is subject more to popularity than to competence. Elected officers frequently resent the high visibility of the paid administrator, and the tenuous relationship can become very strained. I do not see signifi-

cant changes taking place within the craft organizations regarding staff-board relationships. The administrator's position is still precarious, political, and torn between two elements. The very same job that requires flair, imagination, and the gambler's instinct also needs conservative, stolid management. It's hard to go in both directions at the same time, hard to both lead and follow. There are few familiar faces left from my years in guild administration. Most of us have moved on to more stable and less painful positions; new faces are fighting the same old battles.

The situation isn't likely to change in Appalachia. We are in one sense more production oriented, more traditional in product, more geared toward the craft "center," but the individual craftspeople continue to develop in both directions, toward art and toward business, with enough success both ways to keep everyone busy. Private enterprise has grown into a large part of the marketing role once filled by the guilds, and the reality that guild membership is no longer crucial to financial survival has lessened the tensions to some degree. But, regardless of staff-trustee-member friction, the work gets done.

During the summer of 1984, the Southern Highland Handicraft Guild operated the "Craft Emporium" as part of Silver Dollar City (now Dollywood) amusement park in Pigeon Forge, Tennessee. Sales had been projected at $60,000 but wound up at only $29,325. The experience and the low sales volume were typical of attempts to market quality crafts in an amusement-park setting, a concept many craftspeople and park operators still want to pursue. It sounds like a good idea, bringing area souvenirs to where large crowds are gathered in a festive mood, but even at Disney World the market is more for specific mementos of the visit. And the other reality is that the profit margin on crafts is not as good as the margin on imports.

The guild quickly pulled out of Silver Dollar City and tried to

salvage an inventory damaged from exposure, soot from the coal-fired locomotive, and the pawing hands of tourists. The experience is evidence of the need, still, for a more controlled, selective marketplace for crafts, the very situation the guild has at the Folk Art Center.

In Kentucky, during 1985, state government was still actively promoting crafts. In November, Martha Layne Collins was elected governor, and her support would be solid, personal, and more lasting than what went before. Crit Luallen, commissioner of the Department of the Arts, also gave craft marketing much personal attention. "The current state administration's crafts program is somewhat less flamboyant than Mrs. Brown's," wrote Joe Ward for the Louisville *Courier-Journal*, "but people in the industry say it has its points."[24]

To back up my estimate of a total annual Kentucky craft market of $10 to $12 million, Ward cited annual figures from Berea College (about $1 million), Churchill Weavers ($555,000), Appalachian Fireside Crafts ($600,000 over two years), and Valley Hill Herbs and Everlastings ("several hundred thousand") plus a state guess that the 950 craftspeople or craft centers on their list employed over 2,000 full and part-time people. A new Craft Marketing Division project, a Kentucky booth at the New York Gift Show, was set. The state would spend about $10,000 to help 10 crafts producers show under "Made in Kentucky" banners.[25]

In 1985, a University of Georgia research report recorded the results of a survey sent to 600 craftspeople located in North Georgia and the extreme western counties of North Carolina. Though inconclusive, the study verified some assumptions and dug out some interesting statistics. As could have been predicted, 39.1 percent of those who responded had lived in the area for less than ten years. Some 73 percent reported education beyond high school. Only about 10 percent went into crafts because of family or cultural tradition. Local markets accounted for 62 percent of

sales; 77 percent felt craft fairs were their most important marketing technique despite reporting that studio sales (31.9 percent) and privately operated retail shops (27.6 percent) accounted for a larger market share than did craft fairs (19.6 percent).

Sixty-seven percent said their craftwork was "one of a kind"; 41 percent said they did production. One hundred of those responding were leatherworkers. The 97 full-time craftspeople reported average gross sales of just over $25,000 a year; almost 20 percent figured they earned less than $1 per hour for their work.[26]

In their conclusions, the researchers essentially admitted that every operation was so distinct that there were no consistent patterns. Their recommendations were nothing new, nothing that wasn't already being done or hadn't been underway since 1930.

This survey and its results won't surprise anybody familiar with the Appalachian area. We are a land of "pockets," with dramatic differences between relatively close areas; scoot the Georgia survey 150 miles east to include the Asheville/Penland area, and the annual earnings will rise significantly. Such studies as the Georgia research are interesting but not of much value. A better method of determining the region's craft market is to study the organizations, major retail stores and fairs, and the large production centers, and then get someone who knows the business to project the results. The many "projections" I've mentioned throughout this study are likely more accurate than the few formal surveys. The key factors are who makes the projection and for what purpose. Economic developers and state governments inflate their figures, craftspeople always understate income, and organizations would rather not be included. Overall sales numbers are also very misleading; so much of the gross income goes to hobby and part-time craftspeople and to the retailers that net individual earnings are deceptively low. Craftspeople still work from love of craft, not expectations of profit.

My best "projection" of the Kentucky–West Virginia–Tennes-

see–North Carolina craft market? Including craft fairs, shops, studio sales, mail order, and wholesale shipments, I'd put the 1987 total at $150 million.

During 1984–85 there were changes in the venerable Berea College Student Craft Industries. Richard Bellando had already resigned as director before new President John B. Stephenson reassigned the administration of the crafts from the Student Life to the Business and Finance division of the college. The Business Office promptly terminated nonproducing management positions in woodcraft, weaving and needlecraft, and broomcraft; discontinued a marketing consultant; and even changed the name. The new "Berea College Student Crafts Program" would market as "Berea College Crafts," with another change which every manager-director for twenty years had requested. There would be two administrative positions, a director and a marketing manager, to share the hectic work load of running six production units, three retail stores, a mail-order catalog, and a wholesale warehouse and sales center. The immediate challenge would be to curb drastically rising operational costs, reverse a slumping sales trend, restore quality controls, and reestablish "a tradition of excellence" as the working philosophy.

Despite my change of careers and my move away from craft administration, the appeal of Berea College and the challenge of working in the new situation were strong. I accepted the position of marketing and customer service manager for the revamped Student Crafts Program and came back to Berea and the world of craft marketing in June 1985.

10.

The Late 1980s

Hard Work at Berea, Gift Shows
in New York, and More Media

Coming back to work for Berea College after nearly fifteen years, coming back into craft administration after a fairly successful switch of careers, coming back into the worlds of the Kentucky and Southern Highland guilds, was not easy. Terry Fields, the new director of the Student Crafts Program, was also a Berea graduate and a former woodcraft manager, so neither of us needed introductions; we simply walked in and went to work.

We had an off-the-cuff budget projection that cut the program's previous year's deficit by about 60 percent, and we had a new color catalog already in the works. Most of the details of the changes we implemented during the first two years are in two articles that appeared in *The Crafts Report*.[1]

The busy first year was mostly a matter of "tending to business," dealing with a backlog of problems and hustling to get the program working again. Employees were demoralized by almost a year without a director, and the many changes of administration and personnel had confused the situation. We moved the office and warehouse from cluttered second- and third-floor disorder into a ground-level location, implemented quick decisions on management and procedures, hired the Berea Chamber of Commerce's director, Peggy Burgio, to manage the Log House Sales Room, and piled into a flurry of activity. Terry surprised me

and everybody else by leaving at the end of 1985; for six months I did his job as well as mine and was dangerously close to leaving myself until Terry was reappointed in July 1986 and my title was changed to assistant director and marketing manager.

But in mid-1985 we were getting to know the Crafts Marketing Division staff of the Kentucky Department of the Arts and preparing for the New York Gift Show in August. Fran Redmon, Shari Cunningham, B. J. Dollase, Bob Stewart, Crit Luallen, and Governor Collins were all part of the spirited group that went to New York, a repeat of the successful February venture.

Selling in the world's biggest gift market was a new experience, a new marketing direction for crafts which forced some reevaluation of techniques and production. Selling to mail-order catalogs, chain stores, and executive gift suppliers means volume, one item in large quantities, and dealing with each potential customer on an individual basis. Our first new catalog had to be hand assembled, but the elegant piece went a long way toward reestablishing the credibility of Berea's crafts. We *met* that optimistic first-year budget proposal, and we've continued to stay on target.

We were not the only busy group. In 1985 the Kentucky Guild of Artists and Craftsmen received an $11,250 grant from the DELvelopment Foundation, Inc., and $3,000 from the Kentucky Arts Council to support its twenty-fifth-year celebration.[2] Activities in 1986 would include a new fair in Louisville, presentation of Guild Fellows, exhibitions of historical and current works by members, and publication of the excellent, informative program, Larry Hackley's *Kentucky Guild of Artists and Craftsmen Twenty-fifth Anniversary Celebration*, which I've referenced so extensively.

A 1985 survey was conducted for Kentucky by Coopers & Lybrand, in which staff members "conducted over one hundred interviews of crafts producers, cooperative administrators,

wholesale shows sponsors, retailers, academics, professionals in the National Endowment for the Arts and Smithsonian Institution, bankers, and employees and officials of state governments, among others. The team reviewed many studies of crafts conducted since 1960, seven of which focused on Kentucky, and over one hundred additional books, booklets, articles, government (both state and federal) publications and data collections pertaining to crafts, tourism and state parks, market assessment, and economic and small business development."[3]

This survey was used as the basis for new programs announced by Governor Martha Layne Collins in 1986. It was reported that, during a press conference in the Governor's Mansion, Collins "cited a recent Appalachian Regional Commission study which concluded that strong government support could double the current $20 million sales figure registered by Kentucky crafts" and introduced a new low-interest loan program for craftspeople. "A pool of about $500,000 will be available for such loans, in addition to state guarantees for loans made through local banks."[4] Other parts of the governor's package were to be a Crafts Business Development Program for the Kentucky Commerce Department, increased craft marketing in the state parks system, displays of crafts in highway welcome centers, and a new seven-member Governor's Craft Council to oversee the activity.

The effort to increase craft sales through Kentucky's highly touted parks system will probably fail again. The best hope would have been to keep Governor Martha Layne Collins for a second term (and Crit Luallen in the commissioner's office of the Department of the Arts). The majority of the Kentucky Department of Parks gift shops buy crafts only under pressure from the top. Department administrators still don't think crafts will sell, and to most of these administrators "craft" means hobby, kit, or photo-reproduced bird prints in "limited editions" of fifty thousand.

Some parks buyers *do* know and purchase quality crafts, but most prefer to stick with T-shirts, tomahawks, and rubber lizards. The new loan program, as finally implemented, is too complicated and short-term to be of major help to craftspeople.

Nonetheless, I went to the gala press conference in 1986, had my picture made with Governor Collins, and hoped that the gambit—a ploy to continue active state support of crafts into the next administration—would succeed. At this writing, results are very mixed. Neither craftspeople nor state government seems to learn from history (or else they simply don't know the history), so in Kentucky we start over every four years. Martha Layne Collins was our first governor to ever get so personally and visibly involved in the crafts effort, to offer such unwavering support to the crafts world, and I doubt that we'll soon see that level of activity again from our chief executive.

We were staying active in Berea. In 1986–87 we took Berea College Crafts to the Buyers Market for American Crafts in Valley Forge, Pennsylvania. We converted the Log House Sales Room into a TV studio for a day and hosted a live news broadcast by WKYT-TV from Lexington. We were featured on the "Today" show, the "Home" show, and in a dozen different magazines. Total sales for Berea College Crafts, for the fiscal year 1986–87, were $1,193,207, and the 1987–88 figure was $1,339,764, compared to $880,673 in 1984–85. The 52 percent sales increase in three years was matched by a drastic cut in operating expenses and in increased productivity from both full-time and student employees. The dramatic turnaround is the result of much hard work, enthusiasm, and support from the administration. In June 1989 a new Berea College Crafts retail store was opened in the Lexington Civic Center Shops, and in early 1990 Peggy Burgio was named retail coordinator for all four outlets.

The face of the Appalachian craft world is rapidly changing.

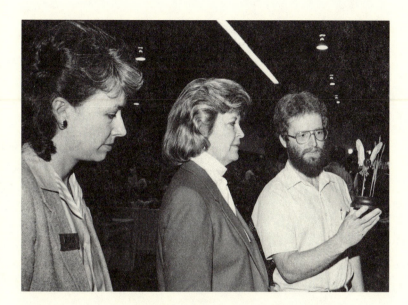

33. Former Kentucky Department of the Arts Commissioner Crit Luallen, *left*, and former Governor Martha Layne Collins with woodcarver Tim Hall during the 1986 Kentucky Craft Market. Photo used with permission of the Commonwealth of Kentucky.

The MATCH board of directors voted reluctantly in February 1989 to dissolve the organization and close the Appalachia Shop in Lexington. The failure of MATCH shops in Cincinnati and Berea, plus a 50 percent drop in Lexington sales, prompted the closure. Working under a heavy debt load, losing member-ship production as craft cooperatives failed, and trying to oper-ate without capital ended a fifteen-year effort. Stanton Wood-craft, Valley Hill Herbs and Everlastings, Artisans Cooperative, Handex, and the Kentucky Design Center are gone. Kentucky Hills Industries is largely supported now by the Save the Chil-dren Federation (SCF). SCF also essentially operates the Quick-sand Craft Center as an in-house weaving center.

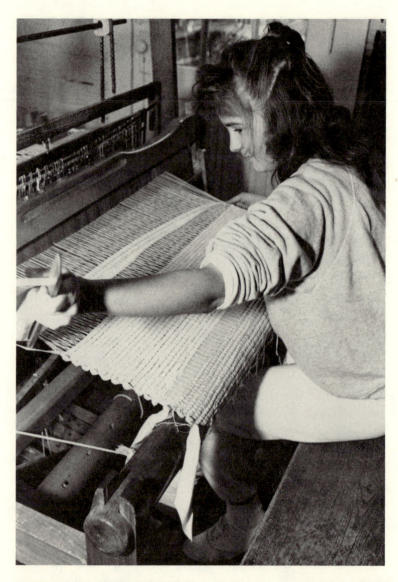

34. Lois Warren, a late-1980s student at Berea College, works on a rag rug in the Fireside Weaving Program. Photo by Joe Bagnoli, used with permission of Berea College.

35. Susan Hutchinson broke through traditional barriers by working as an apprentice in Berea College's Wrought Iron studio in 1989. Photo by Ariff Quili, used with permission of Berea College.

The SCF craft programs are solid ventures. Appalachian Fireside Crafts, a Kentucky corporation established by SCF, owns a warehouse–training complex in Booneville, Kentucky; a farm at Pilot Knob near Berea which was once a farmers market; and the bank–gallery building in Berea with the upper floor rented to SCF Appalachian Program. SCF funds assure that the production and sales programs are always first class, and the craftwork— especially the quilts—is always excellent, and the financial benefits to hundreds of mountain families have been and are a major contribution.

The Kentucky Guild's Lexington shop and Berea fairs have been somewhat eroded by strong new competition. The new Waterside Fair in Louisville has been more of an artistic success than a marketplace. Much of the leadership and educational role the guild once carried is now handled by the Kentucky Art and Craft Foundation and the Crafts Marketing Program of the Department of the Arts. The guild *has* made changes to the fairs, opening up participation and doing less complicated construction, but the huge throngs at an outdoor craft fair in Kentucky are history.

The Kentucky Art and Craft Foundation publishes *Made in Kentucky* three times a year. The summer 1988 issue reported on the third Waterside Craft Fair, jointly sponsored by the foundation, the Louisville Art Gallery–Water Tower Association, and the Kentucky Guild, a show that incorporated performing arts, film, gourmet concessions, and 130 exhibitors.[5] Corporate sponsorships and a gala ball help keep the foundation's programs afloat, and the foundation itself—headed nominally by Phyllis George Brown—focuses more on the one-of-a-kind, arty end of the craft spectrum; the foundation's gallery in Louisville generates sales of over $300,000 annually. In 1988, the Waterside show and the seventh Berea Craft Festival fell on the same July week-

end, providing three contrasting days of craft activity. For 1989, the Louisville event was moved up to a late June schedule to avoid the oppressive heat.

In neighboring West Virginia, the Cultural Center Shop has replaced the widespread arts and crafts programs once run by the Department of Commerce, and now the Department of Culture and History operates shops in Charleston, Wheeling, and in Fayetteville County to sell West Virginia crafts, books, art, and music. The Charleston shop, in the Cultural Center, posted 1987 sales of $161,200 plus processing orders for about $28,000 for six state-park gift shops and running a sales booth at the New York Gift Show. Requirements for marketing through the Cultural Center Shops are West Virginia residency and approval through a jury system.

Much scaled down from the 1960s–1970s craft programs, the Cultural Center Shop operation is somewhat hamstrung by concentrating on an in-state market without the heavy flow of Berea-Gatlinburg-Asheville tourists. Traffic through Southern Appalachia flows primarily along a North-South route, the I-75 and I-40 arteries; the western mountains of West Virginia, unlike the flatter eastern end of the state, don't draw the affluent craft customers on a steady basis.

The same circumstances apply to Northeast Kentucky, where the lack of any sizeable resident population compounds the marketing difficulty. The major exceptions are the almost "ethnic" festivals—the Sorghum Festival in West Liberty, the Apple Festival in Paintsville, the Black Gold Festival in Hazard, "Hillbilly Days" in Pikeville, Court Day in Mt. Sterling—but the market at these events is more for food and trinkets. Morehead State University's annual Appalachian Celebration includes a one-day craft market with the potential for success, but it needs more rigid quality controls and better promotion in Central Kentucky

and the Ashland/Huntington areas. The old truth—that the Appalachian craft buyers come from the "outside"—stands squarely in the way.

In February 1989, Morehead State University and the Kentucky Art and Craft Foundation cosponsored three days of marketing workshops, a sort of mobile marketing seminar which followed slippery eastern Kentucky highways from Carter Caves State Park to Prestonsburg to Berea. In 1990 the mobile workshops program was repeated—cosponsored by the foundation, the Crafts Marketing Program, and the Kentucky Guild—this time in the Western Kentucky cities of Mayfield, Madisonville, and Bowling Green.

The audience for these sessions ranged from rank beginners to successful professionals, a very difficult cross-section to address, an ironic reminder of just how much still needs to be done. A large percentage of those attending were not, by my definition, even doing crafts. They were doing "handywork," wood cutouts and kit-based fabrics, selling to a local marketplace more geared to the flea market than a craft showroom. Industrious and ambitious, more interested in economics than art, very unaware of market realities, this group represents much technical skill which could—if channeled into well-designed products for an out-of-Kentucky market—create a lasting economic impact.

But, as countless developers and organizations have learned, that "channeling" is a very difficult task. It's much easier to find a market for good traditional crafts—native baskets, quilts, and carvings—than to redirect efforts from making trinkets to creating quality handcrafts. The successful craft organizations took existing quality and created a market. The many federal projects that tried to quickly train craftspeople failed miserably. Simple skills can be taught; love for craft cannot. Color and design cannot be taught in a one-day workshop, nor can an understanding of quality marketing.

Most fringe craftspeople will likely stay where they are, artistically and commercially, despite our quixotic lectures and seminars. A few will make the transition to a quality product and marketplace, but most will continue to make by hand items that are already mass manufactured or offered in kit or pattern form. Crafts cannot compete with manufacturing technology, especially now that industry is copying the craft "look" more frequently and successfully, and most smaller Kentucky craft fairs suffer from that reality.

West Virginia's craft fairs, especially the Mountain State Fair in Ripley and the Mountain Heritage events in Harper's Ferry, are much more successful because both are fairly accessible to the large, nearby urban populations. The Northeast Kentucky festivals serve a much larger purpose than craft marketing. These almost rowdy events, usually highlighted by country music, food, parades, and pickup trucks, are much-needed celebrations of local culture, home-grown events that more accurately reflect the Kentucky mountain personality than do dulcimer-dance-folktale weekends.

But, as craft markets, most of the Kentucky mountain festivals cater to the refrigerator magnet–leather sunvisor–offset print variety of "craft." Over the years, I've worked with hundreds of groups and communities wanting to start a local festival, and my consistent advice has been "showcase what you've got." Berea cannot be duplicated with any success, and almost every community has some angle, some history, or some feature that can be incorporated into an event.

To the south, the Southern Highland Handicraft Guild is thriving primarily because of the Folk Art Center, which several years ago replaced the fairs as the major source of revenue. The fairs, much changed in personality and operation during this decade, no longer draw the crush of visitors, and now there's talk within

the guild of going back to Gatlinburg or starting a new show in Charlotte or Atlanta.

That discussion was the focus of the guild's April 1988 meeting in Spruce Pine, North Carolina. During that meeting, then-Treasurer Herb Cohen reported sales of $148,290 in Guild Crafts, $318,820 in the Parkway Craft Center, $77,568 from Guild Gallery, and a whopping $950,211 from Allanstand in the Folk Art Center. Fair sales in 1987 were $477,392, for a year's total of $1,972,281. In 1988 the Allanstand Shop broke the million-dollar barrier, posting sales of $1,038,529. Sales were $1,622,322 for the four shops combined, and total guild income for the year (sales, dues, etc., plus *net* income from the two fairs) was over $2 million.[6] Lively discussions of shop management (whether to open a new one, where, and why) and other future guild marketing

Table 1. Southern Highland Handicraft Guild Sales, 1976–87

Year	Shops	July Fair	October Fair	Warehouse	Total	
1976	$403,179	$140,864	$158,212	$130,356	$832,611	
1977	$398,121	$160,845	$121,313	$122,533	$802,612	(-3.5%)
1978	$434,211	$164,739	$94,486	$88,676	$782,112	(-2.7%)
1979	$471,915	$124,453	$92,368	$161,306	$850,042	(+8.6%)
1980	$757,598	$155,509	$96,615	$247,761	$1,257,483	(+47.9%)
1981	$851,289	$175,174	$89,181	—	$1,115,644	(-11.2%)
1982	$892,146	$184,934	$76,247	—	$1,153,327	(+3.4%)
1983	$920,485	$142,442	$112,923	—	$1,175,850	(+1.9%)
1984	$955,940	$169,236	$129,762	—	$1,254,398	(+6.6%)
1985	$1,123,926	$195,509	$198,550	—	$1,517,985	(+21%)
1986	$1,215,530	$245,275	$200,271	—	$1,661,076	(+9.4%)
1987	$1,494,889	$265,998	$211,394	—	$1,972,281	(+18.7%)

SOURCE: Southern Highland Handicraft Guild.
NOTE: The warehouse was closed in 1980.

Table 2. Annual Shop and Fair Sales Totals, 1976–80

Year	Total	
1976	$702,255	
1977	$680,279	(-3.1%)
1978	$693,436	(+1.9%)
1979	$688,739	(-0.6%)
1980	$1,009,722	(+46.6%)

efforts led to a nearly unanimous vote during the 1988 meeting to reestablish the Marketing Committee to advise the board of trustees on future directions.

To better look at the guild's member marketing programs, shop, warehouse, and fair sales were compiled and are charted in table 1 for the period from 1976 through 1987.

If warehouse sales are excluded, the annual 1976 through 1980 shop and fair sales totals are as given in table 2.

The 270 percent shop sales growth, from $403,179 in 1976 to $1,494,889 in 1987, is very real but a little deceptive. In 1980, shop sales totals leapt by $285,683, marking the opening of the Folk Art Center and giving an early indication of just how much the center was to mean to the guild. And if Allanstand Shop sales are backed out of the 1987 total, the other three stores did only about $495,000, a much more realistic growth pattern, and the venerable Parkway Craft Center accounted for about $319,000 of that total. The warehouse sales total of $247,761 in 1980 is also deceptive. In that final year of operation there was a "clearance sale" to liquidate inventory.

Fair sales patterns are more erratic. The October 1975 fair, the last in Gatlinburg, posted sales of almost $225,000. The rapid decline that started in Knoxville continued even after the 1980 move to Asheville, bottoming out in the recession year of 1982,

but has climbed steadily since then. The July fair, which suffers in pre-1976 comparisons to October in Gatlinburg, has since 1977 been the stronger event. The July show is one full day longer, perhaps accounting for the volume difference, but in 1985 the October fair was actually a better sales event. Combined fair sales have increased by 59.6 percent during the period charted. The July 1988 fair posted sales of $216,741, down 18 percent from the 1987 total, prompting much consternation, complaining, and intensified promotion of the October edition. "Edition," by the way, reflects a change in the way the fairs are promoted. After many years as the "Craftsman's Fair of the Southern Highlands," a name change was deemed necessary to distinguish this event from the many others, and the result was "Guild Fair," summer or fall "edition."

Total guild sales climbed from $832,611 in 1976 to $1,972,281 in 1987, a 137 percent gain despite the closing of the warehouse. Those impressive numbers, mostly reflecting the presence of the Folk Art Center, likely account for the tension present in today's guild management and reflected in the annual meetings.

One direct result of the 1988 annual meeting was a marketing survey mailed to members in late 1988, an effort by the new Marketing Committee to find out just *who* guild members are in terms of the sales arena. Of the approximately 700 surveys mailed, about 230 were returned. The validity of this survey, even with the high percentage of participation, is lessened by the diversity of the guild's membership; the only concrete assumptions that can be made about the total membership are that (1) they live within the geographic boundaries, and (2) their work has been approved by the guild's Standards Committee.

The assumption cannot be made that every member even wants to sell. Many guild members are retired or semiretired; many work at full-time jobs and do their crafts as a sideline; some

join the guild for reasons of prestige, social interaction, or educational opportunities.

Perhaps the most telling statistic from the 1989 survey is that (of those responding) 24 percent earn $5,000 or less per year from the sale of crafts, and 40 percent earn $20,000 or more. Those extremes seem to identify the two most diverse elements of the guild, those who work in crafts for pleasure and those who are craft professionals. Almost 62 percent said they depend on craft sales for their primary income. About 85 percent sell wholesale, and of these 42 percent report that over half their annual volume is wholesale.

About 31 percent of those responding do not sell to the guild shops at all, and another 20 percent sell the guild less than 10 percent of their annual production. But 76 percent said they would supply a new guild shop and 69 percent would participate in a new fair. The disagreement here is what type of shop and where, and where to stage the third fair. One strong group wants a gallery-type shop in a metropolitan location, slanted toward the sale of more contemporary craftwork; others simply want another shop. "Gatlinburg" and "Not Gatlinburg" were strong contenders in the location for a new fair, along with Atlanta and Charlotte.[7] Information from the survey is, at this writing, still under study by the new Marketing Committee (70 percent of those who responded to the survey also wanted this committee to "assume an active role in evaluating/overseeing current marketing programs") and the guild's board of trustees.

Most of the Appalachian institutions involved so actively in the late-1920s craft revival are still strong and active. I've already discussed Berea College at length. I would add only that the support for the crafts cuts across departmental lines and that the healthy tension of operating as a business within an educational institution assures that we'll never become either merely a pro-

duction factory or just a craft school. Our most important products are not the skittles games, brooms, or woven placemats; we help the rest of Berea College produce students and graduates whose liberal arts educations have been broadened and strengthened by the craft experience.

Three other institutions were and are the cornerstones of the Appalachian craft world. The John C. Campbell Folk School, Arrowmont, and Penland have served and survived by adapting to changing times.

Nowhere in Appalachia do the settlement schools still serve their original purpose of bringing basic educational opportunity into remote mountain areas. Improved highways and public school systems had largely displaced that traditional role by the early 1960s, and the schools that were to survive had to find new ways to serve. Some who closed their doors were Annville Institute and Hazel Green Academy, both once active in crafts, though Dorothy and Enos Brockman bought and continued Annville's "Campus Crafts" weaving program. Probably a dozen more settlement schools shut down when the need for mountain boarding schools was gone. A notable exception is the Hindman Settlement School in Kentucky, which now offers very specialized educational programs and summer sessions such as the Appalachian Writers Workshop.

But the Campbell Folk School, Penland, and Arrowmont have kept their focus on crafts, though in changing ways, over the decades. Perhaps the Campbell Folk School has had the most difficulty in clearly defining its new role. Changes of staff and of emphasis—from farming to summer workshops to alternative lifestyles—have left some confusion, and a seeming indecision as to direction has held back the school's craft instructional and marketing programs. The workshops seem to try to be both folklore and contemporary in direction, very different from the work of Penland and Arrowmont. One constant has been the wood-

carving program, one of Olive Dame Campbell's early efforts, though the idle store-bench whittlers have been mostly displaced by women who carve.

Funding from the Lyndhurst Foundation has enabled the Campbell Folk School to make its programs better known in nearby Chattanooga, Tennessee. The school's director, Ron Hill, in 1988 announced plans to build a new 4,500 square-foot multi-purpose building, a $500,000 complex that would include a new dining hall. A National Endowment for the Arts grant has funded Doug Day's staff position as folklorist, a move Hill calls "the first step toward a planned regional folklore center" at the school.[8]

At Penland, Verne Stanford, the then-new director, announced a 1988 schedule which included a basic design course and a residency in craft writing. A $3 million fund drive was underway, with $750,000 pledged at the outset. Workshop leaders for 1988 included Val Cushing, Tom Turner, Daniel Rhodes, Robert Levin, Evon Streetman, Heikki Seppa, and Arturo Sandoval.[9] Though somewhat less colorful in his approach, Stanford was obviously carrying forward Bill Brown's concept of "getting the best horses in the business." Classes in drawing, *ta'i chi*, paper, and book arts reflect changing trends.

Penland must survive without the financial support of an organized educational institution, though college credit is offered through East Tennessee State University and Western Carolina University, so fund-raising is a constant for the school's director and board of directors. A 1988 "Master Plan" for Penland's physical renovation calls for functional changes to separate, consolidate, and streamline operations; money-making enterprises such as increased retail sales, farming and timber sales; patrons to support building projects; and a laundry facility. This study deals with the physical needs and potentials of Penland, a necessary complement to the superb educational effort.[10]

Two new major grants totaling $300,000 are helping Penland

move toward its goals. Late in 1988 Verne Stanford announced that the Steele-Reese Foundation had awarded $200,000 to be used as matching funds for a National Endowment Challenge Grant, and that the Janirve Foundation was providing $100,000 toward the construction of a new print arts facility.[11] Stanford has since left Penland.

Across the mountain in Gatlinburg, the Pi Beta Phi School became Arrowcraft School, which became Arrowmont. Sandra Blain was assistant director of the school for eleven years before becoming director in 1979; Sandy is also professor of ceramics at the University of Tennessee in Knoxville, an outstanding clay-worker, and a trustee emeritus of the American Crafts Council.

The University of Tennessee was the first southeastern university to include crafts in the curriculum. Jean Harris, dean of the College of Home Economics, established the Crafts Department and brought Marian Heard to Knoxville, with the far-reaching results discussed throughout this book.

Arrowmont's history began in 1912, when the national women's sorority founded the Pi Beta Phi School, which operated through the late sixties as Gatlinburg's elementary school. In 1926 the Arrowcraft Shop was added, and in 1945 the first craft workshops—directed by Elsa Ulbrecht—were presented. Ulbrecht and Marian Heard were codirectors of the workshops in 1946, and from then until her retirement, Heard directed the sessions. Today, about one thousand students attend Arrowmont each year. Spring and summer sessions feature some of the nation's finest craftspeople—Tim Mather, Ed Lambert, Lenore Davis, Terrie Mangat, and Liam O'Neill were on the roster for "Summer 88"—and Arrowmont hosts Elderhostels as well as enrichment programs for area elementary and high-school students. Arrowmont is a regional meeting center (for groups such as the American Crafts Council and Southern Highland Guild) and

sponsors competitive exhibitions such as "The Dripless Spout: Innovative Teapots" in 1988 and "Animal Imagery: New Forms, New Functions" in 1989.

The Southern Highland Handicraft Guild Fairs in Gatlinburg—from 1948 to 1949 on the grounds of the Pi Beta Phi School, from 1959 to 1975 in the new auditorium—were the best craft displays and markets of the era, handsome exhibits supported by an affluent, eager audience. During the 1988 annual meeting, members discussed a possible spring fair in Gatlinburg; some wondered if the supportive customers would still come to Gatlinburg, which once was primarily for the upper-level income groups but now draws everyone, while others called the Gatlinburg market "too traditional" and felt that the current, more contemporary craftworkers could not sell there. The argument fizzled, and no action was taken in 1989.

Ray Pierotti, formerly the director of Arrowmont, is now working to revive the historic Hambidge Center in the North Georgia mountains. Work at the Joe L. Evins Center for Appalachian Crafts in Tennessee goes on quietly as part of Tennessee Tech. The major graduate-level crafts program in Appalachia is still at the University of Tennessee; a strong two-year program is part of Haywood Technical Institute in North Carolina. Craft education is alive and well in Appalachia, with more emphasis now on the craftsperson's financial survival.

In a different vein is the work of Morehead State University in Kentucky, which since 1985 has been collecting the folk art of Northeastern Kentucky. Art Department Chair Tom Sternal and Collection Curator Adrian Swain moved into marketing by staging such events as "Good and Evil," a two-month exhibition in Gallery Nine at the School of Art and Design of the University of Illinois at Champaign-Urbana. In the catalog for that exhibit, Lisa Wainwright concludes that "the success of folk art lies in the

depth of the artist's convictions. The folk artist creates from a purely spiritual and pleasurable impulse, with only an audience of family and friends."[12]

Morehead State University's success in marketing folk art through urban galleries led to funding, in 1989, for a full-time marketing position within the Art Department. Much as the early leaders of the Southern Highland Handicraft Guild discovered during the 1920s, MSU has found that commerce can support creativity and preservation.

Not all aspects of folk art marketing are positive, especially in human terms. Jan Arnow, in *By Southern Hands: A Celebration of Craft Traditions in the South*, worried about the impact of publicity on native craftspeople, and was warned that intervention might bring problems. Arnow wrote, "I have personally witnessed the tragic devastation caused by well-intentioned but careless patronage, and I share the folklorists' passionate concerns for the lives and work of traditional craftspeople as a vulnerable trust."[13]

Michael Owen Jones wrote about Chester Cornett, the Eastern Kentucky chairmaker, a master craftsman and folk artist who was "discovered" in the sixties and ultimately became almost a parody of himself and of the "mountain man." Jones wrote, "Chester seemed to feel greatly indebted to those who helped him. He retained a deep reverence for Gurney Norman, the young journalist at the Hazard *Herald* who had published an essay about him in the spring of 1965. This article resulted in a photo essay in the Louisville *Courier-Journal* in June 1965, then a piece in the *National Observer* in December. It eventually led to other articles in other regional and national publications—all of which provided many additional sales for Chester at higher prices, which at the time he said he wanted."[14]

"Letters went to comin in," said Chester Cornett in a letter to Jones, "from East South North West wantin to no if they Culd

Buy a Laddre Back Rockker and they said they Enjoid Redin about me in the natin advzer newspaper, I never herd of this papre."[15]

Cornett, who patterned his appearance after Li'l Abner as a sales gimmick, and whose personal life was worsened by his overexposure, may have been the inspiration for Jim Wayne Miller's poem, "The Brier Losing Touch with His Traditions":

> Once he was a chairmaker.
> People up north discovered him.
> They said he was "an authentic mountain craftsman."
> People came and made pictures of him working,
> wrote him up in the newspapers.
> He got famous.
> Got a lot of orders for his chairs.
>
> When he moved up to Cincinnati
> so he could be closer to his market
> (besides, a lot of people lived there now)
> he found out he was a Brier.
>
> And when customers found out
> he was using an electric lathe and power drill
> just to keep up with all the orders,
> they said he was losing touch with his traditions.
> His orders fell off something awful.
> He figured it had been a bad mistake
> to let the magazine people take those pictures
> of him with his power tools, clean-shaven,
> wearing a flowered sports shirt and drip-dry pants.
>
> So he moved back down to east Kentucky
> Had himself a brochure printed up
> with a picture of him using his hand lathe.
> Then when folks would come from the magazines,
> he'd get rid of them before suppertime
> so he could put on his shoes, his flowered sport shirt
> and double-knit pants, and open a can of beer

and watch the six-thirty news on TV
out of New York and Washington.

He had to have some time to be himself.[16]

Whether we do local craftspeople a favor by "discovering" them will be a long-term argument, one likely never to be settled to anyone's satisfaction. Underestimating the sophistication of Appalachian people has been a common error, but often damage has been done by spotlighting a life-style which is so easily misunderstood.

Many old friends from the craft world have shifted gears and started anew. Gentle Joe Patelidas went from the Southern Highland Handicraft Guild to the Blue Ridge Hearthside Crafts Association; then he left there in turmoil and now is in fast-food management. Tennessee administrator and potter Roy Overcast makes sponge-decorated pottery in truckload quantities for the Cracker Barrel store chain. Sue Ford has gone back into private business in Georgia. Don Page operated a coal mining museum in West Virginia; in early 1990 he came to Renfro Valley, Kentucky, to be part of a major rejuvenation program underway there; he went back to West Virginia before the year was over. Nina Poage was city manager of Richmond, Kentucky. Charles Counts's pot shop moved to Atlanta and new Counts is in Nigeria. Successful Kentucky potter Robert Wolchock abruptly quit to go back into advertising. Still others talk about career changes, the need for a more stable life-style and security past the whims of the next craft fair. Success in the craft world is sometimes shallow, and the intensity of the effort can wear down the strongest of personalities.

In 1989 the death of Mike Scott, editor of *The Crafts Report*, silenced a major positive voice for the craft world, and dampened the excitement of the entry into the new decade.

The 1990s craftsperson has many options. He or she can teach, be an individual studio producer, move into large-scale production with employees and apprentices, do one-of-a-kind art or mugs by the thousand, and have in every direction the *potential* for success. Skill, creativity, excellence, hard work, and marketing are, as they've always been, the necessary prerequisites. The work of the past sixty years has opened doors, but each individual must bear the ultimate responsibility for success or failure.

As every new wave of activity peaks and fades, those who were in crafts for the glamour and life-style drop out, and a sort of natural selection takes place. Those who won't stick with a commitment to excellence, those unwilling to make the sacrifices and put in the hours, find something else to do. Those who love the craft, who live for the craft, grow and survive. Every heavily funded and overly publicized effort, such as the 1960s–1970s federal projects, opens the doors for a few more lasting efforts by groups and individuals.

The next chapter discusses Appalachian craft design from past and future viewpoints, drawing heavily on personal opinion. The final chapter is an evaluation, a discussion of why it has all happened and what might take place in the future.

The work goes on.

11.

"Ma Took a Notion"

An Irreverent Study of Appalachian Craft Design

For more than three decades, southbound tourists wound slowly around and over the hills of Kentucky, Tennessee, and North Carolina on crowded U.S. 25E, a winding two-lane asphalt ribbon which was Appalachia's major north-south artery for most of this century. The narrow roadway twisted out of Berea to Cumberland Gap, over Clinch Mountain to Bean Station in Tennessee, around the TVA lakes to Newport and Hot Springs, followed the French Broad River to Asheville, then dropped down to flatter lands and the direct route to Florida.

Travelers motored past Fort Sequoyah and Dogpatch, past chained rocks and chained black bear cubs, whitewashed diners and quaint tourist cabins, past roadside stands overflowing with sourwood honey and clumps of bright orange bittersweet. Most stopped to buy from these roadside merchants, to dig through racks of gaudy chenille peacock bedspreads and bathrobes, heavy chalk roosters and plaster-of-paris nativity scenes, Comanche warbonnets, and crude chairs pinned together with rusted nails. Storefronts advertising "mountain handicrafts" stocked their shelves with corncob pipes and corncob jelly, Confederate battle flags and "hillbilly" dolls, teddy bears and landscaped china plates, tufted rugs, and long-billed green sunvisors.

A shorter version of this chapter appeared in *Appalachian Heritage* (Berea, Ky.: Berea College), 16, nos. 2 and 3 (Spring–Summer 1988): 89–94.

Today, busy Interstate 75 whisks the tourists through Kentucky and over Jellico Mountain in bland efficiency. A new four-lane road bisects troublesome Clinch Mountain, and Interstate 40, from Newport to Asheville, is one of America's most expensive and scenic stretches of modern roadway. The old roadside stands are largely gone, but a "handicraft" market still thrives in places like downtown Gatlinburg, Tennessee, and Cherokee, North Carolina—garish wastelands of gimmickry and imported gadgets. Millions of Americans have traveled through the very heart of Appalachia, spent their cash and crawled happily across Mt. LeConte in snail-like processions of bear watching, and gone home carrying indelible impressions of Appalachians as plastic people. To many travelers, we must surely be perceived as some oddball cross between Southwest Plains Indians, drooling Li'l Abner hillbillies, and America's major manufacturers of firecrackers.

But, fortunately, increasingly large numbers of tourists seek out the craft shops of Berea; track down the superb studio craftspeople of Gatlinburg and see the Arrowcraft Shop and Arrowmont School's galleries; visit the Qualla Arts and Crafts Mutual in Cherokee; and tour the Southern Highland Folk Art Center on the Blue Ridge Parkway in Asheville. Craft fairs, exhibitions, and media coverage are working, giving good exposure to Appalachia's quality crafts, building an increased awareness of the excellence of design and workmanship that gives the region's crafts a lasting impact.

Artisanry—detailed, skilled, intricate handcraft—is the benchmark of Appalachia's craftspeople. For the most part, the reputation is well deserved. Appalachian craft design is another matter, a hotly disputed issue between folklorists, production centers, educators, and contemporary designer-craftspeople. There is no one, simple, agreeable answer to the question of just what Appalachian craft design is.

Patchwork quilts, handwoven coverlets, split-oak egg baskets, animal carvings, and rustic brooms are generally considered native to Appalachia, but the same crafts are also part of ancient cultures all over the world. Many insist that the "Appalachian" dulcimer is a true development of the region, but North Carolina dulcimer maker Edsel Martin saw it differently when interviewed in Edward DuPuy's *Artisans of the Appalachians*: "As far back as I can trace it," said Martin, "it was the third chapter of Daniel; I believe it was King Nebuchadnezzar. That's as far back as I want to take it."[1]

Appalachia's traditional craftspeople were never overly concerned about a design history, nor were they impressed by new innovations. Clementine Douglas, while traveling up Crank's Creek in Kentucky during the 1920s, admired a weaver's coverlet:

> My hostess said "Thatun's called Bonaparte's Defeat." I said I'd heard tell of Bonaparte and she said "Hit don't mean a thing; it's jest how you call it." When I asked about another, she said "We just call it 'Ma Took a Notion.'"[2]

Design inspiration in Appalachia is often delightfully direct and simple. Smith Ross wrote in *Come Go with Me*:

> At one time there were twelve women making cornshuck dolls. We learned to identify each person's work. Grace's dolls all looked as if they were pregnant. Perhaps it was because she had twelve children and had been pregnant most of her life.[3]

The traditional Appalachian handcraft designs came from the Scottish highlands, from the Irish and English and German settlers, from the ingenuity of an isolated people making do with what they had. The purity of the coverlet and quilt patterns was preserved because there were few outside influences and no ready marketplaces.

The "gee haw whimmydiddle," the magic stick of mountain lore, sometimes called a "liar's stick," is simply two short sticks, one notched with a propeller attached; when the sticks are rubbed together, the propeller turns. One way of rubbing makes the propeller turn right ("gee," in mule-driving terminology), and a different rub creates a leftward rotation ("haw"). Uncertain of origin, made from whatever wood is handy, the whimmydiddle has long been a staple of the Appalachian craft market.

What makes a whimmydiddle work? According to West Virginia toymaker Dick Schnacke's tongue-in-cheek analysis, "The variably generated vibration frequencies and harmonies thereof react in concert upon the main body of given mass and configuration to set up vibration patterns and nodes which agitate the essentially statically balanced and frictionless rotor into rhythmic rotational movement."[4] That is, *if* you say "gee" or "haw," and if you hold your fingers right. To learn more, visit the Southern Highland Handicraft Guild's World Champion Whimmydiddle Competition, held each August at the Folk Art Center in Asheville.

The other famed "Appalachian" game made at Berea College, "skittles," is really an ageless game originally called "quille" and brought from France to England where it became popular during the fourteenth century as a tavern betting game.[5] Skittles came to Berea College's Woodcraft Program in 1929, brought by Dr. William Gordon Ross, and over sixty years later is still Berea's best-selling product. Each November, the William Gordon Ross Skittles Tournament, the "world championship" event, is staged in the college's Log House Sales Room.

The past sixty years of increased production and sales have, in many minds, weakened the craft tradition by bringing in an infiltration of design changes, new materials, bolder colors, and working shortcuts. A fear of losing the Appalachian tradition of

quality and honesty in craftwork, plus a sincere desire to up-grade product design, has preoccupied many educators and craftspeople since the turn of the century. Fear of the growing use of machinery and apprehension over the booming late-1930s tourist market obviously prompted Mary Ela's "Made by Hand" address, delivered in 1940 to members of the Southern Highland Handicraft Guild gathered in Cherokee, North Carolina.

"The skill of a craftsman is not precious to any one but himself unless he uses that skill to make honest, useful, interesting things," Ela told the guild members,

> There is no virtue in spending time on a dull design, and there is no reason why anyone should pay a craftsman for time thus spent. The craftsman of this time and place answers with his life and his products the question of the place of handcrafts in this century. He may prostrate himself to the "tourist trade" and flood a trinket-flooded market with more trinkets. He may comfort himself with the belief that his trinkets are better in design and workmanship than are the trinkets of his neighboring craftsman. But if he is a designer crafts-man, with love of life and people as well as a hunger for bread, he will not be satisfied with letting tourist demands for less-than-a-dollar purchases keep him from weaving the blanket that is as soft and as gray and white as the clouds, or building the bench which is as honest and as whole and right as a living cherry tree.[6]

Other comments from Ela's same address:

> *Design is the life force of a craftsman projected into material.* Unless the craftsman has that force, unless he can see and feel and know the beauty of the thing he builds growing in his hands, he cannot even copy a design with vitality.

> Other generations made things for people, instead of the market.

> A tradition which the world respects and a hunger which it does not outgrow is in our keeping. If we are strong enough, handicraft may be a force in helping the race of man remember that the machine is a

36. The gee-haw whimmydiddle in action, powered by physics, myth, and folklore. Photo by Andy Shupe, used with permission of Berea College.

tool and not his master; that there is, within each of us who breathes, a precious quality of life which makes a man different from a machine.[7]

Some of Mary Ela's concerns are shared to a degree by folklorists, who tend to protest the evolution of Appalachia's traditional designs and processes; true folk art, some insist, does not respond to the marketplace.

History would disagree. So would I. Few folk artists ever worked purely for the pleasure of creating. Almost always, there has been a physical need for the artisan's work, a market of some sort; always, the folk artist has worked with contemporary tools, materials, and techniques.

Stages and examples of folk art are preserved in museums. Living folk art continually evolves. For better or worse, today's Appalachian folk arts are the calico bonnets and gee-haw whimmy-diddles, the patchwork pillow tops and plentiful rag dolls, the bright woven throw rugs and colorful cornshuck flowers.

Charles Counts, in his valuable study *Encouraging American Handcrafts: What Role in Economic Development*, touched briefly on the relationship of folk art preservation to marketing: "Crafts which have persisted longest in Appalachia or on Indian reservations have been those with authentic ethnic qualities, based on excellence in design—*that is, when they were also supported by sound marketing practices*."[8] Counts hoped to avoid pitfalls and familiar old arguments in his report by *"recognizing design as the common denominator for all material products of human expression, whether made by hand or machine."*[9] Charles also noted that true working folk artists were rare even in the more remote Appalachia of twenty years ago.

Thirty years earlier Allen Eaton *had* found some mountain woodcarvers who had "worked out their designs largely or en-

tirely unaided, designs that sometimes resulted in as true expressions of folk art as can be found anywhere." One such carver, Nicodemus Demon Adams of Virginia, has as his favorite subjects "miniature coffins and tombstones which he executes with remarkable technique, the coffins being made of one piece of wood with sliding lids which fit perfectly. Mr. Adams does not find these coffins very popular."[10] But, added Eaton, Mr. Adams did enjoy carving the coffins and giving them to his friends. No response from these friends is quoted.

Edsel Martin's 1960s coffin carvings were more complete. Usually they included a team of mules pulling a wagon, along with a teamster and a preacher, and—to the shock of most who slid open the coffin lid—the corpse. Edsel, perhaps as a sign of how times change in thirty years, actually sold his carvings.

In addition to disagreement on how to identify and preserve folk art, there are some common misconceptions regarding design "traditions" in parts of Appalachia. The smooth, stylized North Carolina Cherokee Indian woodcarvings—the modernistic ducks, bears, and geese—do not stem from tribal tradition or primitive artistic expression. The Cherokee carving style is the imprint of Amanda Crowe, a native who studied art and sculpture at the Art Institute of Chicago and came home to teach. The skills are what are traditional, and the sculpting reflects an innate knowledge of animal skeletal structure, but the style is simply Amanda.

Gatlinburg's woodworkers were not born at the lathe, shaping acorn bookends and candlesticks. The "heritage" stems from O. J. Mattil, who supervised a 1930s training program that involved many of Gatlinburg's woodworkers. The sons and grandsons carry on the work, passing on the skills and the new tradition, but the source was one man's unflagging effort to build a craft industry in a remote little Tennessee town.

Berea College's elegant Woodcraft Program furniture is of New England heritage; the program was heavily influenced by collector and author Wallace M. Nutting. Bybee Pottery's designs are universal and timeless, though perhaps weakened over the years by increased use of molds and mass production.

David Whisnant, in his highly controversial *All That Is Native and Fine*, credited mountain missionaries of the early 1900s with creating artificial Appalachian "traditions" in crafts, dance, and music. Whisnant uses the Hindman Settlement School, the John C. Campbell Folk School, and the White Top Folk Festival as examples of how Scandinavian, English, and Danish influences were introduced, of how perhaps well-meaning but misguided missionary workers "improved" the primitive mountain culture. Of leaders such as Mary Ela, quoted above, Whisnant points to overemphasis on art as opposed to native talent, of designing non-Appalachian goods for an urban marketplace.

Whisnant's facts are accurate, painful to many; I agree that much of what is now considered "Appalachian" was literally imposed by outsiders (with help from a willing marketplace, as far as the crafts are concerned). I disagree with some of Whisnant's conclusions, and firmly believe that, *without* the missionary effort, much of today's craft market would not exist. The ultimate benefits outweigh the deceit.

Native craftspeople, writers, and musicians—those who draw on their own upbringing rather than on footnoted academic studies—are sometimes eyed warily by Appalachian scholars. The quaint, orderly image projected by groups such as Berea College's Country Dancers is a far cry from the harsh reality of survival in a coal camp or on a hillside farm, and most dainty academic studies lose the mountaineer's sometimes humorous and bawdy personality. At any rate, Whisnant's book is must reading for anyone studying Appalachian arts and culture, a study of "how

mostly educated, urban, middle- and upper-class 'culture work-
ers' perceived, manipulated, and projected the culture of the
mostly rural, lower-class working people in the Southern moun-
tains."[11] And Whisnant does, indeed, say bad things about good
people.

If there exists a true "Appalachian" design tradition, it is per-
haps best described as simplicity and function, tempered with
individual ornamentation. I wrote, for a mid-1970s "common
sense" design assembly convened by Kentucky Governor Julian
M. Carroll:

> "Design" is not a word or a world reserved for artists. Rather,
> design is an integral element of life and our surroundings. Our cars,
> buildings, dishes, clothes, tools, and artifacts are all end results of the
> designer's skill. A sturdy and simple screwdriver is a prime example
> of form and function effectively combined.
>
> Honesty and simplicity are design essentials, and Kentucky's fu-
> ture planning should adhere to straightforward excellence. Kentucky's
> heritage, culture, and natural abundance should influence all design,
> but careful avoidance of overstated "down home" themes is neces-
> sary.
>
> Common sense design stresses excellence, and this should be
> Kentucky's goal.[12]

Good, indigenous Appalachian design is honest and direct, a
creative solution to a practical problem. That tradition is obvious
in the work of family-trained and self-taught crafts producers of
the region, though some family-trained artisans are so far re-
moved from the beginnings that they no longer know why their
products were originally designed as they are.

The output of the schooled Appalachian craftspeople, and that
of the many skilled artisans who have relocated here, is another
story. A current exhibition of Appalachian handcrafts would
likely include but little traditional work; the spotlight would be
on contemporary weaving, ceramics, metal, and wood very simi-

lar in appearance to crafts being produced almost anywhere else in America.

Newcomers alter the traditions. Quilts become bold, modernistic wallhangings; baskets evolve to loosely woven sculptures which do not function as containers. Pottery is primarily decorative. The contemporary Appalachian studio craftsperson is university trained, a talented professional, and—though decorative design sometimes reflects the mountain setting—the artwork differs little from works done outside the region.

In the forties and fifties, craftspeople from across America discovered the beauty (and comparatively low cost) of homesites in North Carolina and Tennessee, found a thriving marketplace in the shops and fairs of the Southern Highland Handicraft Guild, and relocated here. The impact of the newcomers is a fiercely debated issue, compounded by the 1960s influx of eager young people drawn by the "War on Poverty"; when the war was lost, many of the soldiers stayed on. The "Connecticut hippies," as one West Virginia craft administrator affectionately labeled this group, brought leather shops and wood-fired kilns, tie-dyed T-shirts, and cast wax candles, as well as an unfinished look which prevailed for much of two decades.

Bill Brown's innovative residency programs at the Penland School brought in talented young craft professionals, and many decided to live nearby after completing their residencies. In and around Gatlinburg, up the hollows of Kentucky and West Virginia, and across Western North Carolina, a new breed of craftspeople set up shop.

The better-educated, more vocal newcomers, depending on your point of view, either (A) brought new life and leadership to the withering craft organizations of Appalachia, improved the overall design levels, and upgraded the craft community, or they (B) took over the organizations for their own selfish purposes,

pushed the traditional Appalachian craftspeople aside, and diluted the purity of the region's handcrafts.

Certainly the outsiders (or educated insiders), the contemporary craftspeople and the university-connected teachers and administrators, dominate the organizations. Few traditional craftspeople serve on boards or committees; the native craftsperson is often reluctant to speak out in large public gatherings. My experience, based on work with the Southern Highland Handicraft Guild and the Kentucky Guild of Artists and Craftsmen, tells me not only that neither organization could have been born without the almost evangelistic effort of "outside" leadership but that today's new leaders have lost much of the cooperative spirit and respect for local culture which characterized their predecessors.

But the newcomers definitely have brought new design directions to Appalachian crafts. Woodworker Rude Osolnik came to Kentucky in 1937, found an abundance of native hardwoods and eager Berea College students, and is still here. Osolnik has been a leader in Appalachian craft organizations for over forty years and has forever altered the Appalachian woodworking industry.

Osolnik is a master of wood utilization, of letting the pattern and grain of the wood shape the final product. His graceful lathe-turned candlesticks and free-form twig pots (done originally to make use of wood scraps) are imitated in dozens of production studios. Osolnik, by example and by almost fifty years of teaching, has been a major influence on the region's wood design, working always toward uncluttered, flowing excellence.

One of Rude Osolnik's pet terms, "overengineered," is an apt description of much of the Appalachian production flowing to the market. Fussy, overdecorated objects, usually inspired by kits or magazine "how to" articles, are the bane of Appalachia's quality craft marketplace.

A relatively new breed of craftsperson is the native who re-

ceives advanced training and comes home to live and work. Charles Counts is a native Appalachian, heavily influenced by his early work at Berea College and his studies of the region's family production potteries, but his own work is more reflective of his studies with Marguerite Wildenhain. Technical perfection and prolific output are Counts's more Appalachian characteristics, and his graphic designs—most dramatic in his clay mosaics and striking quilt patterns—carry the mountain motif.

Education in Appalachia's handcraft centers is far removed from tradition. Students at Penland School, Arrowmont, and the Joe L. Evins Appalachian Center come mostly from outside the region, as do the instructors and working concepts. At Berea College, tradition is much more evident in the work-oriented Student Crafts Program than in the art classrooms.

Traditional mountain crafts are the media flag for Appalachian craft fairs, but most of the work actually shown and sold is very contemporary. Show sponsors, aware of the colorful drawing power of chairmakers and basket weavers, are understandably reluctant to confess to the public that native craftspeople are in the minority. It works: customers drawn by traditional craft demonstrations stay to buy decorative pottery and glass.

Craft production centers, more common to Appalachia than to any other region, vary in their design approaches. The much-touted 1960s solution—bringing in outside designers and applying traditional skills to more modern products—has been less than a sparkling success.

A Kentucky group once known as "Mountain Toymakers" was moderately successful in marketing members' traditional sewn dolls, enough so to attract the attention of area economic development agencies. The new "Possum Trot" toy line was superb, delightful, and—unfortunately—too slick and expensive. They lost the handmade, Appalachian quality which had been

the group's market advantage. Now, both Mountain Toymakers and Possum Trot are gone; the factory was used to sew children's clothing for an English firm until closed.

Progress, as defined by business developers, does not always work in the Appalachian craft world. The more successful craft cooperatives stick with local designs, traditional products made in the home and collected into a central location for marketing. The products have been modified, in varying degrees, to speed production. Much improvement has been made in the quilts, soft toys, and cloth accessories which are the staples of many co-ops, primarily through the centralized purchasing and distribution of all-new, color-coordinated materials. Cabin Creek Quilts, a two-hundred-member West Virginia cooperative, maintains a huge inventory of cloth and precuts the patterns in selected colors. To the horror of purists, one woman may piece the top and another do the actual quilting, while staff members do the actual design and marketing. Appalachian Fireside Crafts in Kentucky uses a similar approach to quilt production. Staff members control pattern and color to make use of existing strong technical skills to create bold, contemporary quilts based on traditional design.

Improving the design of existing production—as opposed to introducing totally new concepts—has been a much more workable means of developing Appalachian craft production. Quite unintentionally, the federal government dramatically upgraded the quality of soft toys and bedding products with its tough safety standards; the mountain tradition of making quilts from scraps of used material had to stop when finished goods started crossing state lines to be sold in states with strict bedding laws. All-new material is now used for batting and covers on the quilts sold by major producers.

Appalachia's large, on-site crafts producers—such as Churchill Weavers, the Stuart Nye Silver Shop, and Iron Mountain Stone-

ware—employ production workers to execute set designs. At Churchill Weavers, the weaving patterns are traditional but the colors and materials shift to meet the changing fashion market. A new wrinkle, added by Richard and Lila Bellando, has been the weaving of custom materials for designers. For Gerhard Knodel's architectural commissions, Churchill's technicians found ways to weave space-age fibers on D.C. Churchill's patented handmade looms. Craftspeople at the Stuart Nye Silver Shop in Asheville hammer out the late Stuart Nye's dogwood designs in silver or copper. The patterns come from nature; superb marketing keeps the tradition strong.

At Berea College, full-time and student craftspeople share the looms, lathes, and broom machines. The emphasis must be on relatively uncomplicated production, on products which can be made to high-quality standards by two-hour-a-day students with minimal training. The results are surprisingly good; students who want to go farther and become skilled craftspeople are encouraged to do so. The degree of student accomplishment within the Student Crafts Program depends largely on individual effort and desire. Some former students—Charles Counts, Homer Ledford, Kelly Mehler, Sarah Culbreth, and others—have built on work experiences and classroom studies to create studio careers.

The thriving marketplace actually *inhibits* the development of design in Appalachian crafts production; or, depending on your viewpoint, the market preserves the traditional design. Customers demand huge quantities of baskets, brooms, patchwork, pillows, toys, cornshuck dolls, carvings, and functional pottery, all done in the traditional patterns. The "country look" so advocated by designers and magazines has been a gold mine for some Appalachian craft centers.

To meet increased demands, production shortcuts have been implemented. Sometimes design suffers; sometimes it actually improves. It all depends on who is taking the shortcut. Edsel

Martin has for years used a bandsaw to rough-shape his carvings. His sawed blocks are perhaps 80 percent finished. The final product? As good as ever. Edsel Martin is as much artist with the bandsaw as he is with his pocketknife.

Kentucky woodcarver William McClure learned to rough-cut his huge dough bowls with a chainsaw. The image suffers, but the end product is identical to the bowls McClure once made using a hatchet, mallet, and chisel. North Carolina woodworker Fred Smith said, "I can get a good design and then get them out a little faster by using some machine, then go back and forth between machine and handwork. If a machine can do it as well as I can, then let the machine *do* it. Then I pick up where the machine *can't* do it and put all my touches to it."[13]

Almost all the broomcorn, and the cornshucks used for dolls and chairbottoms, is ordered in bulk from the Midwest or Mexico. Busy crafts producers don't have time to hoe hillside cornpatches, and the quality of the purchased corn is much better. Blacksmiths use electric saws and pneumatic hammers to save time and weary backs; woodworkers depend on their routers, planers, and electronic glue guns. Most potters use electric wheels, premixed clay, and commercial glaze chemicals. Weavers purchase ready-to-use yarns. Tools and new processes eliminate drudgery, not creativity or quality.

But the debate goes on. Does technology destroy the intrinsic value of traditional Appalachian handcrafts? Even when the final product is unchanged in appearance and quality, the romance is gone. Perhaps it is a sign of growth and maturity that Appalachia's craftspeople no longer have to trade on romance. Now the product must stand largely alone and sell more on its own merits. Still, for sales purposes, the rustic image, the illusion of primitive artisanry, is maintained. Good businesspeople that we are, we don't dare risk losing the market advantage.

I confess to a degree of personal disillusion, an emotional pref-

erence for the unmechanized methods, but I lay aside such romantic notions whenever I measure the tremendous economic impact of handcraft sales on the quality of life in the mountains. Volume marketing to larger retail stores and mail-order catalogs forces a degree of repetition that does not set well with individual craftspeople, and that fact sends wholesale buyers scurrying to the larger production centers where the product line is controlled. New York designers continue to be frustrated by Appalachian reluctance to churn out fake primitive pine furniture, to dye split-oak baskets rosy pink or trendy peach, or to whip up two thousand identical cornshuck dolls with two weeks' notice.

Despite the sometimes heated criticism for becoming too production oriented, Appalachia's craftspeople have stubbornly refused to totally give in to market demands. That ornery independence, a trait heartily cursed by economic developers and highly treasured by those of us who love the mountain culture, prevents total modernization of handcraft production, and preserves the individuality of the crafts. The mountaineer has never been one to blindly follow directions; much like our fabled mules, we prefer to pick and choose, to maintain a strong degree of common sense and freedom.

Though the science of predicting the future is no more exact in Appalachia than it is anywhere else, a few assumptions are safe.

Appalachians will continue to produce the traditional handcrafts as long as there is a market. Appalachians will continue to produce junk as long as there is a market. Appalachian handcraft design, excluding the purely traditional works, will become even more mainstream American as the new generations take an even firmer control of the industry and the culture.

And we'll continue to argue, hopefully without coming to blows, about just what Appalachian craft design is anyhow.

12.

Why and Where to from Here?

The Reasons for the Growth,
and One Guess at What Lies Ahead

Why was there such a revival and continuing marketplace expansion within the Appalachian craft world?

Isolation preserved the culture well into the twentieth century, and the "outside" missionaries led the early organized preservation efforts, but the primary factor in that and subsequent development has been pure and simple economics. Cash money. Nonfarm income. Supplemental or full-time wages for making use of skills handed down through the generations.

The way Appalachia's craft marketing efforts helped preserve the culture drew interest in 1989 from Saudi Arabia, taking me to New York University on September 20 to 21 for the United States–Saudi Cultural Heritage Conference. As assistant director of the Berea College Student Crafts Program, I was quoted in *The Crafts Report*: "Ready markets encourage the production and subsequent preservation of traditional native craftwork, . . . and that market must be controlled to some degree to maintain standards of excellence."[1] Simply put, the mountain market for quality crafts was created and manipulated, not just discovered and nourished.

There has always, in Appalachia, been a strong love for the craft. Show-off quilts, complicated whittlings, "face jugs," Aunt Cord Ritchie's "dream" baskets, and intricate woven coverlets *were* the art of early Appalachia, the life and color of the remote

mountain households. But had it not been for the work of Berea College, the Southern Highland Handicraft Guild, and visionaries like Clem Douglas and Francis Goodrich, today's art of Appalachia would be, hands down, the chenille peacock bedspread, pink flamingos, and plaster-cast roosters.

The efforts of the 1920s and 1930s, despite David Whisnant's protests of cultural politics, saved a quickly vanishing craft tradition, and the Southern Highland Handicraft Guild kept the activity going during the 1940s and 1950s through extensive educational efforts and by creating quality marketplaces. During that period the "outside" craftspeople were drawn by the ready market and low cost of land, adding another dimension to the Appalachian craft world.

But why, during the late 1960s, did the current revival begin? Give the decade itself part of the credit: the back-to-the-earth movement; the disillusion with big business, government, plastic, and mass production; the new generation, which was breaking rules, challenging concepts, breaking loose, wearing tie-dyed shirts, looking for something better, something real besides the war in Vietnam; the almost desperate search for an alternative life-style.

Crafts everywhere benefited from the new thinking, but the Appalachian market appeal was even greater. Simple people, a simple lifestyle, traditions two hundred years old, and established outlets in Berea, Gatlinburg, and Asheville drew the new sixties customers to the region. Part myth, part reality, part marketing, the Appalachian mystique was strong. We were perceived as a non-nuclear people, "close to the land," romantic primitives, craftspeople who didn't know the value of our own skills.

That last part was a little too true. In 1965, excellent handmade quilts sold for thirty-five dollars, an Edsel Martin dulcimer for sixty dollars, a cornshuck doll for two dollars. A good stoneware

mug retailed for two dollars. I bought a ladderback chair from the Mace Family for four dollars, and Cherokee river cane baskets for a dollar each. Retail craft prices have always depended largely on what the market would bear, and not until demand outran supply in the sixties did prices go up. Simple economics.

Some excellent, timely promotion by the craft organizations, a sort of controlled marketing (the Southern Highland Guild's shops, for example, were the only place you could buy much Appalachian craftwork), incredible publicity—good and bad— about the region, and a more affluent audience combined to create a situation where crafts could begin to command more reasonable prices.

We saw, in the late sixties, new young customers, better educated and more aware, who appreciated natural materials and native skills. The proliferation of new craft fairs, which usually included regional music and food, created tremendous exposure and fostered the concept that *crafts are fun*. Craft, unlike art, has always been available, usually understandable, free from museum walls. Functional crafts in a festival booth are much less intimidating, much more accessible and inviting than are abstract sculptures in a formal gallery opening. The very *function* of craft helped create the 1960s marketplace, helped draw the customers who are today's collectors.

Of course, the same rush to recognize and purchase quilts, baskets, and dulcimers also created the production and marketing of tons of junk. Scrolled beer-can sculptures, coal jewelry, cutout Clorox bottles, and hastily sewn imitations of copyrighted patterns were rushed to the market as "craft," often with a federal or state subsidy. It was left to the private organizations, the guilds, to point out the differences, to select and spotlight excellence, to create and strengthen the market for quality.

The perseverance, uniqueness, and colorful appeal of Appala-

chian crafts have generated enormous publicity. Mention Berea College anywhere in the United States, and someone will ask about the brooms, weaving, or woodwork (often to the dismay of the faculty, who'd rather have people know about Berea's academic excellence). In 1971 a Berea College student journalist offered a sage assessment of the crafts/academics situation at Berea, and of the public perception:

> Crafts can get along good with academics, if some are manned by professors and reinforced in the classroom. They can get along good with students if initiative and skill are rewarded and if the working atmosphere is pleasant. They can get along good with the business office if the needs of the marketplace do not overpower the style of the craftsman and his apprentice. They can get along good with Development and Public Relations if they are represented for precisely what they are.
>
> Not that such representation will have much effect upon the tourist. For him the weaver or potter or cabinetmaker is the past revived, the nostalgic word made flesh. Berea College, to most people, will always be "the place where those hill people make things the way they used to." Myths die hard, if at all.[2]

Berea College, Bybee Pottery, Churchill Weavers, Stuart Nye Jewelry, bizarre downtown Gatlinburg, and the Campbell Folk School have been written about, visited, shown on television, and talked about like no other regional culture. And make no mistake, it is the Appalachian, the traditional, the very regional crafts that have garnered most of the publicity. "Folk" artists make a better story than do contemporary, university-trained glassworkers or weavers. The direct honesty and regional flavor of a William McClure, Edd Presnell, Bea Hensley, Homer Ledford, or Edsel Martin—craftspeople whose personalities are as colorful as their work is excellent—get the headlines. Everybody benefits. Customers drawn by tradition purchase the contemporary, but all the trade was built from the tradition.

The 1960s stirrings were but a prelude to the next two decades, but the reasons for the later growth are pretty much the same. A more aware buying public continues to invest in handmade excellence. Much more interest in the contemporary, less-functional work has emerged, another reflection of changing educational levels and affluence.

Fads have always been a part of the Appalachian craft world. We've pretty well survived tie-dye, macramé, crude leatherwork, the country look, the marijuana paraphernalia, the unfinished era, and whatever else TV and California sent us. We've adapted tradition to today's marketplace with boldly colored quilts, new materials in weaving, new machines and finishes for woodworking. Throughout the hectic seventies, Appalachian craft organizations have grown, expanded into markets that had been building since 1890, and reaped the benefits of decades of hard work.

During the 1980s, the craft world became more businesslike, more geared toward filling consumer demands, but it also grew in the opposite direction. Craft as art is now a major part of the culture, even in Appalachia. Already, it's hard to tell the difference between a craft fair in Asheville, North Carolina, and one in Anaheim, California. Craft shops in Berea sell bronze bells from New Mexico, and customers don't question the non-Appalachian origin. The crossover that has changed everything else in America is changing the mountain craft world. For better or for worse, the mountain personality is being gradually absorbed into the mainstream, and the result is "homogenized" craftwork. The combined influences of education and the marketplace have steadily changed and "improved" Appalachian crafts for the past fifty years, eliminating the regional flavor from all but the staunchest of crafts producers, and the future holds more of the same.

Richard Blaustein, director of East Tennessee State University's Center for Appalachian Studies and Services, writing for a spe-

cial "Appalachian Art: Folk and Fine" issue of *Now and Then*, expressed a similar thought:

> The actual historical and cultural patterns we find in Appalachia today are far more complex and diverse than our generalized impressions would lead us to believe. Contrary to H. L. Mencken's canard, we are not living in the Sahara of the Bozarts. Neither are we dealing with North America's own Shangri-La or Brigadoon, an endemic enclave of traditionality isolated from the currents of fashion and change sweeping over the rest of the modern world. . . .
>
> Appalachia has its cosmopolitan composers, poets and painters, as well as a wide array of non-elite artists and craftspeople. Some still work within traditional family and neighborhood contexts, while others have been lionized by the alienated exurban romantics who have historically been the patrons and advocates of folk revivalism in this country and elsewhere. Whether we like to admit it or not, there is a nostalgia industry in Appalachia which caters to the real, continuing desires for authentic, organic alternatives to the perceived sterility and aridity of an overorganized, overcultivated mainstream culture. The rhetoric of folk revivalism has given rise to new realities, to the selective reconstruction and reinterpretation of older cultural symbols to suit contemporary social needs, not only of the people who were born and raised in Appalachia but also of newcomers who have come to identify with the region.
>
> To make sense of the complete spectrum of Appalachian artistic expression, we need to stop trying to distinguish the authentic from the synthetic. We should pay more attention to the universal human needs which all forms and genres of art fulfill.[3]

Collectors and museums are preserving the traditional works, and the marketplace will, to some degree, preserve traditional products such as baskets, brooms, whimmydiddles, and dulcimers. Change is the natural process; those of us who would cling to a regional culture *know* we're being absorbed into the American mainstream and even, at a rational level, agree with the change, for the very isolation and regionalism which helped pre-

serve the Appalachian craft culture also helped preserve poverty, inferior educational systems, and a very difficult way of life. One price of progress, and perhaps a small price at that, is the vanishing culture. Scholars preserve the music, the literature, the folktales, and the dances through festivals, recordings, and the printed word, but the mountain balladeer of the future is more likely to be a graduate student from Minnesota than a farm boy from Eastern Kentucky.

The Kentucky boy will be playing country rock through a set of amplified speakers.

The very same process applies to the mountain crafts. New generations of craft-making families would rather do something else. North Carolina basketmaker B. S. Gilliland had fourteen children, all excellent basketmakers. Yet, when Mr. Gilliland died, none wanted to continue the business, even though the income potential from basketry was far better than from unskilled labor. The lure of a weekly paycheck outweighed the heritage.

For others, the educational process changes the focus more to art. Sandra Blain, director of the Arrowmont School, addressed that issue: "I think that we sometimes fail to realize that we have a rather homogenized society today. People that are working in this Appalachian region are either self-taught or they're university-trained. And I think that a university-trained person for the most part is not going to regress to doing the typical folk art, the truly traditional Appalachian folk crafts. Because why would they have gotten an MFA painting or ceramic degree and then do something where there's no personal expression allowed?"[4]

Two major museums of the Appalachian culture incorporate crafts into their collections, exhibits, demonstrations, and educational programs. Berea College's Appalachian Museum is much more than it appears to tourists who walk through the building; its collection includes a great deal of historical craftwork, and a

series of slide and tape programs documents much of the traditional Appalachian craft process.

The more visible Museum of Appalachia near Norris, Tennessee, is the effort of one person. John Rice Irwin has built the museum into a viable tourist attraction, with billboards on busy I-75 and ongoing events, with support from the frequent presence of author Alex Haley. Irwin's books on quilts and guns add an academic credibility to the effort, and weekend festivals help build the audience.

The influx of "outside" craftspeople, drawn to Appalachia by the natural beauty and ready marketplace, long ago displaced the native mountaineers in influence and visibility. The future belongs to the university-trained designer-craftspeople, those whose desire to reach "national standards" will continue the homogenization. The Appalachian crafts of the future will be excellent, well designed and executed, well marketed, and visually exciting but far removed from the weavers and basketmakers that William Frost found when he toured the mountains in 1893.

The work of Allen Eaton, Marian Heard, Bill Brown, and the many others who've labored so effectively to upgrade the design of Appalachia's crafts will continue over the coming decades, led now more by young craftspeople who, as they should be, are more concerned with their own work than with that being done by native, traditional artisans.

Efforts to preserve Appalachia's craft traditions are certain to continue. There are enough scholarly projects, museums, historians, and folklorists to assure a well-documented record of the work prior to the seventies.

People made the Appalachian craft revival possible. William G. Frost and Olive Dame Campbell, Frances Goodrich and Helen Dingman, Allen Eaton and Miss Lucy Morgan, Marian Heard and O. J. Mattil, Clem Douglas and Eleanor Churchill, Bill Brown

and Bob Gray, Rude Osolnik and Charles Counts, and the many others who gave so selflessly and worked so diligently built the Appalachian craft world into the economic, cultural, and educational factor it now is.

People will define and develop the future of Appalachia's crafts: the producers who maintain the traditions, the innovators who expand the forms and techniques, the paid and volunteer leaders whose voices and actions set the pace. The old missionary effort is largely over, replaced by craft professionals who run the schools, organizations, and marketing efforts. And the maintaining of the movement is a more precarious task than was the building.

For decades there was nothing to lose by gambling on a bold new venture, but now decisions must be weighed more carefully, with consideration always for possible weakening of the existing marketplace, credibility, and degree of accomplishment. Craftspeople in most of Appalachia now enjoy a professional respect which has far transcended Allen Eaton's concerned but oversimplified portrait of the simple mountain artisan, and the craft industry is now such an economic force that surely some of those whose careers span four or five decades must occasionally pinch themselves to be sure they're not just dreaming.

The ready markets and casual acceptance which so many young craftspeople now take for granted was *built*, not born, and those who did the building have set an example that today's leaders should carefully study. The Southern Highland Handicraft Guild in particular, the wheelhorse of the Appalachian craft revival, must look to the future carefully but boldly, must preserve a sixty-year effort but move into new worlds with vitality and a creative, responsive leadership. The primary function of the guild, the reason most people join, is the prestige marketplace. And, all grumbling aside, nobody does it better. A sixty-

year effort, credibility, and stability carry the guild's marketing program along, and current rumbles within the membership are perhaps valid concerns that the guild has grown content to simply maintain, to let a proven system grind along, to concentrate leadership efforts in other directions.

It is impossible, though, to just *maintain*; there will be either growth or decline. The marketing effort must be constantly monitored, revised, expanded, and promoted. Somewhat surprisingly, the Southern Highland Handicraft Guild has no staff marketing director, no employee whose primary responsibility is managing a $2 million–a–year operation, and there are those who feel the guild's board of trustees prefers to concentrate its energies in other directions. In 1989 there was a squabble brewing within the venerable guild, the healthy disagreement which usually leads to change, the tension between art and economics which has simmered and sputtered from the very beginnings, and in April 1990, Director Jim Gentry resigned.

A new organization just for marketing? It's unlikely, either within the Southern Highland Handicraft Guild or elsewhere in the region. Craftspeople are weary and wary of new institutions, and most simply don't have the time to serve on boards of trustees or active committees. As pointed out often in this study, busy production craftspeople find it hard to serve on governing bodies, and those positions go by default to educators or others with noncraft sources of income. Those people who can and will do good work for an organization are worked to death and burned out, and newcomers unfamiliar with history tend to waste much time reinventing the wheel, espousing "new" ideas which are often as old as the organization itself.

Charles Counts, during an especially stormy annual meeting of the guild in the late sixties, angered many members by calling for change, by asserting that "it's better to burn out than to rust out." I don't even remember that day's thorny issues, but I clearly

recall Charles's passion and the hostile reaction he received. New ideas are not always welcomed; new directions are often perceived as threats.

The Appalachian craft marketplace of the future will draw on tradition and technology, on ancient skills combined with sophisticated selling, computerized accounting, and even computer-assisted design; personal computers are excellent tools for weavers, furniture makers, and others who need to input data, project and evaluate results. The secret is, and will be, to use the computer as a tool and not as a crutch.

In the future, Appalachian crafts will become even more of a profession, a business. Craftspeople will, as you'd expect, continue to move in totally opposite directions with equal success. Expect more professional credibility for craftspeople as visual artists, craftspeople as entrepreneurs. Expect the "quaint" mountain image to continue to fade away. Laser-carving machines, automatic lathes, M.F.A. degrees, toll-free order lines, and twenty-first-century price tags are not quaint.

Expect most craft organizations in the region to continue to slip in influence and visibility. They are no longer absolutely necessary or crucial to survival, and private businesspeople are moving strongly into the marketplace. A major exception will be the Southern Highland Handicraft Guild, which will continue to become more local and less regional, which can survive financially from its inside market on the Blue Ridge Parkway but runs the risk of depending too much on a single market outlet. The production centers—Berea College Crafts, Churchill Weavers, Stuart Nye Jewelry—will use tradition, good business practices, and strong marketing programs to continue. Our future market appeal will not be so much the regional heritage and design of our crafts as it will be the new tradition of lots of crafts being produced in Appalachia.

One aspect of the 1990s may be troubling. In March 1990, a

Kentucky lawsuit challenged, for the first time, an organization's jurying procedures. Filed in Madison County, the suit questions the Kentucky Guild of Artists and Craftsmen's right to revoke a member's exhibiting and selling privileges.[5] A common guild practice for more than two decades, the rejurying process has always provoked anger, but never before has it brought legal action.

The subjective procedure used by craft organizations for over sixty years may now be challenged, and the lawsuit raises some interesting questions. Can a private organization which accepts state and federal funding legally revoke or even deny selling privileges? Will the basic premise of quality craft marketing survive a courtroom challenge? Those questions may soon be answered.

Others see the future of Appalachia's crafts in different lights. I asked two of the region's leaders what they saw ahead for the craft world, and whether they felt tradition would continue to be a part of that future. Charles Counts's eloquent, positive statement reasserts this passionate man's deep-rooted belief in Appalachia and in craft:

> What creatures on this small planet dare anticipate the future? I once asked Michael Cardew a few questions sent to me by a craftsman doing "the Delphi probe" for a school in New England. "Oh, crystal ball gazing, are you?" was Cardew's response. I stiffened, expecting chastisement. Not this time. "You Americans are really good at that," he said.

> Crafts and the future in the Southern Highlands. USA. Yes. Of course. For at least three good reasons:
> the people
> the land
> and the CRAFT
> We who grew up knowing the land are really and truly attached to the land in ways that cannot divide us even in our dreams and nightmares. Even if we are finding ourselves in some hostile city like

Detroit as was Gertie in Harriette Arnow's novel *The Dollmaker*, we still recall our agrarian past. And it is not poverty that we shall recall. Rather we will also be remembering some certain urge to make something of ourselves and our lives. We are a people of cunning, braving in some stubborn way the need to do something of our own making even if that doing is the doing of nothing but staying alive.

The Southern Highland landscape is a sacred part of planet earth from the Blue Ridges of Georgia upward through the incredible Cumberlands all around the state of West Virginia and across the Eastern Kentucky heights and over into Southwestern Virginia—nothing else quite like this region. There is a beauty here and an awesome mystery about the region even at its worst that silences the most critical analysis of any scholar. At their best the mountains carry a natural beauty that stirs the soul. Imagine a few hours alone, at dawn, on the Blue Ridge Parkway.

Inside each of the crafts is a continuity and discipline that will never be lost to technology and change. Craftsmanship itself was once pioneer adapting to the utilization of materials at hand combined with the needs community based. If the planet has become a global village then there are those people all around who will respond to the basic act of making something well. That poetry: simply making something well, is the foundation of any learning. We in the Southern Highlands have held on to a written promise of making things by hand. Our few institutions, although not in the "Hanseatic league" of another history, have nonetheless seemingly acted in concert to test the viability of learning the craft arts. Penland, Arrowmont, and Berea are the institutions about which I speak. But there are craft courses at every major university in our region and crafts also fill the calendar of many smaller school and community centers.

If I were to stand again on the westward slope of Lookout Mountain near Rising Fawn to watch the inevitable sundown of any midsummer moment I would swear to you without any doubt that the future of making things by hand was as certain as that sunset and as inevitable as the coolest dawn.

AS LONG AS HUMANS HAVE BREATH. . . .[6]

Less poetic but equally thoughtful is Jim Gentry, former direc-
tor of the Southern Highland Handicraft Guild, who for over
twenty years dealt daily with the more practical aspects of craft
administration. According to Gentry, "the heart and mainstay [of
the Appalachian craft world] has been and will continue to be
that which sets us apart as a region."[7] The folk art element, the
traditions of producing functional crafts, and the colorful moun-
tain heritage, predicts Gentry, will continue as factors in the crafts
made and marketed in Southern Appalachia. A positive regional-
ism will, as it has since 1920, set this culture apart.

But the face of Appalachia's major craft organization is chang-
ing. "Ten years ago," says Gentry, "the guild was basically a
single-purpose organization. It's now more segmented, by craft
media and by marketing needs, and we will continue to see more
of that departmentalization."[8] Gentry also perceives a current
"industrial revolution" within the craft world, an increased use
of production shortcuts to meet the growing market demands.
Purely handmade products cannot be done in the quantities cus-
tomers now are demanding, and aids such as the jiggering and
molding of pottery—once seen as commercial evils—are helping
increase output.

Gentry does not foresee major changes in craft marketing.
"People tend to overlook the basics," he says, "and want some
sort of magic. The look of crafts is always changing, but basic
marketing is the same: get the goods or products, with the trans-
mitted energy of the craftsperson, before the customers."[9]

The actual market procedure may change, according to Gen-
try, to reflect evolving life-styles and technology. The future may
bring decreased purchasing power, and smaller living spaces may
reduce the scale of purchases. Each crafts producer will need to
find even more of an individual niche, a specialized marketplace,
as the more sophisticated systems such as telemarketing offer
consumers virtually unlimited access to the total marketplace.

The crafts community will not, in the future, be isolated. Gentry sees even more regional networking, and a stronger flow of information at all levels. "But," he warns, "we may all wind up spending too much time just processing that flow, just dealing with all that information."[10] Even in the world of handcraft, it seems, modern communications technology can create an overload.

And, even within the prestigious Southern Highland Handicraft Guild, built from the beginning on solid foundations of cooperative marketing, there are more and more signs of specialized, compartmentalized, sales efforts. Special demonstrations at guild fairs are now media focused, beginning with fiber at the July 1988 show, and the Marketing Committee proposed a series of "mini-catalogs" showcasing specific media groupings.

The same committee conducted a marketing survey that confirms the current diversity of needs and objectives within the guild membership, helping to further the realization that the guild can no longer be all things to all people. It will be up to the guild's board of trustees to define direction, to make a painful break away from the traditional concept that every program must serve every member. Jim Gentry wrote in early 1989:

> One by-product of our move to be professional seems to have been the removal of the aura which surrounded the world of art/craft in the past. While it is a likely change as the world of crafts has matured, we'd be unrealistic to say it came about without a price. In the process of being "the best" business people, we frequently overlook the ingredient which attracted the visitor/customer to the artist. It was "spirit," individuality, a chance to know the person who was responsible for shaping that clay from wet to dry, with care and understanding for all stages in between.
>
> A recapturing of spirit to leaven the business professionalism seems a worthy goal for all of us in '89. In the guild we have worthy models: Frances Goodrich, Allen Eaton, Clementine Douglas, Lucy Morgan,

O. J. Mattil, Pearl Bowling, and numerous others who have been the essence of spirit with no reduction in commerce.[11]

Contemporary Appalachian craftspeople are very aware of national trends and very much up to date on technology, technique, and design directions. Those who do production are constantly looking for new labor-saving devices and concepts, juggling always the contradictory demands of craft versus commerce. In Kentucky, craftspeople have been part of the state's "industry appreciation" efforts since 1987, formal recognition of the crafts as a significant production-marketing-tourism factor in the economy. In July 1990, the Kentucky Crafts Marketing Program was moved from the Department of the Arts to the Small Business Division of the Kentucky Cabinet for Economic Development. In 1988 Berea was officially designated the "Folk Art and Crafts Capital of Kentucky" by the state legislature, an honor I view with mixed sentiments. It's true, and has been since the 1890s, but somehow the legislated title seems shallow and commercial. The "crafts capital" tag sometimes conjures up, to me, visions of downtown Gatlinburg.

I hope the future does not bring Appalachia even more boardwalk artists, portrait painters and redwood sign makers, more fake Indian chiefs, hillbilly dolls and corncob pipes, more rebel flags and painted pine. I'd rather have the chenille peacocks back; in one sense the gaudy bedspreads and plaster collies are now a form of folk art, part of the era of shark-finned automobiles and neon-lit roadside tourist cabins, evoking a tacky innocence which I sort of miss in this age of prefabricated chain motels, fast food, and yuppielike sameness.

I hope Appalachia's crafts will retain that quirky independence, the eccentric refusal to work to suit somebody else, that underlying sense of humor that defies understanding except to a native.

No matter what the future brings, I will treasure the past, the years of work and friendship, the almost clannish bonds between the people of the Appalachian craft world. Our sometimes flawed, amateurish efforts paved the way for whatever is yet to come, and future generations would do well to sometimes step back from the hectic pace, watch a mountain sunrise burn the morning mist away from a sleeping valley, and recall the words of Allen Eaton: "He who does creative work, whether he dwell in a palace or a hut, has in his house a window through which he may look upon some of life's finest scenes."[12]

If that window can be kept open, the Appalachian craft world will survive and continue to grow.

Epilogue

Reading back through these pages, I remember much more which wasn't included, for which I'm sure many readers will be grateful. Mostly, I'm awed by the early work and the massive level of activity from 1965 to now, by the tremendous effort put forth by the hundreds of people who were involved. Each organization, every state, most groups and individuals would make a good book all by themselves. I've largely overlooked the work in the mountains of Southwestern Virginia, where the late Margaret Bolton led a strong effort to preserve and market traditional works, where the Vaten School was a pioneering effort toward craft education. I've said little about the craftspeople in North Alabama or the Western Maryland mountains; I've written mostly about Kentucky and the Southern Highland Handicraft Guild because that's where I've been most closely involved.

I know I've cited my own writings far too often, but those were the articles where I was most likely to have copies, and there *are* a lot of them. The hardest job was to go back through and eliminate the too-personal parts, cut irrelevant material, and try to pull it all into some semblance of readable order.

For the many people who took time to talk with me, to remember and evaluate, I'm grateful. Writing this book has been, at times, a very emotional experience. There are things I don't like to recall, don't like to talk about. But most of the memories were warm and alive, shared fun and hard work, a great adventure.

Bob Gray's help has been crucial. Loyal Jones read the early drafts; Bernice Stevens's evaluation corrected the facts and tight-

ened the writing, and then Marian Heard added a thorough critique. My wife Anita has had to tolerate stacks of papers, books, stale cigarette ashes, my middle-of-the-night work habits, and magazines all over the house. She put up with me somehow while I was trying to learn how to use the computer, and that very process of learning how to manage disk space and to *save* copy was a revelation.

Sometimes it feels odd to remember so much, to have been a part of so much, and still be, at least by my standards, so young. I've been part of the Appalachian crafts world for twenty-five years, and was fortunate enough to work closely with many of those whose careers and efforts go back into the 1920s. I suppose I'm working now with some who will take the work well into the twenty-first century. At times I feel very much like some grizzled ancient, a relic, but then something needs to be done and I remember that I'm very much a part of today and tomorrow.

People from the past kept popping up unexpectedly while I was working on this book. Out of the blue came a letter from Monty Saulmon full of sketches, ideas, jokes, and memories. In 1967, at the end of a hectic fair week, Monty gave my two-year-old son Greg a walnut child's rocker made by Shadrack Mace. The day before Monty's 1988 letter arrived, my grandson Brian, new owner of the treasured rocking chair, was born.

A Sparky Rucker concert in Berea reminded me of all the music that was so much a part of the fairs in Indian Fort Theater. Sparky, Jean Ritchie, the McLain Family Band, Lily May Ledford, Sonja Bird Yancey, Homer Ledford, Muddy Creek, the Russell Brothers, and many others performed for us; my fondest memories are of Jennie Armstrong's opening serenade on bagpipe, the Ritchie family reunion concert, and the young classical guitarist whose soft music complemented the birds and breezes of the Berea College forest.

Writing this book was a challenge, over two years of working almost every day, trying to find time to write between trips, projects, and daily demands. The actual writing, of course, came after the years of working, collecting information, and enduring. One thing I realized very early in the process was that I could not cover everything and everybody. I feel I've worked in the major happenings, influences, and trends of regional impact; I also narrowed the focus to one person's viewpoint.

Maybe now others will fill in the gaps, correct my mistakes, amplify the significance of some aspects, and prove that some of my assumptions are wrong. Please do. I'll read every word.

This book is more of a starting place for recording and evaluating the recent history of the Appalachian craft world. I've started it. You finish it.

Notes

Chapter 1

1. Wilma Dykeman and James Stokely, *The Border States* (New York: Time-Life Books, 1968), 115–16.

2. David Whisnant, *All That Is Native and Fine* (Chapel Hill: University of North Carolina Press, 1983), 7–8.

3. Ibid., 12.

4. Ibid.

5. Ibid., 13.

6. Ibid., 13–14.

7. Allen H. Eaton, *Handicrafts of the Southern Highlands* (New York: Russell Sage Foundation, 1937; reprint, New York: Dover Books, 1973), 60–61.

8. Elizabeth S. Peck and Emily Ann Smith, *Berea's First 125 Years: 1855–1980* (Lexington: University Press of Kentucky, 1982), 117.

9. Eaton, *Handicrafts of the Southern Highlands*, 63.

10. Ibid.

11. Jan Davidson, Introduction to *Mountain Homespun*, by Frances Louisa Goodrich (Knoxville: University of Tennessee Press, 1990), [34].

12. Pat McNelly, *The First 40 Years: John C. Campbell Folk School* (Atlanta: McNelly–Rudd, 1966), 2.

13. Quoted in McNelly, *The First 40 Years*, 30.

14. Ibid., 27.

15. Whisnant, *All That Is Native and Fine*, 11.

16. Lucy Morgan with Legette Blythe, *Gift from the Hills* (Chapel Hill: University of North Carolina Press, 1971), 50.

17. Eaton, *Handicrafts of the Southern Highlands*, 237.

18. Ibid.

19. Ibid., 240.

20. Quoted in Eaton, *Handicrafts of the Southern Highlands*, 242.

21. Ibid.

22. Eaton, *Handicrafts of the Southern Highlands*, 243.

Chapter 2

1. Eaton, *Handicrafts of the Southern Highlands*, 244.

2. Ibid.

3. Eaton, "The Mountain Handicrafts: Their Importance to

the Country and to the People in Mountain Homes," *Mountain Life and Work* 6, no. 11 (July 1930): 22–30.

4. Eaton, *Handicrafts of the Southern Highlands*, 244.

5. Ibid., 245.

6. Ibid., 248.

7. Ibid., 249.

8. Ibid., 270.

9. Helen Bullard, *Crafts and Craftsmen of the Tennessee Mountains* (Falls Church, Va.: Summit Press, 1976), 197.

10. Ibid., 199–200.

11. Eaton, *Handicrafts of the Southern Highlands*, 265; my emphasis added.

12. Ibid., 272–73.

13. Ibid., 275.

14. Ibid., 277.

15. Ibid., 279.

16. Ibid.

17. Ibid., 280.

18. Ibid., 282.

19. Ibid., 283.

20. Ibid., 282.

21. Ibid., 284.

22. Ibid., 252.

23. Whisnant, *All That Is Native and Fine*, 161–62; my emphasis added.

24. Ibid., 162.

25. Ibid., 162–63.

26. Ibid., 164.

Chapter 3

1. Peck and Smith, *Berea's First 125 Years*, 191–92.

2. Ibid., 193.

3. Ibid.; emphasis in original

4. Mary Ela, "Made by Hand," *Mountain Life and Work* 16, no. 3 (Fall 1940): 7.

5. Ibid., 6.

6. Ibid., 6–7.

7. Harriette Simpson Arnow, *The Dollmaker* (New York: Macmillan, 1954), 48.

8. Smith G. Ross, *Come, Go with Me* (Detroit: Harlo Press, 1977), 27.

9. Ibid., 28.

10. Ibid.

11. Arnow, Foreword to *Come Go with Me*, vi.

12. Bernice A. Stevens, *A Weavin' Woman* (Gatlinburg, Tenn.: Buckhorn Press, 1971), 74.

13. Robert Stanley Russell, "The Southern Highland Handicraft Guild, 1928–1975," Ed.D. thesis, Columbia University Teachers College, 1976, 113–16.

14. Ibid., 295–96.

15. Whisnant, *All That Is Native and Fine*, 175.

16. Ibid.

17. Stevens, *A Weavin' Woman*, 75.

18. Quoted by David B. Van Dommelen in "Allen Eaton: In Quest of Beauty," *American Craft* 45, no. 3 (June–July 1985): 38.

19. Russell, The Southern Highland Handicraft Guild," 118–22.

20. Ibid., 123.

21. Ibid., 123–30.

22. Ibid., 111–12.

23. Ibid., 298–99.

24. Ibid., 221–22.

Chapter 4

1. Edward DuPuy and Emma Weaver, *Artisans of the Appalachians* (Asheville, N.C.: Miller Printing Company, 1967), 119.

2. Russell, "The Southern Highland Handicraft Guild," 204.

3. Ibid., 208.

4. Ibid., 130.

5. Ibid., 209.

6. Emma Weaver, *Crafts in the Southern Highlands*, (Asheville, N.C.: Southern Highland Handicraft Guild, 1958), 13.

7. Russell, "The Southern Highland Handicraft Guild," 185–86.

8. Ibid., 186.

9. Ibid., 223.

10. Bernice A. Stevens, "The Revival of Handicrafts," in *The Southern Appalachian Region: A Survey*, ed. Thomas R. Ford (Lexington: University Press of Kentucky, 1962), 279–88.

11. Russell, "The Southern Highland Handicraft Guild," 223–24.

Chapter 5

1. Garry Barker, "We're a Generation of 'In-Betweeners,'" *Southern Exposure* 11, no. 3 (May–June 1983), 172.

2. Stevens, "The Revival of Handicrafts," 285.

3. Ibid., 286.

4. Ibid., 286–87.

5. Ibid., 288.

6. Rupert B. Vance, "The Region's Future: A National Challenge," in *The Southern Appalachian Region: A Survey*, ed. Thomas R. Ford, 295.

7. Garry Barker, "Crafts are fine, but they're not a cure," Lexington *Herald-Leader*, Mar. 11, 1990.

8. Willis D. Weatherford, Sr., Foreword to *The Southern Appalachian Region: A Survey*, ed. Thomas R. Ford, 5.

9. Ibid.

10. Larry Hackley, *Kentucky Guild of Artists and Craftsmen Twenty-fifth Anniversary Celebration* (Louisville, Ky.: Water Tower Association and Kentucky Guild of Artists and Craftsmen, 1986), 11.

11. Charles Counts, *Encouraging American Handcrafts: What Role in Economic Development?* (Washington, D.C.: U.S. Dept. of Commerce, 1966), 45.

12. Hackley, *Kentucky Guild of Artists and Craftsmen*, 13.

13. Ibid., 38.

14. Ibid., 14.

15. Ross, *Come, Go with Me*, 33–38.

16. Ibid., 63.

17. Ibid., 75–76.

18. Russell, "The Southern Highland Handicraft Guild," 215–17.

19. Counts, *Encouraging American Handcrafts*, 30.

20. David Van Dommelen, "Allen Eaton: In Quest of Beauty," 35.

21. Harry Caudill, *Night Comes to the Cumberlands* (Boston: Atlantic Monthly Press, 1962), 5.

22. Stuart Sprague, "ARC from Implementation to Payoff Decade and Beyond," *Morehead State University Appalachian Development Center Research Report* (Morehead, KY), no. 11 (1986): 1.

23. Ibid.

24. Russell, "The Southern Highland Handicraft Guild," 300.

Chapter 6

1. Charles Counts, "Written for Rose," *Craft Horizons* 26, no. 3 (June 1966): 37.

2. Jonathan Williams, "The Southern Appalachians," *Craft Horizons* 26, no. 3 (June 1966): 49.

3. Ibid., 64.

4. Ibid., 55–56.

5. Ibid., 57.

6. Ibid.

7. Ibid., 58.

8. Mary Cowles, "Federal Funds Urged to Advance Crafts in Appalachia," Asheville *Citizen*, Feb. 26, 1966.

9. Nell Znamierowski, "Southeast Region," *Craft Horizons* 26, no. 3 (June 1966): 79.

10. Counts, *Encouraging American Handcrafts*, 15–18.

11. Ibid., 23.

12. Ibid.

13. Ibid., 25–31.

14. Ibid., 32–36.

15. "Spotlight on Appalachian Craftsmen," New York *Times*, Apr. 12, 1967.

16. Robert Wright, "Appalachia Is Creating New Taxpayers," New York *Times*, Apr. 19, 1967.

17. "Miss Clementine Douglas' Rites Conducted Today," Asheville *Times*, May 15, 1967.

18. Russell, "The Southern Highland Handicraft Guild," 300–301.

19. Ibid., 210.

20. Ibid.

21. Eaton, *Handicrafts of the Southern Highlands*, 280.

22. Hackley, *Kentucky Guild of Artists and Craftsmen*, 30.

23. Ibid., 39.

24. Yvonne Eaton, "Rare Wood Goes into Furniture Made in Kentucky," Louisville *Courier-Journal*, Mar. 24, 1976.

25. Ibid.

Chapter 7

1. Hackley, *Kentucky Guild of Artists and Craftsmen*, 39.
2. Garry Barker, "Apprenticeship at Berea." *Ceramics Monthly* 23, no. 6 (June 1975): 19.
3. *The Guild Record* 15, no. 3 (May–June 1975) [unnumbered].
4. Russell, "The Southern Highland Handicraft Guild," 300–301.
5. Ibid., 211–12.
6. Ibid., 278.
7. Guy Mendes, "Appalachia Revisited," *Craft Horizons* 38, no. 3 (June 1977): 75.
8. Ibid.
9. Barker, "Appalachian Craft Cooperative Markets Rural Handicrafts," *Farmer Cooperatives* 48, no. 9 (Dec. 1981): 18–19.
10. Mendes, "Appalachia Revisited," 74.
11. Ibid.
12. Ibid.
13. Ibid., 32.
14. Ibid., 72.
15. *The Guild Record* 15, no. 6 (Nov.–Dec. 1975).
16. Sprague, "ARC from Implementation to Payoff Decade and Beyond," 13.
17. Ibid.

Chapter 8

1. Russell, "The Southern Highland Handicraft Guild," 281.
2. Bob Owens, "Development of the Appalachian Crafts," in *Final Report: Georgia Crafts Appalachia* (Atlanta: GCAH Crafts Program, 1981), 5.
3. Ibid.
4. Hackley, *Kentucky Guild of Artists and Craftsmen*, 40.
5. Barker, "Appalachian Craft Cooperative Markets Rural Handicrafts," 18–19.
6. Charles Counts, "Crafts and the Future," *National Handcraftsman* 1, no. 1 (1976): 17.
7. Rex Robinson, "United We Grow, Isolated We Fall," *Kentucky Artist and Craftsmen* (Owensboro, Ky.: Communications Art Productions), 1, no. 1 (Sept.–Oct. 1976): 3.
8. Mendes, "Appalachia Revisited," 30–31.
9. Ibid., 34.
10. Ibid., 40.
11. Ibid., 71.
12. Ibid.
13. Ibid., 75–76.
14. Ibid., 34.
15. *The Guild Record* 17, no. 4 (June–July 1977).
16. "ACC's National Conference to Hail U.S. Craft History and Tradition," *Craft Horizons* 37, no. 2 (Apr. 1977): 7.

17. Eudorah Moore, Edited transcript of Craft Administrators Conference, July 19-21, 1979.

18. "Grant News," *Craft Horizons* 38, no. 8 (Dec. 1978): 43.

19. F. Borden Mace, Introduction to *Artisans/Appalachia/USA* (Boone, N.C.: Appalachian Consortium Press, 1977).

20. Counts, *Common Clay* (Anderson, S.C.: Droke House/Hallux, 1971).

21. "Solomon Quits GSA," *The Crafts Report* 5, no. 47 (May 1979): 16.

22. *The Guild Record* 18, no. 4 (June–July 1978).

23. Ibid.

24. Persis Grayson, "'Counterpoint' Blends Down Home and Uptown," *Craft Horizons* 38, no. 5 (Aug. 1978): 50.

25. Sandra Timms Bishop, ed., *Craft Administrators Journal* 1980.

26. "Southeast Craft Administrators Will Assemble for Conference," *Craft Horizons* 39, no. 1 (Feb. 1979): 35.

27. *Georgia Crafts/Appalachia* (Atlanta: Georgia Council for the Arts and Humanities, 1979), 11–12.

28. "Georgia Conference Discusses Marketing," *The Crafts Report* 5, no. 51 (Oct. 1979): 13.

29. Ibid., 14.

Chapter 9

1. Phyllis George, *Kentucky Crafts: Handmade and Heartfelt* (New York: Crown Publishers, 1989), 10.

2. Sharon Reynolds, "Selling Kentucky Items Can Be a Crafty Business," Lexington (Ky.) *Herald-Leader*, Jan. 31, 1982.

3. "The Folk Art Center Fund Drive : A Summary" (Asheville, N.C.: Southern Highland Handicraft Guild, not dated or paginated).

4. Donna Wescott, "More West Virginia," *Sunshine Artists*, Sept. 1980, 13.

5. "Making It," *Hands On*, July–Aug. 1980, 25.

6. "Interview with Bob Gray, Director of the Southern Highland Handicraft Guild," *Hands On*, July–Aug. 1980, 8.

7. Ibid.

8. "One Good Turner," *Hands On*, Jan.–Feb., 1982, 8.

9. "Guild Appoints Gentry," *The Crafts Report* 7, no. 69 (May 1981): 13.

10. Barker, "Has the Federal Money Given the Arts Done More Harm Than Good?" Louisville (Ky.) *Courier-Journal*, Mar. 6, 1981.

11. Barker, "Mrs. Brown Took State's Crafts to the Top," Louisville (Ky.) *Courier-Journal*, June 19, 1983.

12. Barker, "MATCH Organizes Cooperative Effort," *The Crafts Report* 7, no. 67 (Mar. 1981): 5.

13. Barker, "Computer Provides Working Solution to Complicated Inventory Management," *The Crafts Report* 8, no. 77 (Feb. 1982): 7.

14. Barker, "Appalachian Handicrafts," *Heirloom* 1, no. 2 (1982): 52–59, no. 3 (1983): 30–37, no. 4 (1983): 54–63.

15. Barker, "Three Berea Potters," *Ceramics Monthly* 31, no. 6 (Summer 1983): 39–44.

16. Ron Cooper, "Promoting Tradition outside Kentucky," *Kentucky Business Ledger* (Louisville), 17, no. 1 (Jan. 1982): 3.

17. "Guild Tightens Belt, Shuts Warehouse and Store," *The Crafts Report* 8, no. 79 (Apr. 1982): 1, 15.

18. "Appalachian Craftspeople Hope to Share World's Fair Tourist Dollars," *The Crafts Report* 8, no. 79 (Apr. 1982): 1, 7.

19. Barker, "Beer Hall Is Best Reason to Visit Knoxville World's Fair Unless You Get a Kick from Guided Tours of Machinery," *The Crafts Report* 8, no. 82 (July 1982): 7.

20. "Upheaval and Uncertainty Beset Appalachian Center for Crafts," *The Crafts Report* 8 (Aug.–Sept. 1982): 1, 21.

21. "Recession Puts Squeeze on Crafts: Rhinebeck Fair Down Half Million," *The Crafts Report* 8 (Aug.–Sept. 1982): 1, 10.

22. Hackley, *Kentucky Guild of Artists and Craftsmen*, 41.

23. "ACC Names Lois Moran Executive Director," *The Crafts Report* 14, no. 151 (Oct. 1988): 1, 42.

24. Joe Ward, "Kentucky's Crafts Industry Still Booming in Wake of High-Flying Days of Phyllis George," Louisville *Courier-Journal*, Feb. 11, 1985.

25. Ibid.

26. E. Evan Brown, et al., *Social and Economic Characteristics of Southern Appalachia's Handicraft Industry* (Athens: University of Georgia Dept. of Agriculture, 1985), 1–22.

Chapter 10

1. Barker, "The Student Crafts Program at Berea College: New Directions for an Historic Institution," *The Crafts Report* 12, no. 130 (Dec. 1986): 19; Barker, "Historic Berea College Crafts Program Hits New Highs after Nearly a Century," *The Crafts Report* 14, no. 145 (Mar. 1988): 17.

2. Hackley, *Kentucky Guild of Artists and Craftsmen*, 41.

3. *Building a Crafts Industry in Kentucky: Report to the Kentucky Commerce Cabinet* (Frankfort, Ky.: Coopers & Lybrand, 1985), 1.

4. "Kentucky Governor Initiates State-Sponsored Craft Industries Program," *The Crafts Report* 12, no. 130 (Dec. 1986): 48.

5. *Made in Kentucky*, Summer 1988.

6. Southern Highland Handicraft Guild and Crafts of Nine States, Inc., "Cash Flow Analysis, December, 1989," photocopy, Asheville, N.C., 1989.

7. Southern Highland Handicraft Guild, "Final Marketing Committee Survey Report," photocopy, Asheville, N.C., Mar. 1989.

8. "Campbell Folk School Builds Structure and Program," *The Crafts Report* 14, no. 151 (Oct. 1988): 50.

9. *Penland Journal* 3 (Summer 1988).

10. William Max Dixon, *Penland School: Planning and Expansion* (Charlotte, N.C.: Max Studios, 1988), unpaginated.

11. "Penland Receives Two Grants Totaling $300,000," *The Crafts Report* 14, no. 151 (Oct. 1988): 39.

12. Lisa Wainwright, "Eastern Kentucky Folk Art: A Contribution to the History of Spiritual Expression," *Good and Evil* exhibition catalog (Champaign-Urbana: University of Illinois, 1988), unpaginated.

13. Jan Arnow, *By Southern Hands: A Celebration of Craft Traditions in the South* (Birmingham, Ala.: Oxmoor House, 1987), 39.

14. Michael Owen Jones, *Craftsman of the Cumberlands: Tradition and Creativity* (Lexington: University Press of Kentucky, 1989), 56.

15. Ibid., 59.

16. Jim W. Miller, *The Mountains Have Come Closer* (Boone, N.C.: Appalachian Consortium Press, 1980), 44. Used with author's permission.

Chapter 11

1. DuPuy and Weaver, *Artisans of the Appalachians*, 30.

2. Ibid., 116.

3. Smith Ross, *Come, Go with Me*, 35.

4. Dick Schnacke, *American Folk Toys. How to Make Them* (New York: G. P. Putnam's Sons, 1973), 16–17.

5. "Quilles," in *Games of the World*, ed. Frederick Grunfeld (New York: Holt, Rhinehart & Winston, 1975), 192–93.

6. Ela, "Made by Hand," 4–5.

7. Ibid., 6–7; emphasis mine.

8. Counts, *Encouraging American Handcrafts*, 26; emphasis mine.

9. Ibid., 13; emphasis mine.

10. Eaton, *Handicrafts of the Southern Highlands*, 184.

11. Whisnant, Preface to *All That Is Native and Fine*, 13.

12. Barker, *Governor's Design Assembly Program* (Frankfort, Ky., ca. 1975), 5.

13. Deedee Welborn and Shane Holcomb, "I Think That I Shall Never Saw Exactly Down the Line I Draw," *Foxfire* 21, no 3 (Fall 1987): 162.

Chapter 12

1. "U.S., Saudi Crafts Are Compared at Conference," *The Crafts Report* 15, no. 164 (Nov. 1989): 15.

2. Eldon Chambers, "Broomcraft," *The Berea Alumnus*, Nov.-Dec. 1971, 13.

3. Richard Blaustein, "Beyond Nostalgia," *Now and Then* 6, no. 3 (Fall 1989): 3.

4. Quoted in Jane Harris Woodside, "A Dialogue in Folk and Fine Art," *Now and Then* 6, no. 3 (Fall 1989): 42.

5. Lexington (Ky.) *Herald-Leader*, Mar. 21, 1990.

6. Notes from Charles Counts to the author, June 1988, used with permission.

7. Telephone interview with James Gentry, Aug. 29, 1988, used with permission.

8. Ibid.

9. Ibid.

10. Ibid.

11. Jim Gentry, "Letter from the Director," *Highland Highlights* 30, no. 2 (Feb. 1989): 2.

12. Eaton, *Handicrafts of the Southern Highlands*, 25–26.

Bibliography

Arnow, Harriette Simpson. *The Dollmaker*. New York: Macmillan, 1954.
Reprint. New York: Avon, 1972.

Arnow, Jan. *By Southern Hands: A Celebration of Craft Traditions in the South*. Birmingham, Ala.: Oxmoor House, 1987.

Asheville (N.C.) *Citizen*. 1966.

Asheville (N.C.) *Times*. 1967.

Barker, Garry. "Apprenticeship at Berea." *Ceramics Monthly* (Columbus, Ohio), 23, no. 6 (June 1975): 19–24.

_____ . "MATCH Organizes Cooperative Effort." *The Crafts Report* 7, no. 67 (Mar. 1981): 5.

_____ . "Has the Federal Money Given the Arts Done More Harm Than Good?" Louisville (Ky.) *Courier-Journal*, Mar. 6, 1981.

_____ . "Appalachian Craft Cooperative Markets Rural Handicrafts." *Farmer Cooperatives* (Washington, D.C.: U.S. Dept. of Agriculture Agricultural Cooperative Service), 48, no. 9 (Dec. 1981): 18–24.

_____ . "Computer Provides Working Solution to Complicated Inventory Management." *The Crafts Report* 8, no. 77 (Feb. 1982): 7.

_____ . "Beer Hall Is Best Reason to Visit Knoxville World's Fair Unless You Get a Kick from Guided Tours of Machinery." *The Crafts Report* 8, no. 82 (July 1982): 7.

_____ . "Appalachian Handicrafts." *Heirloom* (Hong Kong: Sino International Trade Co.), 1, no. 2 (1982): 52–59, no. 3 (1983): 30–37, no. 4 (1983): 54–63.

_____ "We're a Generation of 'In-Betweeners.'" *Southern Exposure* (Durham, N.C.: Institute for Southern Studies), 11, no. 3 (May–June 1983): 1721.

_____ . "Mrs. Brown Took State's Crafts to the Top." Louisville (Ky.) *Courier-Journal*, June 19, 1983.

_____ . "Three Berea Potters." *Ceramics Monthly* 31, no. 6 (Summer 1983): 39–44.

_____. "The Student Crafts Program at Berea College: New Directions for an Historic Institution." *The Crafts Report* 12, no. 130 (Dec. 1986): 19.

_____. "Historic Berea College Crafts Program Hits New Highs after Nearly a Century." *The Crafts Report* 14, no. 145 (Mar. 1988): 17.

_____. "Crafts Are Fine, But They're Not a Cure." Lexington *Herald-Leader*, Mar. 21, 1990.

Blaustein, Richard. "Beyond Nostalgia." *Now and Then* (Johnson City: East Tennessee State University Center for Appalachian Studies and Services), 6, no. 3 (Fall 1989): 3.

Brown, E. Evan, et al. *Social and Economic Characteristics of Southern Appalachia's Handicraft Industry*. Athens: University of Georgia Dept. of Agriculture, 1985.

Building a Crafts Industry in Kentucky: Report to the Kentucky Commerce Cabinet. Frankfort, Ky.: Coopers & Lybrand, 1985.

Bullard, Helen. *Crafts and Craftsmen of the Tennessee Mountains*. Falls Church, Va.: Summit Press, 1976.

Caudill, Harry. *Night Comes to the Cumberlands*. Boston: Atlantic Monthly Press, 1962.

Chambers, Eldon. "Broomcraft." *The Berea Alumnus* 42, no. 3 (Nov.-Dec. 1971): 12.

Cooper, Ron. "Promoting Tradition outside Kentucky." *Kentucky Business Ledger* (Louisville), 17, no. 1 (Jan. 1982): 3.

Counts, Charles. *Encouraging American Handcrafts: What Role in Economic Development?* Washington, D.C.: U.S. Dept. of Commerce, 1966.

_____. *Common Clay*. Anderson, S.C.: Droke House/Hallux, 1971.

_____. "Crafts and the Future." *National Handcraftsman* (Hunt Valley, Md.: National Association of Handcraftsmen), 1, no. 1 (1976): 17.

Craft Administrators Journal, ed. Sandra Timms Bishop (Asheville, N.C.: Southern Highland Handicraft Guild), 1980.

Craft Horizons (name changed to *American Craft*; New York: American Crafts Council), 1966-90.

The Crafts Report (Seattle, Wash.: The Crafts Report Publishing Co.), 1974-90.

Dixon, William Max. *Penland School: Planning and Expansion*. Charlotte, N.C.: Max Studios, 1988.

DuPuy, Edward, and Emma Weaver, *Artisans of the Appalachians*. Asheville, N.C.: Miller Printing Co., 1967.

Dykeman, Wilma, and James Stokely. *The Border States*. New York: Time-Life Books, 1968.

Eaton, Allen H. "The Mountain Handicrafts: Their Importance to the Country and to the People in Mountain Homes." *Mountain Life and Work* (Berea, Ky.: Council of the Southern Mountains), 6, no. 11 (July 1930): 22–30.

_____. *Handicrafts of the Southern Highlands*. New York: Russell Sage Foundation, 1937. Reprint. New York: Dover Books, 1973.

Eaton, Yvonne. "Rare Wood Goes into Furniture Made in Kentucky." Louisville *Courier-Journal*, Mar. 24, 1976.

Ela, Mary. "Made by Hand." *Mountain Life and Work* (Berea, Ky.: Council of the Southern Mountains), 16, no. 3 (Fall 1940): 1–9.

Final Report: Georgia Crafts Appalachia. Atlanta: GCAH Crafts Program, 1981.

Ford, Thomas R., ed. *The Southern Appalachian Region: A Survey*. Lexington: University Press of Kentucky, 1962.

Gentry, Jim. "Letter from the Director." *Highland Highlights* (Asheville, N.C.: Southern Highland Handicraft Guild), 30, no. 2 (Feb. 1989): 2.

George, Phyllis. *Kentucky Crafts: Handmade and Heartfelt*. New York: Crown Publishers, 1989.

Georgia Crafts/Appalachia. Atlanta: Georgia Council for the Arts and Humanities, Appalachian Crafts Project, 1979.

Goodrich, Frances Louisa. *Mountain Homespun*. 1931. Facsimile edition with new introduction by Jan Davidson. Knoxville: University of Tennessee Press, 1990.

Governor's Design Assembly Program. Frankfort, Ky.: Kentucky Arts Commission, ca. 1975.

Grunfeld, Frederick V., ed. *Games of the World*. New York: Holt, Rhinehart, & Winston, 1975.

The Guild Record (Berea: Kentucky Guild of Artists and Craftsmen), 1971–90.

Hackley, Larry. *Kentucky Guild of Artists and Craftsmen Twenty-fifth Anniversary Celebration, 1986*. Louisville, Ky.: Water Tower Association and Kentucky Guild of Artists and Craftsmen, 1986.

Hands On (Vandalia, Ohio: Shopsmith, Inc.), 1980–82.

Jones, Michael Owen. *Craftsman of the Cumberlands: Tradition and Creativity*. Lexington: University Press of Kentucky, 1989.

Made in Kentucky (Louisville: Kentucky Art and Craft Foundation), 1988.

Mace, F. Borden. Introduction to *Artisans/Appalachia/USA*. Boone, N.C.: Appalachian Consortium Press, 1977.

McNelly, Pat. *The First 40 Years: John C. Campbell Folk School*. Atlanta: McNelly–Rudd, 1966.

Miller, Jim W. *The Mountains Have Come Closer*. Boone, N.C.: Appalachian Consortium Press, 1980.

Moore, Eudorah. Edited transcript of Craft Administrators Conference, July 19-21, 1979. Asheville, N.C.: Southern Highland Handicraft Guild.

Morgan, Lucy, with Legette Blythe. *Gift from the Hills*. New York: Bobbs-Merrill Co., 1958. Enlarged edition. Chapel Hill: University of North Carolina Press, 1971.

Owens, Bob. "Development of the Appalachian Crafts" In *Final Report: Georgia Crafts Appalachia*. Atlanta: GCAH Crafts Program, 1981.

Peck, Elizabeth S., and Emily Ann Smith. *Berea's First 125 Years: 1855–1980*. Lexington: University Press of Kentucky, 1982.

Penland Journal (Penland, N.C.: Penland School), 3 (Summer 1988).

Reynolds, Sharon. "Selling Kentucky Items Can Be a Crafty Business." Lexington (Ky.) *Herald-Leader*, Jan. 31, 1982.

Robinson, Rex W. "United We Grow, Isolated We Fall." *Kentucky Artist and Craftsmen* (Owensboro, Ky.: Communications Art Productions), 1, no. 1 (Sept.–Oct. 1976): 3.

Ross, Smith G. *Come, Go with Me: How to Be Independent and Enjoy Rural Living*. Detroit: Harlo Press, 1977.

Russell, Robert Stanley. "The Southern Highland Handicraft Guild, 1928–1975." Ed.D. thesis, Columbia University Teachers College, 1976.

Schnacke, Dick. *American Folk Toys. How to Make Them*. New York: G. P. Putnam's Sons, 1973.

Southern Highland Handicraft Guild. "Final Marketing Committee Survey Report." Photocopy. Asheville, N.C., 1989.

Southern Highland Handicraft Guild and Crafts of Nine States, Inc. "Cash Flow Analysis, December 1989." Photocopy. Asheville, N.C., 1989.

"Spotlight on Appalachian Craftsmen." New York *Times*, Apr. 12, 1967.

Sprague, Stuart Seely. "ARC from Implementation to Payoff Decade and Beyond." *Morehead State University Appalachian Development Center Research Report* (Morehead, Ky.), no. 11 (1986).

Stevens, Bernice A. *A Weavin' Woman*. Gatlinburg, Tenn.: Buckhorn Press, 1971.

Sunshine Artists (Winter Park, Fla.: Sun Country Enterprises), 1974–82.

Van Dommelen, David. "Allen Eaton: In Quest of Beauty." *American Craft* 45 (June–July 1985): 35–39.

Wainwright, Lisa. "Eastern Kentucky Folk Art: A Contribution to the History of Spiritual Expression." *Good and Evil* exhibition catalog. Champaign-Urbana: University of Illinois, 1988.

Ward, Joe. "Kentucky's Crafts Industry Still Booming in Wake of High-Flying Days of Phyllis George." Louisville *Courier-Journal*, Feb. 11, 1985.

Weaver, Emma. *Crafts in the Southern Highlands*. Asheville, N.C.: Southern Highland Handicraft Guild, 1958.

Wellborn, Deedee, and Shane Holcomb. "I Think That I Shall Never Saw Exactly Down the Line I Draw." *Foxfire* 21, no. 3 (Fall 1987): 152–65.

Whisnant, David. *All That Is Native and Fine: The Politics of Culture in an American Region*. Chapel Hill: University of North Carolina Press, 1983.

Woodside, Jane Harris. "A Dialogue in Folk and Fine Art." *Now and Then* (Johnson City: East Tennessee State University Center for Appalachian Studies and Services), 6, no. 3 (Fall 1989): 41–43.

Index